PRICING PHOTOGRAPHY

The Complete Guide to Assignment and Stock Prices

THIRD EDITION

Michal Heron and David MacTavish

ALLWORTH PRESS
NEW YORK

Dedication: To Our Families

ACKNOWLEDGMENTS:
The authors wish to express their appreciation to the many ASMP colleagues, photographers, legal advisors who have contributed their expertise to this book. In particular gratitude goes to our publisher Tad Crawford for his vision and continuing patience and to Liz Van Hoose for her pleasant manner and her diligent, precise editing.

07 06 05 04 03 02 5 4 3 2 1

Published by Allworth Press
An imprint of Allworth Communications
10 East 23rd Street, New York, NY 10010

Cover design by Douglas Design Associates, New York, NY

Page composition and typography by SR Desktop Services, Ridge, NY

Library of Congress Cataloging-in-Publication Data
Heron, Michal.
 Pricing photography : the complete guide to assignment and stock prices / by Michal Heron
and David MacTavish.—3rd ed.
 p. cm.
 Includes bibliographical references and index.
 ISBN 1-58115-207-8
 1. Photography—Prices. 2. Commercial photography. I. McTavish, David. II. Title.
TR690.H45 2002
770'.68'8—dc21 2001005450

Printed in Canada

Table of Contents

The Business of Photography

P hotography is an obsession, mostly a joyful one. This doesn't have to be explained to any photographer who has felt an adrenalin rush while shooting—trying to capture a fleeting winter twilight, the image of a Mongolian horseman racing across a sunset, the magical geometry on a factory exterior, a child's evocative expression, or, simply, after hours of labor, the right glint on a perfume bottle.

The profession of photography is unusual in the extraordinary range of abilities it demands of a practitioner. It combines artistic, emotional, and technical skills; it requires one to understand the physics of light, the chemistry of film, and computer programs for digitizing, and to have physical, organizational, mental, and emotional strengths as well. You must be at once left- and right-brained—in short, you must do it all.

The joy of photography is in its challenge, adventure, and satisfactions. It is a "profession" in that it is a way to earn a living; it is also a profession of our faith in the artistic side of our nature. When you first love photography you are embracing an addiction—to the pleasures of creating with light, to a fascination with seeing, and to the delight of sharing the visualization of your emotions and your intellect. And, it's fun.

Our purpose here is to help you get paid fairly for doing what you love.

Earning a Living in Photography

The business of photography can be loosely divided into two major areas—consumer and publication. There are other service photography specialties, of course, such as banquet, insurance, or even forensic photography. Even so, most of the business falls into two general categories.

Consumer-based photography, such as wedding and portraiture, provides a product to a retail customer. In this case the actual product purchased, the photographic print, changes hands and generally is retained by the buyer. Photography for publication, on the other hand, most often provides a service, not a product. It means that the customer (or final user) is a client who uses a photograph in, for example, an advertisement, a calendar, a magazine, or company brochure. In this instance, the photographer allows temporary access to the photograph. The physical property of the photograph generally is not sold or turned over permanently. The clients pay merely for the permission to reproduce (to license) the photograph as part of their publication (magazine) or in a product (greeting card), and the physical property of the photograph is on loan for that purpose. The photographer is licensing the rights to the photo for a period of time and particular use and is not selling it. In casual speech, you will often hear the word "sell" with reference to publication photography. However, it is more accurate to say that you license rights or grant permission to reproduce the image.

Fine art photography and the selling of gallery prints to collectors and museums, a specialty unto itself, crosses over into all aspects of photography. Art can originate in any part of the business. Pricing of fine art photography is determined by the power of the work, the reputation of the photographer, and the skill of the gallery.

The pricing and negotiating techniques in this book will concentrate on photography for publication.

Photography Career Choices

How do you earn your living as a photographer? Lifestyle preference and circumstance (like what jobs are available) will largely determine whether photographers work on staff as employees or on their own as independent businesspersons or entrepreneurs.

Staff photographers are used by companies as varied as newspapers and book publishers or medical audiovisual producers, as well as by institutions ranging from museums to governmental agencies—actually, wherever an institution has a large enough volume of work to keep a photographer busy. Catalog studios are likely to use staff, particularly digital photographers.

Staff jobs generally pay a relatively low salary but offer the security of a regular income, benefits, access to expensive equipment without the overhead of maintaining it, and an opportunity to gain practical experience in a variety of photographic areas. Staff jobs can also provide continuity, often offering the photographer the opportunity to work with the same people or on the same types of projects, and sometimes even to become a specialist in one field.

Being an independent photographer means you are in business for yourself, whether you work as a sole proprietor (just you) or run a photography studio with a full staff. This lifestyle offers variety, creative challenges, the possibility of a higher income than a staff position—and fear. Along with the excitement and satisfaction of running your own operation comes the pressure of maintaining an overhead with an uncertain income flow. A word about words: the term "freelance" is widely used to describe the independent photographer and is just as widely misunderstood, even by photographers themselves. The dictionary meaning is clear but narrow: "someone who works in a profession, selling work or services by the hour, day, or project rather than working on a regular salary basis for one employer."

The word is often misused and is sometimes given the unprofessional connotation of working with a rather casual commitment to a profession—"Oh, you're a freelancer, how nice, you can work when you feel like it. . . ."—while to others it is merely a euphemism for being out of work. Freelance can also conjure up the romantic image of a foot-loose photojournalist, camera bags swinging, while boarding the last helicopter out of today's trouble spot.

What the word does not properly convey is the sense that photography is a business and photographers are businesspersons. All of this etymology has a point. The words used reflect the way photographers think of themselves; the sooner photographers recognize that in addition to being creative people they are also businesspeople, the more likely it will be that success and contentment will follow.

The information in this book is critical to the financial success of an independent photography business. But it is equally (and perhaps more) useful to the staff photographer who sells stock or does the occasional freelance job. The staff person, being out of the mainstream of day-to-day pricing, may be more at sea when called upon to negotiate an assignment or stock photo sale.

Photography Income

The two main sources of photography income for the independent photographer working for publication are:

1. Assignment photography
2. Stock photography

Assignment photography is new photography, commissioned and paid for by a client. We photographers are selling our ability to create a photograph and also the rights for the client to reproduce that photograph for a very specific usage and time period.

In stock photography we are selling (licensing) rights to reproduce an already existing photograph. Those stock photographs are any to which the photographer owns the rights. They may have resulted from many sources, from an assignment (the outtakes—the images to which the photographer retains the rights from an assignment), from photography produced specifically with stock in mind, or from any other impetus such as travel shooting, family portraits, or lighting experiments. Any good photography to which you own the rights is potential stock photography.

Stock photography can be marketed for us by one or more professional stock photo agencies to a range of clients worldwide. Photo agencies maintain staff to handle everything from the routine filing of the images and paperwork to the development of sophisticated new technology for electronic marketing. To cover these costs, they keep a commission from any fees they collect for usage licensing (commonly 50 percent). They do not own the copyrights but merely act as agents on our behalf. The alternative is for the photographer to handle the entire marketing of stock through his or her own business. (For thorough coverage of this complex industry, consult the books listed in the bibliography.)

What Are We Selling?

Photographers offer a service made up of many intangibles, including a creative eye; technical ability; an array of complicat-

ed equipment; the logistical skills to plan and produce a shoot; an ability to hire and manage assistants, stylists, or location scouts; and, perhaps the most important of all, intelligence. A client is buying the brain behind the camera, the keen insights of a well-informed mind—informed on the newest equipment in photography, informed on stylistic trends, informed on business and world events.

Time is not what photographers sell primarily; you'll find this assertion to be a continuing theme throughout this book. Calculating the time spent taking a photograph as the sole or principal value of your photography is foolhardy. It reduces your contribution to that of a day laborer and totally ignores the creativity and expertise you bring to a shoot.

So, what are we selling? A photographer's ability to translate the client's message into a powerful graphic statement is the service being offered. And, the usage rights to the resulting photograph(s) are what's being "sold." These are key points for photographers to understand and then to communicate to clients. As you'll see in chapter 2, while the time you spend in all aspects of an assignment is not ignored and rather will be an element of pricing, it is merely one factor in the equation.

THE VALUE OF COPYRIGHT
The most important asset you have is the copyright in your photographs. Once you have brought to bear all the talents listed above, the tangible result, the photograph, has a life of its own. The right to reproduce it, which is called the copyright, is the primary asset of the photograph.

An understanding of copyright is integral to your success as a photographer. You should protect your copyright with a copyright notice (© symbol, name, date of first publication), and for greatest protection, register your photographs with the copyright office in Washington, D.C. *(www.loc.gov/copyright)*. We urge you to read more detailed coverage on copyright in some of the books and Web sites listed in the bibliography and resources. But for now, here are the basics.

The copyright is actually composed of a bundle of rights that can be separated and portioned off for different purposes and licensed to a variety of clients for a wide range of fees. The

same photograph has a virtually unlimited number of uses over its lifetime. Under law, the copyright belongs to you from the moment of creation: the moment the shutter clicks and the image is fixed on the film or in digital form. And that copyright continues for your life plus seventy years. The only exceptions to this are if you are an employee or if you have signed a "work-for-hire" contract with a client.

If you are an employee and unless you've made a special arrangement to the contrary, the copyright in any photograph taken on the job belongs to the employer. However, the copyright to any work done on your own time, vacation or weekends, for example, is yours.

The other exception to your ownership of copyright is an aspect of the law called "work-for-hire." You will lose your copyright (by literally giving it away) if you sign a work-for-hire contract with a client. This has become a major problem in assignment work, when clients request, or often demand, work-for-hire as a condition of obtaining the assignment. Stock photography can never be considered a work made for hire. By signing a work-for-hire contract, you give up all your rights in the photograph(s) and all future income from them. Under law, work-for-hire dictates that the client, not you, created the photograph. The client receives all the fruits of your labor and your creativity. This dreadful, onerous aspect to the law should be stringently avoided. (See page 33.)

It's easy to see that work-for-hire will erode your future income and strip you of creative control of your life's work. And there are other ways for a client to skin this cat. Be aware of the client who wants to accomplish almost the same end by simply demanding all rights, a buyout, or a transfer of copyright, all of which may have a similar devastating economic effect on you. So, whatever the terminology used in the effort to take it away, the value of your major asset, the copyright in your photographs, must be protected.

Congress gave something special to creators through the protection of copyright. Use it.

The History of Pricing
The traditional industry practice for photographic assignments is that clients pay a photography fee, plus all expenses related to

the shoot, in exchange for which they get specific usage rights to the photography. The client's investment in new work can be protected from use by competitors by the photographer's granting restrictions, either by withholding all outtakes from stock sales until the assigning client's needs are met or by withholding their use by the client's competitors for some period of time.

The payment for use of stock photography is for specific reproduction usage. There may be other fees the client pays, such as research or holding fees, but clients do not pick up the specific expenses connected with the shoot. (More about these points in chapter 2.)

Historically, pricing levels have been different in each segment of the industry—advertising, corporate, and editorial.

Advertising has paid the highest fees. These rates have been influenced primarily by the size of the advertising budgets for the purchase of space in which to display the ad, as well as by the perceived importance (by the client) of the photo in relation to the ad. In advertising the photographer usually remained anonymous; photo credits were, and still are, thought to distract from the advertiser's message.

And the trade-off has meant higher fees to compensate for the loss of credit.

Corporate clients have paid fees only slightly lower than advertising clients. They place great importance, and therefore money, on the value of first-class photography to their annual reports and brochures—publications that present the corporation to the public. This work usually requires a very high level of creative lighting and technical skill.

Editorial clients, newspapers, magazine and book publishers, have tended to have low budgets but offered what was perceived as interesting, meaningful work—assignments to document the influence of industrialization on the Indians of the Brazilian rain forest, for example. Photo credits, seen as a form of promotion for the photographer, were offered in part to offset the low fees.

There are technical aspects to the history of this pricing disparity as well. Editorial fees have been lower partly because clients were thought to have lower technical demands and fewer expectations. Therefore less expensive equipment was required.

Advertising and corporate clients, however, have demanded high production quality, which is expensive to deliver.

CHANGES IN THE BUSINESS

Twenty years ago the casual perception was that to be an editorial photographer, all you needed was "a couple of Nikons and some fast film." At that time, advertising photography was characterized as a business of large productions in a studio with set constructions, legions of assistants, models, and stylists, using zillions of watts of light sometimes with an 8″ × 10″ view camera.

Things have come full circle. Today's editorial shoot often requires sophisticated lighting, models, and sometimes sets. It may be more production/illustration than traditional documentary/editorial. At the same time, the advertising pendulum has swung; the style sometimes mimics the gritty look of real life instead of polished perfection that once was standard. The scenes and models are still carefully controlled and of high production quality, but shot with a grainy film and staged to create the feel of spontaneity.

Although stylistic distinctions are now blurred and technical demands are equal, fees have not reflected these changes. And this is so at a time when photographs are an increasingly powerful method of selling goods and services.

The greatest change in the business has been the switch to digital photography. As you will see in chapter 10, it affects every aspect of the business, requiring new equipment and new digital expertise for assignment and stock photographers.

PRICING TODAY

It's no secret that the economy of the past years has been volatile. The world of photography has been hit hard for several reasons. The mergers of the 1980s meant a shrinkage in clients across the industry—from advertising agencies and publishers to corporations. Photo budgets were cut and projects canceled. Even the prosperity of the 1990s didn't significantly raise photography prices. There were more projects available, but bottom-liners in corporations were increasing their profitability through cutting costs, and photography budgets are always an easy target. Into the new century, conditions remain difficult.

Add to this the ever-increasing number of photographers emerging from schools across the country. There is also the perception that the magical technology of the new cameras make skilled professionals unnecessary for many photo needs.

The cold fact is that photography prices have stagnated for years while costs have risen dramatically. There has been pressure downward from budget-slashing clients, often with no corresponding push upward on the part of photographers. This is as foolish as when companies cut ad budgets because their sales are down. But that's the reality.

IMPORTANCE OF PRICING

But doom and gloom is not reality. History shows that successful new businesses were started even in the depths of the great depression of the 1930s. There is always room for new photographers with fresh energy and ideas. Experienced pros can weather the economic hard times through skillful promotion of their vision and business. What won't work is to turn tail and run, cutting prices as you go. Many photographers still think they can demolish competition by undercutting fees but eventually find they will only be left with their own business in ruins. Accelerating a downward spiral by continually lowering prices will result only in driving you and your colleagues out of business.

Where These Prices Originated

The prices in the charts, later in this book, have come from a wide range of professional photographers and stock photo agents across the country and at different levels in the profession. They are intended to give you a starting point for negotiation and a guide to industry practices.

What This Book Is About

This book is based on the assumption that you have the necessary knowledge of photography to create handsome, meaningful photographs. The creative, technical, marketing, and production skills or legal information you need to run a successful business are not covered. For that, consult the many useful books listed in the bibliography at the end of this book.

The purpose of this book is to help you understand how much you need to earn to stay in business, and how to calculate and negotiate prices that will allow you to earn the amount you need. By simplifying the process of pricing, you will have more time and creative energy for your photography. In a happy sort of ellipse, this in turn will give you greater income to invest back into the business, allowing you to savor, even more, the joy of photography.

New In This Edition

In the current edition of this book, you will find revisions in all chapters to reflect changing market conditions and to clarify the need for assessing your overhead and understanding the reality of your costs as a basis for running a sound business.

An "Appendix of Forms" has been added at the end of the book. Once you have worked out the "deal" with a client, these forms will prove invaluable with the final step in any pricing negotiation—closing the deal—which means putting it in writing. Whether you are confirming an assignment estimate or sending a stock delivery submission, having the terms you negotiated, as you understand them, spelled out in writing, is a critical aspect of pricing. Even the delivery of photographs from an assignment should be documented with as much detail as you have time for. Whether you are submitting film you have edited, labeled, and numbered; a digital transmission of images; or simply raw film straight from the lab, documentation will keep the understanding and value of your images in the client's mind. When working on tight deadlines or from remote locations, you can still cover delivery of assignments by sending a cover delivery memo prior to the project to state that all deliveries will be under the terms of this memo. Then actual deliveries can be covered by a follow-up e-mail or hard copy listing the number of rolls, the number of images, and descriptions. Delivery of assignments is one of the areas least tended to by photographers, especially when working in good faith with a repeat client. Remember that conditions in a corporation can change, art directors may leave, and only your paperwork will spell out the original understanding of the assignment and the number of images submitted. Use of these forms is likely to keep the relationship with your client smooth and foster return business.

Future income can be lost if the terms of your agreement are muddy. Should you negotiate an assignment without clearly spelling out your residual rights in the assignment, later use of those images for stock becomes problematic. While you do retain the rights under copyright (unless you have specifically transferred them in writing), if the agreement isn't clear, the client may remember a different version of events—objecting to your terms only after the fact. This increases the difficulty of getting your work returned, and the chance of reaching an amicable agreement at a later date becomes remote. Lawsuits are commonly made on the backs of absent paperwork. Being right isn't always enough.

In the appendix you will find the face and reverse sides of four forms:

1. Assignment Photography Estimate / Confirmation / Invoice–License
2. Assignment Photography Delivery Memo
3. Stock Photography Delivery Memo
4. Stock Photography Invoice–License

The terms and conditions on the reverse spell out your rights in the transaction and the standard industry practices. You should be sure to include them in the forms you develop for your business, and it's advisable to have them reviewed by your lawyer, especially in light of any local laws that may affect the terms. Use these forms to present transaction information clearly, to protect the prices you so skillfully negotiated.

And, finally, a glossary of terms has been written for your reference. Titles, professions, image types, various rights, and other terms that are often used in contracts and negotiations are explained in detail. Use this final section whenever you prepare for a negotiation, and always refer to the terms' definitions when you are drawing up or reviewing a contract.

Work-for-Hire

Work-for-hire means that the assigning client has become the creator, instead of you, and that the copyright vests in the client from the moment of creation; it's as if you never existed. And this applies to every photograph taken during the assignment, not just those used by the client.

Work-for-hire can be established only if both of the following conditions apply:

1. You and the client have signed a work-for-hire contract, and
2. The type of work falls under one of nine categories listed in the law, the most relevant to photographers being:
 • A contribution to a collective work such as a magazine, newspaper, or anthology
 • A supplementary work—a smaller work intended to accompany a larger whole
 • A contribution to be used as part of an audiovisual production
 • A contribution to be used as part of a motion picture

The effect of work-for-hire is that you are made into an employee for the duration of this project, but you are not given the benefits a staff employee enjoys, such as health insurance and paid vacations.

The results of work-for-hire are:

• Loss of authorship—the client becomes the creator
• Loss of creative control over future use of the photograph
• Loss of control or use of any photographs taken during the assignment
• Loss of residual income from the photograph
• Loss of future income for your retirement or your estate
• Loss of bargaining power
• Absence of employee benefits
• Lack of rights to authorship credit.

Not only do you give up all of this, but you must face the possibility that you may be competing against your own work some day. The client, now the copyright owner, has not only unlimited use and control of the photographs but can also sell them, just as a stock agency would, with no payment to you. And, yes, the client can even give these photographs away for free! It has happened. Can you or your stock agent(s) successfully compete when someone else is giving away your work?

The Economics of Photography

There is an interesting truth that photographers (and perhaps all creative people) should commit to memory. And that is, photographers can be artistically successful with a moderate amount of technical knowledge, but they can only be financially successful by learning, honing, and applying business skills as much or more than they do artistic ones.

This chapter first looks at the business of publication photography and at determining what it is you have to offer clients. The heart of this chapter teaches you how to determine overhead—what it costs you to be in business before you ever take an assignment, license a stock photograph, or produce a digital image.

On Being a Businessperson

Many creative people look at business as an evil to be shunned or ignored, and far too many photographers take some sort of perverse pride in boasting about their lack of business acumen. Too bad. Business dealings are a necessity for anyone who wants to make some money from photography; frankly, business can even be fun. Treat establishing and maintaining your business as a goal worth achieving, because it is. You and your family will be the winners—there are no losers.

A businesslike approach will go a long way towards dispelling any unstated anxieties your clients may have, whether it is their stereotypical ideas about creative individuals dressing sloppily, being poor businesspeople, or simply wondering if you are really competent to handle a complex assignment.

Doing What You Like

While the different markets of photography discussed in this book—advertising, corporate, editorial, and stock—each generate varying degrees of income, making money shouldn't be the major determinant when deciding what field to concentrate in. Generally, you will be happiest doing what you like and what you're good at, rather than just aiming for the highest fees.

This chapter will help you understand:

- What you need to earn to stay in business, how to determine the necessary amount to cover your basic business and personal needs, and to provide for company growth
- What goes into pricing—the elements that you must consider as you determine a price, be it stock or assignment photography

How You Earn: Assignment versus Stock

This book deals with photography that is intended to be published in some manner. Mostly, your work will appear on a printed page, but increasingly photographers will find their work appearing in nontraditional publishing forms—like CD-ROM disks.

The two basic disciplines in publication photography are assignment and stock. Assignment photography can be appealing because it is an opportunity to create new work. It provides the challenge of working with different people and the stimulus of shared ideas as you work to solve visual problems. It also offers the inviting benefit of knowing there will be an immediate financial reward. For the client, commissioning assignments provides the opportunity of fresh, never-before-published work for their project. There can, however, also be a great deal of risk. For the client, risk from having to pay out money without first knowing exactly what the results will be. The photographer, on the other hand, is constantly gambling that all of the preparations, equipment checks, model selection, and lighting design for an assignment will work out as planned, and that the final images will contain the drama and excitement envisioned at the outset.

Stock photography offers an alternative to the pressure of assignments, which some photographers opt to avoid. Instead, stock photography provides the same opportunity to produce

exciting work without many of the limitations presented by clients. You are free to create photographs as you see them, without a client's restricting your creativity by nagging about budgetary discipline. This doesn't mean, however, that stock photography allows total and unbridled freedom. You, not a client, will front the expenses of photography, and financial rewards may not appear for many years. Therefore, to make a go of stock, you must paradoxically be even more strict than any client in controlling time and costs. The risk for you will be in producing photographs that clients will wish to use, and pay to use.

Many photographers find that a blend of assignment and stock provides a satisfying combination, each complementing and rejuvenating the other.

You Aren't Actually Selling

In pricing photography for publication, you must always remember that you are rarely "selling" your images. This is true whether the images were made on assignment or are in your stock photography library. Photographers who do portrait and wedding photography make images that are sold to customers and are products. These images are not intended to be published.

If you are a publication photographer, get in the habit of thinking that you are only letting your clients temporarily use your images. You are, in essence, allowing the client temporary use of your work. This is called "licensing," and it is not to be confused with "leasing," "renting," or, especially, "selling." Each of these terms has distinct legal significance, and they do not describe your arrangement with your clients. Always think LICENSING!

What Are We Pricing?

Whether for stock or assignment, prices are based on general industry assumptions—namely, project budget size (and therefore the value to your client) and the usage rights demanded. These factors directly affect what a client should pay.

In other words, because advertising projects generally have the largest project budgets (and the most potential for realizing profit), larger fees are usually paid. And, if clients want to use a photograph on a billboard, on a package, and as a two-page spread advertisement, that client should expect to pay more. But, a price must be based on more.

Background

Over the years methods of pricing have developed differently in specific areas of photography. In editorial and corporate work, the day rate was a prominent feature of pricing. In advertising, a creative fee was the norm—with the day being incorporated as part of that fee. In recent years a day-rate-only mentality has gained precedence, and photographers have lost sight of the many other factors that affect pricing. It may not be coincidental that photographers have suffered a steady erosion in fees during this time.

Traditionally, photographers based assignment pricing as a "day rate plus expenses" for each billable day. A billable day was usually considered to be any day during which photography actually took place. If there were multiple days, the number was multiplied against the day rate for a total. This approach worked somewhat well for decades, although it didn't accurately reflect the real values of the assignment or the photographer's talents. And, it brought about some friction with photo clients.

Too many clients, when confronted with the term "day rate," react negatively, comparing a day rate to the eight or so hours they toil daily. Because of the simplistic (and, therefore, deficient) "day rate" concept, clients expect to pay only for actual photography days. Worse, they probably don't realize that you may have fewer than one hundred billable days per year. Because they don't understand, clients may compare the amount that they make each day, possibly $100 to $300 per day, to the hundreds and perhaps thousands you may charge on a day rate basis. "Why," they may ask themselves, "should I pay this photographer so much for taking a few photographs?" Clients can't be expected to know that each billable day you work for them will take several additional days for preproduction and possibly another for editing, preparing the photographs for delivery, and so on. And, they probably aren't aware that your fee goes to help pay for overhead items like insurance, health coverage, and the many benefits they take for granted as employees.

Conceived during the heyday of magazine photojournalism, the concept of "day rate," in today's marketplace, is philosophically and financially unwise. Do yourself and your client a big favor: Quote a "creative fee" for the assignment and *not* a "day rate."

A creative fee encompasses much more than the simplistic day rate and consists of: overhead (what it costs you to be in business each billable day), a profit (usually expressed as a percentage of overhead), and, based on the particular assignment, other relevant factors of value (like time, experience, hazards, value to the client, and so on). The grand total will be your creative fee. (Note: Expenses related to the assignment are not included within the creative fee but are usually listed as separate items.)

At first glance, it may seem easier to use the concept of day rate, since it is easily quantifiable and understandable, especially if you are inexperienced or if your authority over an assignment is limited. *What if you incorrectly calculated, and additional time is required to complete the assignment?* some may ask. If you estimate by using a creative fee, their reasoning goes, you might find yourself working extra days without pay. The simple solution is to note in your estimate or bid that "the creative fee assumes a specific time period . . . ," a range within which you feel you can do the photography, possibly one you've already agreed to based on discussions with your client. "Should extra time be required . . . ," your terms and conditions continue, not of your own causing, you "will have to revise the creative fee accordingly." (See the bibliography for more information about paperwork that will protect your position.)

You will find clients commonly asking for your "day rate." Don't be trapped. It's best to tell them that quoting a day rate is not the way you work because you price by the job, and quoting a rate is impossible without knowing all the factors of a job. Why not say instead, "If you care to tell me about an assignment you recently did, or an upcoming one, I'll be glad to give you an idea of what I would charge." This approach has two benefits: Not only are you able to offer a more accurate idea of price, you also have the client involving you in discussions directly related to assignments.

Day Rate versus Shooting Time

In the seminars given around the country by the authors of this book, the most difficult concept in pricing seems to be relating the day rate vis-à-vis accounting for time spent shooting on an assignment. How can this be reconciled? If not through a day rate, how can we be sure our time is covered? Simple—photography shooting time is well accounted for under the umbrella of the creative fee. But, instead of being expressed in a flat fee, time expressed within a creative fee is calculated in a way that relates to your cost of being in business. The day rate, despite everyone's best intentions, becomes a flat fee when a client asks your "day rate" and forever categorizes you by that number. No longer can you account for the many factors that may affect a price—your day rate becomes permanently fixed, regardless of the type of assignment and the rights that are requested. Later, we will dissect the creative fee and show how to use your own costs to build a creative fee tailored to your business. For now, remember that time spent is *not* day rate; time must be a factor in your calculations, and a value must be assigned to it. Time spent reflects the days involved in the assignment, and these days are valued when you include a percentage of your overhead and profit, pro-rated over the number of potential billable days.

Elements of Pricing

Although pricing assignments and stock licenses will be explained in greater detail in later chapters, let's take a brief look at the various elements that make up assignment and stock prices.

ASSIGNMENTS

An assignment price is the amount you will actually charge a client. It is important to remember that all costs associated with production (including your time and overhead) are borne by the client in exchange for the first use of the image(s). The elements that constitute the assignment's bottom line price are expressed as fees or expenses. This approach to assignment pricing works whether you are making images with a camera, computer, finger paints, or any other tools.

1. Creative Fee: This fee is made up of a number of separate elements, expressed as a single fee:

- *Overhead.* The costs you have to account for even if you never take any photographs (e.g., the cost of photographic equipment, studio rental, using your vehicle in business, insurance, salaries, profit, and so on). Later, you'll see how to calculate overhead.

- *Time.* The total amount of time you spend working on the assignment, and not necessarily just the time you spend photographing. Some photographers include in the creative fee a modest amount of time for pre- and post-production, such as phone calls to arrange the assignment, casting, or meetings, unless the assignment calls for extensive logistical arrangements.

- *Value factors* are components affecting your creative fee that include the market where the photos will appear, usage rights or how the client intends to use your image(s), and various photographic elements like special skill or creativity, special risks or hazards, and so on. (See the box, "Value Factors," below.) For example, you may charge less if your image is used in a nonprofit foundation newsletter but far more if a *Fortune* 500 company uses the same image in their annual report. When pricing usage, remember the old adage, "What the market will bear." Some types of use simply pay more than others. (Note: The pricing charts in this book are a visual explanation of what this means.)

The creative fee is the basic fee that must be charged (no matter what you call it), and for any assignment it can be formulated as: annual overhead total divided by the number of assignment days you expect in a year, multiplied by the number of days in the assignment you are pricing, added to various usage or value factors. Don't panic—these terms will be fully explained later. The equation could be drawn as:

> **Creative Fee = Annual Overhead ÷ Annual Photography Days × Assignment Days + Value Factors**

2. Noncreative Fees: These are charges for your time working on an assignment that are not generally thought to be creative acts of photography. These fees can include

- Travel time
- Casting
- Postponement
- Cancellation
- Pre- and post-production
- Reshoot fees
- Weather delays

These fees are charged as required to compensate you for your time or time lost and likely won't be charged very often, but they must be charged when necessary, or you will put yourself in the position of losing money.

3. Expenses: These are the costs you incur doing an assignment and are billed to the client. Assignment expenses do not include any of your overhead, because those costs are already incorporated into your creative fee. You will find a more comprehensive listing of possible expense items in chapter 6, but for now, just note that some expense categories include: casting, crew, insurance, film/lab, location, messengers/shipping, props, rentals, sets, studio, talent, transportation (local), travel, and wardrobe. Reimbursable expenses are generally those items that are disposable or consumable, as opposed to items that are not consumed, like cameras, lighting equipment, and so on.

4. Miscellaneous Charges: Assignment prices may include a number of other, miscellaneous charges:

- *Expense markups* are a small percentage added to the amount you have spent on expenses. The smart photographer adds this charge to compensate you

for the client's use of your money until you are paid. If you extend "credit" on expenses, you should expect to be paid for it.

- *Reuse fees*. Compensation for a client's later, additional use of your assignment photographs. This is a fee that is seldom charged along with your assignment invoicing. It usually comes later, when a client requests additional use of your images. If negotiated at the time of the original assignment, future reuse can be billed as part of the creative fee or as a separate fee amount. If reuse is requested at a later date, these fees may be negotiated and invoiced as reuse fees, similar to stock reproduction fees. The smart photographer will bring up the subject of reuse charges in the original negotiations, because it puts clients on notice that additional use is not free, that they don't own the images, and that you are thinking of their needs and willing to extend a lower rate for reuse.

Some Assignment Fees and Expenses

The checklist below contains many, but not all, of the fees and expenses traditionally billed for assignments. A more complete listing is available in chapter 6.

Fees
- Photography
- Nonphotography

Expenses
- Casting
- Crew
- Insurance
- Film/Lab
- Location
- Messengers/shipping
- Props
- Rental
- Sets
- Studio
- Talent
- Transportation (local)
- Travel
- Wardrobe
- Miscellaneous

STOCK

Because stock photographs are existing images, and since you, not a client, may have shouldered the costs of production, the elements that make up the bottom line price for a stock photograph differ from those related to assignments. A word of advice: Bill all fees separately so that the reproduction fee doesn't appear to be excessive and so that it only reflects usage and the cost of image production.

1. Reproduction, License, or Use Fee: Much like the creative fee in assignment photography pricing, the reproduction fee, also known as a use or licensing fee, compensates you for overhead and additional value factors that apply.

- *Overhead* may now have to reflect additional salaries for an assistant or secretary.
- *Pricing factors* are incorporated into the price because of the uniqueness of a particular photograph, the difficulty or danger obtaining the image, special costs (*e.g.*, equipment rental), the client's licensing use requests, and so on. See the "Pricing Factors" chart for more information.

Reproduction fee = Overhead + Pricing Factors

2. Research Fees may be charged to compensate for the cost of selecting and refiling submission requests and to help discourage casual requests by buyers who are not really serious or are only shopping for ideas or inspiration. In the highly competitive world of stock photography, many stock agents have foolishly given up this charge to gain a competitive advantage. Of course, if everyone does the same thing, there goes the advantage. Research fees are often waived by crediting them against reproduction or license fee charges, but only if a client actually negotiates a license.

3. Holding Fee compensates you for the period of time photos are kept out of circulation by a client, thus preventing you from licensing them to others. If you provide digital files instead of original images, this fee is not necessary, unless you are withholding the image from use by others until the client decides whether to use the image.

4. Loss or Damage Fees are levied for any lost or damaged images to compensate you for lost potential income that you will be deprived of because the image cannot be used, or to compensate you for repairing damage (assuming it can be done digitally) or for having another duplicate image made.

You've seen that in pricing both stock and assignment photography, the main components are overhead, pricing factors, and time. Let's now explore each as they affect photographers, beginning with overhead.

Overhead

What separates this book from most other pricing books and software is our emphasis on understanding and calculating overhead. Determining overhead is an important factor in pricing in every business except photography, it seems. Other pricing aids prefer simplicity. "Here are our prices, isn't that easy," is frequently their approach. Because photographers who depend upon such pricing aids remain ignorant of their overhead requirements, they too often engage in price-cutting. Again and again, however, these photographers struggle to get ahead, go out of business, and depress photography fees for everyone.

Overhead consists of many things that you have to make enough money to cover, from your salary to camera and other equipment purchases to utilities and many other things you take for granted—but you can't afford to take them for granted if you are in business.

If you only consult pricing charts, without knowing your overhead, you are on a short track to nowhere.

WHAT IS OVERHEAD?

Overhead, for photographers, is comprised of all of the costs that you incur that aren't directly attributable to specific assignments or stock licensing. The total of these costs are typically thought of as what it costs to be in business for one year, but it can also be figured on any other time basis—monthly, weekly, or daily. Overhead it is a combination of two kinds of costs: fixed and variable.

Fixed costs are inevitable. Rent or studio/office ownership costs, for instance, are as inescapable as telephone bills and business insurance. Variable costs, on the other hand, will change in amount, depending upon the level of your activities. Some variable costs are inevitable, even if you never have a billable day. For example, film will be used for testing, promotions, or stock production. These costs will vary week-by-week, month-by-month, but you will need to budget and account for them even though many variables can only be estimated.

Note: Fixed and variable costs are not the same as those expenses billed to a client that will be incurred in support of an assignment. Since assignment expenses are usually reimbursable, they are usually billed to your client and therefore do not become part of your overhead commitment.

After you have listed all of your overhead costs, fixed and variable, add them up to derive your overhead subtotal. Our two hypothetical photo businesses show:

The "Calculating Overhead" chart shows that photographer 1 has fixed costs of $60,102, variable costs of $9,962, and profit of $7,006, for an annual overhead total of $77,070.

Photographer 2 has fixed costs of $156,863, variable costs of $66,828, and profit of $22,369, for an annual overhead total of $246,060.

If you are doing digital imaging, you must add into your overhead analysis the much greater costs of fast computer(s), large monitors, film and flatbed scanners, removable media drives (e.g., CD-ROM), CD-writeable or "burner" drives, and so on. These are fixed costs that will likely be depreciated over only three years. Technological advances will require you to replace imaging equipment with ever faster tools. Digital imaging would be expected to add additional thousands of dollars each year, depending upon the extent of your involvement.

Calculating Overhead

Fixed Costs	Photographer #1	#2
Depreciation:		
cameras, lighting, etc.	2,200	9,891
computers	940	2,366
office equipment	650	1,861
office furnishings	985	2,129
van/car/truck	2,450	6,667
Insurance	1,800	4,276
Rent	6,000	24,000
(or mortgage or percent of home office)		
Salaries:		
yours	30,000	45,000
others	10,500	43,000
Taxes		
city	387	1,321
federal	1,783	2,489
property	1,007	4,541
Utilities	2,400	9,322
(telephone, electric, gas)		
Fixed costs subtotal	**$60,102**	**$156,863**

Variable Costs	Photographer #1	#2
Production:		
film	799	4,349
processing	1,013	5,492
model fees		8,923
props		2,734
permits		500
assistants fees (freelance)		1,800
Professional Fees:		
legal, accounting		1,240
bank charges		98
retirement (pension plan, Keogh, IRA)		8,450

Variable Costs	Photographer #1	#2
Repairs:		
studio/office		1,400
photographic equipment	75	721
business equipment		373
Studio/Office:		
messengers		445
promotion/advertising	3,000	8,490
subscriptions/books		750
professional dues	275	275
education		
printing	2,000	3,215
postage	1,200	4,717
office supplies	1,000	2,786
Transportation:		
car	477	1,740
taxicab	123	429
other		313
Travel:		
hotel		2500
meals		876
air fare		3267
car rental		945
Variable costs subtotal	**$9,962**	**$66,828**
Fixed costs subtotal	**$60,102**	**$156,863**
Variable costs subtotal	**$9,962**	**$66,828**
Overhead Subtotal	$70,064*	$223,691*
Profit: 10%	7,006	22,369
Annual Overhead Total	$77,070	$246,060

*The total of fixed and variable costs added together.
NOTE: If you are doing digital imaging, you will have to list in the depreciation section the greater annual overhead of computers, scanners, printers, and so on.

13

WHAT ARE YOUR PERSONAL NEEDS?

Most people want to make money. But how much income do you really need on an annual basis? To start with, you have to figure a salary (i.e., your personal income) for yourself—otherwise, why go into business? Too often, especially when starting up, owners (and that is what you are) approach their small business without factoring in a salary for themselves, hoping instead to live off of any "extra profits." As a result, they never have a clear picture of the financial health of their operation, never get ahead, and slowly find they have to siphon more and more from their business, depleting its resources in order to ensure their own personal survival. Not properly accounting for your own salary (or for every other cost) in overhead is a sure prescription for failure. Another trap small business owners fall into is paying for personal items with company money, instead of investing it back into the company. By not setting up your business with hard and fast rules controlling finances, you will tap the business treasury until it's tapped out! The IRS does not look kindly on business owners who mix business funds and personal needs. Learn early one of the cardinal rules of running a profitable business: Thou shalt not pull the wool over thine own eyes!

Determining salary is somewhat simplified if you have recently been earning a regular salary; if your paycheck met all of your personal and family needs, you know how much you have to make. If it wasn't enough, you need to earn more. (And, if you were wallowing in excess money, why in the world are you reading this book?)

On the other hand, if you haven't received a regular paycheck, you must formulate a budget showing what you spend on housing, food, clothing, insurance, transportation, entertainment, and all other personal or family needs each year. The total is what you need for an annual salary. Remember, though, if you are starting up a new business be prepared to sacrifice somewhat until you've become established. Also understand that your salary is not all of your overhead—it is just one item of overhead.

PROFIT AS PART OF OVERHEAD

You need to determine an amount that can be considered profit—after all, isn't the reward for being in business for oneself a profit? Simply put, profit is money that allows your business to grow.

You can easily approach profit calculation from one of two ways: making it a fixed amount, or dealing with it as a percentage of overhead. A fixed amount for profit could be any reasonable sum you wish, say $50 or $100 for every billable day, although it may have to be much more for a large operation. Better yet, multiply your overhead subtotal by some percentage to derive your profit amount. Since many businesses find 10 percent of overhead to be a more than adequate level, why not try that to start?

In our example for photographer 1, the overhead subtotal of $70,064 is multiplied by 10 percent, and the result ($7,006) is added to the overhead subtotal ($70,064), to make an annual overhead total of $76,767.

Caution—this is not a time to indulge in fantasy. The profit amount you use must maintain a reasonable relationship to your experience and value to your clients. The important point is to understand the concept and importance of profit, and always to include it in your calculations.

Finally, the easiest way to ensure that you cover your overhead costs is to determine what your overhead is on a daily basis.

CALCULATING DAILY OVERHEAD

Planning how to cover annual overhead total is difficult. Instead, think about "daily overhead"—that is, your annual overhead total evenly apportioned on a daily basis to the days when you will shoot an assignment.

Take the overhead total and divide it by the number of annual billable assignment days you can reasonably estimate or expect to have. The result is the minimum amount you must recover for every day you are actually photographing in order to cover (only) your overhead costs. Bill less than this, and you'll soon be getting midnight phone calls from debt collectors.

To help you better understand daily overhead, think about a business that is open fifty-two weeks per year, 5 days per week. The owner needs to know what overhead is each day the business is open, or 260 days per year. A business that is open 6 days per week, but that is closed two weeks for vacation, needs

to know daily overhead for 300 days per year. Calculating daily overhead is easy: Divide annual overhead total by the number of days the business is open per year. Thus, a business open 300 days per year, with annual overhead of $300,000, has daily overhead of $1,000.

The problem for photographers is that although many work five or six days per week, many of those days are devoted to non-income-producing activities like showing portfolios, mailing promotional materials, testing film, talking to insurance agents, photo labs, and so on. All photographers need to earn enough on the days they do billable work or licensing to make up for the days when no income is brought in.

Businesses engaged in stock licensing—and many photography studios and digital imagers—will tend to follow a more traditional Monday through Friday schedule for fifty-two weeks per year. They expect to do work every day that earns income. However, because there are several holidays each year, let's consider that the business will be open only fifty weeks each year. Multiplying fifty times five, one sees that the business will be open 250 days in a year.

Let's assume that photographer 2 operates a studio that is open 250 days per year. Annual overhead total for this firm is $246,060. By dividing annual overhead by 250, it is easy to see that daily overhead will be $984.24. If no sales are made on Monday, it must be made up on Tuesday, along with Tuesday's $984.24 daily overhead (now $1968.48). Alternately, one could look at recovering Monday's overhead by apportioning the $984.24 over the following days, so that on Tuesday, Wednesday, Thursday, and Friday, $1,230.30 must be brought in.

Location photographers and some digital imagers generally aren't able to earn money on a day-of-the-week basis. For them, it may be easier to look at covering overhead on a different basis. Many will estimate how many days per year they will spend photographing for clients and will divide this number into their annual overhead total. Others will use actual photography days and add to that all days spent doing other things that support assignments. For example, if photographer 1 estimates she will have 75 actual days of photography for clients, her daily overhead will be $1,027.60 (i.e., $77,070 annual overhead divided by

75). On the other hand, if that same photographer estimates another 90 days working in support of her assignments, she will divide $77,060 by 165 days (i.e., 90 added to 75) for a daily overhead estimate of $467.09.

Use the following equation to calculate daily overhead. (Note: This is *not* a day rate, but the minimum amount you must recover every billable day. If you don't, you are losing money, running in the red, out of pocket, going in the hole. . . . Got it?)

> Annual Overhead Total ÷ Days = Daily Overhead

Here is the daily overhead calculation for our two hypothetical photographers:

> **PHOTOGRAPHER 1**
> $77,070 ÷ 75 assignment days = $1,026.60 Daily Overhead

> **PHOTOGRAPHER 2**
> $246,060 ÷ 143 days = $984.24 Daily Overhead

Notice the difference between the two? Even though the two photographers have considerably different annual overhead totals, photographer 1 has a greater daily overhead, $1,026.60, than photographer 2 at $984.24. These daily overhead numbers could be considerably different if photographer 2 knew she would have her studio open and did photography for a greater number of days.

Your daily overhead amount becomes part of your creative fee for assignment photography and digital imaging, or part of your license fee in stock photography. Chapters 6 and 7 take a closer look at pricing assignments and stock licenses.

A MIX OF STOCK AND ASSIGNMENTS

Our examples tend to present photographers engaging in either a pure assignment or a stock photography business. However, in

today's market most photographers find that they engage in both, finding a blend of the two to be more rewarding. It will be up to you to decide artistically if a blend will work, as it will be to determine how you will blend the two financially.

When you do a mix of work, you need to apportion annual overhead by the amount of assignment, stock, or digital imaging that is done. If you find, for example, that assignments are 75 percent of your business, then use 75 percent of your annual overhead total when calculating daily overhead for assignment pricing. The other way you could account for overhead, when you have a mix of work, is to base daily overhead on all of the days per year you work, whether it is doing assignments, stock, or digital imaging. Therefore, if you do a mix of photography and digital imaging assignments, add these together and use that total number of days to determine daily overhead.

CAUTION!

We stress the importance of calculating overhead as a basis for establishing your billable day overhead primarily because most photographers ignore this basic business premise. You should annually refigure it as a control on your business costs.

Warning—this can be a trap! Although you need an understanding of your overhead, and billable day overhead, never forget that this is only a foundation. Be very careful that you don't let these numbers dictate your pricing. Remember, client usage and budget remain important factors in determining price. One prominent photographer suggests keeping a sign by the phone "It's the usage, Dummy," to remind you to include all relevant factors when calculating your price.

The next step in pricing is possibly the most difficult. Value factors (see "Value Factors" chart) will be added to daily overhead, resulting in the fee you will actually charge a client.

Pricing Factors

This area of pricing is understandably the most difficult to quantify. Don't despair; understanding the process of pricing is akin to learning to drive a manual shift car. Once you know how, it's hard to remember what made it so tricky, yet it's difficult to explain the process so another driver will be equally skilled and smooth. Photographers skilled at pricing have picked up their knowledge through years of experience, absorbing it as they went, making mistakes but also a few coups.

The box "Pricing Factors" gives an overview of the relationship of the many factors that affect pricing. The better you understand them, the easier it will be to negotiate prices like those listed in the charts. Remember as you read the following material: Pricing factors are all about value.

WHAT ABOUT MY PHOTOGRAPHY?

Determining, "Do my photographs have value?" and, "What is the value of my photography?" is not a lot less difficult than the age-old question, "Which comes first, the chicken or the egg?" It's a dilemma that puzzles many photographers as they wrestle with pricing as a balance of their time, creativity, and the client's need for and use of your work. Each question raises more questions:

- Is it the value of my time?
- Is it the value of my creativity?
- Is it the value of my technical skill?
- Is it the value of the effort or risk involved?
- Is it the value of my photography vis-à-vis the client's project?

They all are part of the equation, but is any one worth more?

PRICING—THE SALAD TEST

For the purpose of untangling the perplexities of placing a value on usage, let's say that photography is analogous to a restaurant meal and that the photographer is the restauranteur. The meal, or any one of its courses, from appetizer to dessert, will vary in the quality of the ingredients, skill in preparation, exquisiteness of fla-

vor, and elegance of presentation, and the graciousness of service and atmosphere will vary from restaurant to restaurant. Prices for meals in individual restaurants will vary according to the level of quality inherent in all of these aspects, and the price to be charged will largely be based on perceived value to the customer. Some clients require only basic meat-and-potatoes photography, while others will be willing to pay more for the delicious flavor of your special lighting or elegantly decorated establishment.

That still leaves the problem of how to evaluate and price each element, whether food or photography.

Let's start with broad categories. The cost of a meal will depend on the category of restaurant a patron chooses: deluxe, middle-of-the-road, or neighborhood bistro, with costs running from high to low. Which one is selected will often be based largely on the patron's ability to pay. Restaurant classification based on cost can be roughly compared with the categories of photography—advertising, corporate, editorial—and the general difference in payment they offer, in their willingness to pay, from high to low.

Now we'll narrow the analogy. Say the photograph itself is a salad. Imagine that all salads contain the basic ingredients of

Pricing Factors

Four general groups of factors can be said to affect pricing. They are all equally important in pricing your work. Two are client- and marketplace-related, and the other two are linked to you the photographer and business owner.

1. **Market Type (Client/Market):** Photo fees traditionally relate to the budgets (media-buy and total production costs) and profitability of the market area:

Purpose of Use	Definition	Price Range
Advertising	Selling a product or service	High
Corporate	Selling a corporate image	Medium–High
Editorial	Selling information or decorating a product (book, magazine, or newspaper)	Lowest
Other markets	Miscellany like mugs or calendars	Varies

2. **Usage Needed (Client):** These concern the visibility and length of time requested by a client.

Visibility Factors	Details
Size	One-quarter, half, full page, double-spread
Placement	Interior, display, part opener, front or back cover

Number of uses	Circulation of newspaper or magazine, press run of brochure or book, number of insertions for advertisement
Time	Length of time used (e.g., one-year billboard)
Distribution	Local, regional, national
Versions	Examples: One language and two translations; or point of purchase and product packaging

3. **Overhead (Photographer):** Fixed and variable costs incurred whether or not you license images, including rent, utilities, insurance, and office and photography equipment purchases.

4. **Photographic Elements (Photographer):** Everything that goes into a photograph.
 - Time: photography, pre-/postproduction, editing
 - Skill: expertise, special equipment
 - Creativity: imagination in color, lighting style
 - Special: hazards, risks, unique contributions
 - Expenses: all job costs—materials, equipment, assistants

All of these factors come into play when pricing either assignments or stock licensing.

lettuce (your time), tomatoes (your skill), and a dressing (your creative ability). Special and more expensive salads may include endive or verdicchio or rare mushrooms; the list is practically endless.

Further, the waiter needs to know what size salad you need (analogous to client usage). Will it be an appetizer, a side dish, or the main course? How important is the salad to your meal (is it for major advertising or a small brochure)? And finally, how many salads (the number of times they want to reproduce your photograph) will your party order?

It's that simple, and that complicated. However, if you don't make the effort to understand the relationship of pricing elements you'll be charging prices for lettuce no matter how many exotic ingredients lavish your salad—a sure recipe for failure.

The value you place on the pricing factors will be based on your level of experience, creative ability, difficulty or danger to produce the images, and so on. This will affect your choice of the high-middle-low price range when you use the price charts. You will notice the "Pricing Factors" chart is absent any financial figures. Because it is impossible to place a specific value on them, experience will become your best guide. Until then, use the price charts in this book to help you seek a range.

VALUE TO CLIENT
As client need increases, so, usually, will their willingness to pay. A perusal of the pricing charts, for instance, will show that advertising assignments generally bring higher fees than will editorial. In part, this has come about because of the demands of advertising—bigger productions, more prominent display of the finished product, and, frankly, because you will be helping some company make more money. So, too, within any one category (e.g., corporate, advertising, editorial, etc.) you will also find varying rates. For example, corporate annual reports, because they help "sell" a company to investors, will usually support higher fees than photographs destined for an in-house magazine.

One of the most important indicators of importance to a client is found either in the publication's "space-rate/media-buy" (see *Standard Rate & Data*) in the case of advertising, or in the total production costs of corporate, editorial, and even advertising projects.

The advertising agency has to place the advertisement where the public can see it, usually in publications and, increasingly, on the Internet. The cost of space varies—the rate for one page in *Time* magazine will be much more than for a local publication; likewise, a billboard along a major city freeway will cost more than one in a small town. The easiest way to determine publication advertising space rates (the amount charged to place an advertisement in a publication) is to look in the publication *Standard Rate & Data* (commonly called the "Red Book") at your local library. You should have an understanding of the relationship between space rates and the value of your fees.

In corporate photography, an estimate of the value of a project to your client can be made by knowing the project production costs total; production costs can also be used as a guide for advertising and editorial assignments. More difficult to determine because there is no easy guide book is the final size of the image as it is used in relationship to the advertisement, magazine or annual report page, brochure, computer screen, Web page, the press run size, and so on. Sometimes, your client will offer some or all of this information if you just inquire. Why not simply say, "This looks like a major effort, and I'd like to be part of it. You say the annual report is going to be sixty-four pages with a press run of one million! Who is going to be the lucky printer?" If you can't elicit this information, talk to printers, talk to graphic designers, or guess.

Editorial photographers will probably not discover the production costs incurred by a publisher, but instead will have to rely more on the press run and circulation of the publication as a guide to the importance and value of the work. Publishers tend to work with set rates for photography, so you may hear terms like "page rate," which simply means that they have budgeted a certain amount for photography per page. If it is by page rate, an indicator of project value would be any variance in the page rate from other projects this publisher has produced. Remember to check the Red Book for the space rate of a publication you are thinking of working for. Higher rates denote that a greater value is placed on each page by the publisher, and it may mean higher fees for you; but only if you ask.

VALUE TO YOU

Never undervalue the time you have to spend producing photographs, whether it is film and equipment testing, dealing with the photo lab and other suppliers, traveling to a site, locating and scanning images for use on your computer, searching for and preparing stock images for shipment, and so on. Your time—all of it—has value, whether you are doing an assignment or creating stock or digital imagery.

Although it wouldn't be advisable to routinely factor this into your pricing and negotiating routine, some photographers give consideration to whether an assignment's photographs will be desirable as stock or for promotional use. If a job promises great photographic possibilities, some photographers may consider a slight downward pricing adjustment to ensure capturing the assignment. They are willing to risk the reduction in income, knowing that future stock sales will offset the lower assignment fees. Warning! This should be considered only by experienced photographers with established stock sales records, who can accurately assess the outcome.

Rid yourself of a misconception that many inexperienced or naïve business people cling to: that clients who beat you down on price will someday make it up to you. Don't give your work away. No one will really appreciate it, and you can't operate a business for very long on hope.

Valuation—What Is a Lost or Damaged Photograph Worth?

The loss of an original transparency or negative is a serious, sometimes devastating, occurrence. Your photographs have value as income producers for years to come—they are a part of your life's work, an annuity for your heirs.

All professional photographers should be knowledgeable in this area. For detailed coverage, read the books on stock and legal practices cited in the bibliography, particularly ASMP's booklet "Valuation of Transparencies," by ASMP Legal Counsel, Michael D. Remer. The information will be invaluable to you and your lawyer.

Here's a brief summary:

- It is standard practice in the industry to charge for the loss or damage of a professional quality, professionally edited original.

- Your earning power is diminished by each lost original.

- The amount of the fee that will be charged for loss or damage should be stipulated in your paperwork. This shows you have thought about specific image values and you are alerting the user to protect the materials in their care.

- The commonly used figure of $1,500 originated in the early 1970s and has been upheld in many court cases. Inflation and other factors may cause stock agencies and photographers to stipulate greater values for the work they send out for inspection or licensing.

- Whatever loss or damage amount is stipulated, whether $1,500 or any other amount, it must be demonstrable should you end up in court. Merely stating a value doesn't guarantee it. It helps if you have confronted the issue in your paperwork by stipulating a figure, but the court will decide if there is a reasonable relationship between your stipulated figure and the photograph's actual value. They must determine that the figure isn't punitive and that there is a basis for the valuation level, often proven by showing licensing records or testimony by an expert witness.

Among the factors that have been cited by the courts in determining value are:

- Technical excellence
- Selective eye of the photographer
- Prestige and earning level
- Uniqueness of the subject matter
- Established sales or use prices
- Group value of the individual slides
- Frequency of acceptance by users

19

Writing a Usage Rights Statement

Let's take a look at how you transfer specific rights to clients (i.e., licensees) while protecting your residual rights. The following are hypothetical but typical usage specifications you might receive from a client. You have gathered the information so that a license statement can be drafted. Here, the information is stated so that it will work for either stock or assignment image licensing. This is not the place where you describe an assignment (e.g., "two days on location, photographing models with the latest model van, in the Arizona desert"); rather you are concerned here with how the images will be used by the licensee, what restrictions you are placing on their use, and what rights you retain for yourself.

Hopefully, you will notice that some of the specifications, like size and time, are imprecisely specified. This is because clients often don't know what they need or because the photographer forgot to ask. This is the nature of the business, but the importance of these value factors in your calculations is in no way lessened. In negotiating and pricing there is no such thing as too much information.

MISCELLANEOUS NOTES

After you have talked to the art director, whether by telephone or face to face, your notes may look something like this:

ANNUAL REPORT: 2003, press run 100k, but the corp. will mail it out to investors upon request for more than one year in U.S., Canada, size unknown—could vary from 8½″ × 11″. Cover = milling operator, full page; CEO inside, ½ page.

SLIDE SHOW: 2 possible, first—run 4 times over next year for investors in N. Amer.; second—probably first show modified into long-running show, new employees U.S., subsides Eng. & Swiss.

USE SPECIFICATIONS

Take your notes and plug them into a form, something like this:

Placement: 2003 Annual Report, ABC Corporation; Cover—XYZ Corp. milling machine operator; Inside—Joe Smith, CEO

Slide Show: #1: Investor meetings; #2: In-house, new employee introduction

Size: Annual Report: unknown, probably 8½″ × 11″

Slide Show: #1: projected onto screens (make sure dupes are made so originals are not used); #2: self–contained, back–lit projector (have dupes made)

Number of Uses: Annual Report—one-time only

Slide Show: #1: 4 times for investors; #2: unlimited

Press Run/Circulation: Annual Report: 100,000

Slide Show: #1: 1 set of duped images; #2: 3 sets of duped images

Time: 2003 Annual Report only

Slide Show: #1: up to one year; #2: indefinitely

Distribution: Annual Report: United States and Canada

Slide Show: #1: United States and Canada investor meetings; #2: ABC Corp. in U.S. and subsidiaries in England and Switzerland

Language versions: English only

USAGE RIGHTS STATEMENT

License specifications should be combined into a simple statement and used on *all* paperwork sent to your client:

GRANT OF RIGHTS

The photographs of Joe Smith, ABC Corp. CEO, and of XYZ Corp. milling machine operator, are licensed for one-time, nonexclusive use, in the 2003 ABC Corporation annual report. The image of Smith may be reproduced up to one-half (½) of an inside page, and the image of the machine operator may be reproduced on the cover, full page. The press run shall be 100,000 copies or less. The images are also licensed for use in an audiovisual presentation to be shown at four investor meetings in 2003, and a second audiovisual presentation to be shown indefinitely to new employees of the ABC Company and its subsidiaries in England and Switzerland. All other rights are retained by photographer."

Your next step is to learn to negotiate beyond need to what you deserve—to prosperity. Your success will depend upon what you can command (your abilities), your preparation (knowing what you need and how to achieve it), and your desire.

Negotiating Principles

N egotiation is an art. It is also an essential skill in business. Any photography business, whether assignment or stock, will founder without a good flow of income derived from the successful negotiating of prices.

The keys to a flourishing photography business are good photography, knowing what price to charge, and being able to negotiate to get that price.

The prices listed in this book are helpful. They show the range of fees being charged by your colleagues throughout the industry, but they are merely a starting point. Without strong negotiating skills, you may find the prices in this book to be of little help.

Picking a figure out of a list may seem the easy answer to a client's request for a price quote. But a price-list price can't possibly offset the intimidation you'll feel from a client who pretends to faint or who barks "You're charging what?" if you don't truly and fully understand why you've selected that price.

At that moment, your adrenaline starts flowing, and fear takes over. Without the information to back it up, your price, if plucked from a list, becomes a mere straw in the wind. Only a firm grasp of the economics of your own business (including your bottom line as outlined in chapter 2) and of skill in using negotiating techniques will make you comfortable answering that client's confrontational question calmly and from a position of strength.

Strength comes from understanding and believing that the figure you've quoted is a reasonable one. It comes from being able to articulate why you've quoted that price and from knowing your bottom line.

The first step in building that negotiating strength is to break the chains of stereotypical attitudes.

Attitudes Toward Negotiation

Negotiating may be photographers' least favorite aspect of the business—and their single greatest weakness. Often, we are our own worst enemies when it comes to dealing with money. A combination of myth and misconception intrudes on our ability to require a fair price for our work.

A fortunate few are born with a natural skill at negotiating. They like the challenge and the excitement that comes with making a successful deal. As surprising as it may seem, negotiation is second nature to them.

But the majority of us must learn how to negotiate. With time and training anyone can become an effective negotiator. It's done by practicing technique and by summoning courage.

The first step is to throw off the yoke of misconception that holds us back from acting in our own best interests. Some of us work with the naïve belief that our talent will be recognized automatically and justly rewarded. Also, we may buy into the following myths:

- It is undignified for a creative person to talk about money.
- We may appear pushy, materialistic, or greedy by holding out for a fair price.
- Our worth is measured by the amount the client is willing to offer (the client must know how much we're worth).
- If we don't accept this deal, the buyer will never call again.

Fear is the culprit here—fear of what a client might think of you, fear of taking risks, fear that paralyzes. The effects of fear are far reaching. They get in the way of clarity, preventing you from asking the right questions and from getting the information you need to quote an accurate price.

WHERE DID THESE ATTITUDES ORIGINATE?

It has not been routine in our culture to negotiate prices for consumer goods. Historically, we have been more likely to accept

and pay a ticket price than to assume we could bargain. In addition, a few arrogant or unpleasant photographers have made negotiating a dirty word. But there are many fainthearted photographers who by their lack of courage have done equal damage to the climate for negotiating. By this attitude, clients have been led to believe that they can dictate photography fees, sometimes to a level below what it costs to run a business. These photographers have accepted the underlying message that we can't sell our work if we dare to question what buyers offer.

Successful, amicable negotiations occur every day in the photography business. To learn the tactics necessary to emulate these transactions, we must first shed old habits.

CHANGING ATTITUDES

To change the attitude, face the attitude. A first step in taking the risks necessary to becoming a good negotiator is to change the way we view the world of negotiating. Consider that reality is the opposite of the myths listed earlier in this chapter. Consider that:

- It is fair and reasonable to charge enough to earn a living.
- It's possible to explain why you must charge a certain price in a dignified, professional manner.
- Charging a fair price is a way of showing respect for your photography.
- Self-confidence is not incompatible with creativity.
- It is not reasonable for buyers to expect to use photographs for whatever price they want to pay, no matter how low.
- You are not personally responsible for the survival of the client's project.
- A love of photography doesn't require you to subsidize everyone who asks.
- It is possible to say "no" courteously to buyers and still have them call you again.

If you are still having trouble justifying your right to a fair price, consider an enlightened self-interest approach. Getting a good fee allows you to improve your service to the client. It allows you to invest in new equipment, spend time and money on testing film, filters, or lighting, and to experiment with new creative approaches. Explain to your client why you need to maintain a fee structure that allows for investment in research and development and how it benefits them. But, make sure you believe it first.

ROLE-PLAYING

In order to feel comfortable making your negotiating points to a buyer, some photographers role-play a buyer/seller situation with each other. It is a technique some stock agencies use to train new sales people. The "buyer" writes down a type of photographic usage, the top price the client's company is willing to pay, and the low price that is buyer's goal. The "photographer" writes down the lowest acceptable price as well as the highest price that seems even remotely possible for the usage—the dream fee.

They begin discussions. When an agreement is reached, the winner is the one who came closest to his or her goal price. It is a great, entertaining technique for polishing the rough edges of negotiating.

Role-playing as a technique for learning to negotiate should not be dismissed lightly. It is enormously valuable and can break down the stage fright one may encounter when talking with a client. Actually, I have had more stage fright when role-playing with my photographer friends than with many clients. I found I was concerned about my colleagues' respect and good opinion of me and sometimes clutched for an answer. After all, with clients it was only money! But that uneasiness of role-playing with friends was a valuable lesson and paid dividends when it came to real negotiating situations. If you are new to the business and don't have many photographer contacts, join the organizations ASMP *(www.asmp.org)*, APA *(www.apanational.org)*, or ASPP *(www.aspp.com)*. For more information, turn to the bibliography and resources section at back of this book.

If you can stir up interest in an informal role-playing group to meet once or twice a month, you'll have done yourself as

much good as the reading of any book. There are conversations at the end of this chapter (in the section "Educate the Client") and again in chapter 5, which will give you a starting point in your role playing—and in real life negotiations.

Once you have polished your negotiating conversations through role-playing, keep in mind that while your practice sessions may give you courage, your presentation style must be polished as well.

Be vigilant when negotiating—given half a chance, photographers needlessly tend to sell themselves short. With clients, your tone should be pleasant and accommodating—holding absolutely firm when they can't meet your bottom price, but standing your ground all in a cordial manner.

The reasons? It's a better negotiating tactic to be pleasant. But the more important reason is that this is your world, this is how you spend your days, and these are your clients. They sometimes become friends. Why not make the time and process enjoyable? Being contentious won't add any joy to the day, license any more photographs, or land any more assignments.

Starting Out

If you are new to the business, you may, as you read this book, be wincing at every reference to "experience" and wondering how you'll get it. As a new photographer, you can use all the techniques we mention, simply modified to your circumstances. If you are looking for assignment work, you have probably done some assisting for established photographers. When working for another photographer, learn all you can from the experienced pro's business habits and negotiating style. If you haven't assisted, try to connect with some experienced photographers through the organizations (ASMP, ASPP) mentioned repeatedly throughout this book. These contacts may also shed light on the stock business.

If it seems more difficult to take the plunge with stock pricing, remember that it doesn't hurt to be honest with a client. In some cases you may even let the client know you are new to the business, but do so with this caution in mind: If the client wants to use your photograph, it has value, no less value for the client's purpose than if you'd been in business for twenty years.

Even as a newcomer, you shouldn't give your work away. You may consider a slight break for volume, or a slight percentage off (10–15 percent, tops) and let the client know why: "I am breaking in and want tearsheets for my portfolio, which is why I can give you a better price." Always negotiate a trade when you adjust your price, and put on your invoice that the discounted price must be accompanied by xx number of tearsheets or reprints, per your discussion. But use this technique *only* if you are really being pressed on price. A client may simply like your photography and pay a standard fee. So don't rush to assume your clients know how green you feel. Playing the novice card is only for the rare, tight pinch.

Negotiating Strategies

Becoming a good negotiator takes practice, a knowledge of the business (so you can educate clients), and confidence in yourself. Lack of courage is what limits most photographers.

The goal and measure of a successful negotiation are clarity, a fair price, and a return client. You need clarity to avoid the confusion and misunderstanding that breeds conflict, a fair price so you can stay in business, and a repeat client because that's how you continue to prosper. The ideal is that both you and your client are happy with the outcome of a negotiation.

You may say, "What's to negotiate? The buyer has a price and a budget in mind. That's what the buyer will pay, and I can simply take it or leave it." Wrong. Every time you discuss price or assignment specifications, it is a negotiation. The only question is how successful the outcome is for you.

There are six basic steps that take place in every negotiation, whether handled in ten minutes or over a period of days, and they are crucial to the process.

Negotiating Steps

Establishing rapport is the first step in any contact with a client. It may seem self-evident, but start with a friendly, welcoming tone. Find some common ground—the weather, the holidays, recent events. Next, express your interest in the client's project.

You may think it's obvious that you are pleased by the call. Not so. Say it. Show interest in the company, in the client's publication, and in this particular request.

If you set a good tone, the caller will enjoy the exchange and remember that it is pleasant to work with you. Removing a little stress from the day will stand you in good stead.

Learn to read the mood of the client through voice inflection or body language. When a client is busy and not inclined to small talk, pick up the clue. Stay cordial, but conclude in a quick, professional manner. However, don't let a buyer rush you into a price quotation before you get the facts. It's perfectly legitimate, and to the client's benefit, to ask for time to give thoughtful attention to figuring a price.

Gathering information is the critical step. Ask about usage. You must know where, how big, for how long, how many times, and for what purpose the picture will be used. Make clear that you can't quote without this information, and explain why. Let your clients know that price depends on usage, size, and many other factors. Make the point that by being very specific with usage you may be able to give them a better price.

When quoting an assignment, explain that it's not only usage that affects the fee but the complexity of the shoot and pre- and post-production logistics as well.

In stock, the fee can also depend on which of your photographs they are considering—one produced under normal conditions or one involving high model costs, travel expenses, or other costs which will affect the price. Use the telephone information forms in chapters 4 and 5 to make sure you've asked all the pertinent questions.

Educate the Client. When you are dealing with a knowledgeable long-time client or with a new one who clearly knows the ropes, you may not have to do any educating. But if you suspect that the buyer is new to the field or inexperienced in the area you're discussing, then it will help if you clarify industry standards as the groundwork to negotiating.

One sign of inexperience (or an experienced but tough negotiator) may be a reluctance or inability to give you information about the project, particularly about usage. "Just tell me how much—I'm not sure how we'll use it," is a giveaway. It's more likely to stem from inexperience than duplicity, but it still creates an impossible negotiating atmosphere, for you at least.

Explain that it is industry standard to price by usage as well as by your cost to produce. Let such clients know that it works to their advantage to limit the rights they need. Explain that vague, sweeping, all-encompassing usage can be more costly. If your clients aren't sure about future uses, create a range of fees for additional usage to help them in planning. Indicate that potential future rights, negotiated now, will be lower than if they come back to you in a few years. Say something like, "We could create a package deal for you with any future uses for posters rated at \$xxx and brochures at \$yyy." This approach relates to assignment usage rights as well as to stock fees.

It is vital that you focus everyone's attention on the disparity between the enormous cost of media placement and the cost of photography. Doing so reminds your clients of an obvious fact they may wish to ignore, and it helps reduce any insecurities you may feel about asking for a fair deal. After all, it's the image-maker that provides the emotional resonance of the advertiser's message; you deserve a fair share for that contribution.

When negotiating assignments, pay very special attention to any request for work-for-hire, all rights, or buyouts from any client. Use the reasons listed above for limiting rights for sake of controlling the client's costs. It's enough to say here that buyouts should be avoided like the plague, since, when you give away all rights, you are dramatically limiting your future earnings by killing off residual usage from the assignment client as well as potential stock use.

Here's another red flag that may indicate inexperience in assigning photography: "We need the Pittsfield facility photographed, and it's a one-day job. No, the Corporate Communications VP will be out of town. No, we don't have the plant manager's phone. He'll show you around when you get there." Let these types of clients know why vague, free-floating arrangements can cause expensive assignment problems and that part of helping them get the best price is to avoid disasters in the making.

When informing an inexperienced client, handle it in a subtle, friendly manner. List the factors that affect a stock price or assignment fee.

In order not to appear condescending or didactic, use the phrase, "As I'm sure you understand . . ." to preface your comments. This lets you present information in a way that helps inexperienced clients relax and possibly save face, so that they can hear your information in a neutral environment.

Why might you be dealing with inexperienced people? In today's fluctuating economy, many advertising agencies, corporate communications departments, and editorial art departments have eliminated various levels of support positions. An overworked art director or photo editor may even use a trainee or secretarial assistant to do groundwork. You are helping yourself when you help the caller become informed.

Don't hesitate to give objective backup to your position by referring an inexperienced client to this and other books or sources. (It might be wise to do this—if you can—*before* pricing comes up.) It's easy to say, "If you don't have copies, you might find some of the ASMP publications useful. They provide a good background on what we're discussing. . . ."

Understanding on the part of both sides makes the process work. While you are educating the client, don't forget the important lessons from chapter 2, and re-educate yourself about the overhead factors that must be a real, if silent, part of every negotiation. You *don't* bring it into a discussion as a whining complaint, "I can't afford to license at that price or I'd go out of business." Rather, use it as a reminder to yourself that you have to cover your overhead in order to continue to provide quality images. If it's necessary to mention this factor, do it in a positive way, to underscore your persistence in holding firm to a price: "I'd love to help you with a lower price, but given the extraordinary costs of materials and overhead, it isn't practical for me to go any lower."

Quoting the price. Though basic approaches still apply, the actual discussion of numbers is where stock and assignment price negotiations will differ.

When negotiating stock prices, you are usually discussing a specific picture. The buyer will use the photograph, or not, based on how closely the perceived value to the client matches the reproduction fee you quote.

However, assignment pricing is complicated by many factors, including costs of preproduction planning, props, models, crew, rental fees, location fees, travel time, creative fee, and photography expenses, such as film and processing.

In pricing either area of the business, stick with the principles:

• Get the information.
• Don't be rushed into a quote.
• Quote a range (to leave some leeway for movement).
• Have a bottom line.

The chapters that follow will go into specific detail on pricing considerations for assignment and stock.

You must guard against taking the shortsighted attitude, "Good for me if I can just cover my overhead, plus a little extra, and save the client. Why not?" This viewpoint continues to cost photographers—from the amount of money they can put in their pocket to the amount of money they will be able to make in the future. Why? Clients use previous production budgets to calculate current and future budgets. Many art buyers have said that once the account executives and clients have gotten accustomed to getting good, usable photography at the fire-sale prices that have prevailed for the past few years, it's almost impossible to increase budgets for future productions. So whether it makes sense or not, art directors are given smaller and smaller budgets to work with and are still told, "Make it happen! Find a photographer to do it for less." And the downward spiral continues. As long as there's no resistance from photographers, pragmatic buyers will continue to squeeze more from the overall budget (at your expense) to cover the ever-increasing cost of media space.

Closing the deal is an aspect of negotiating that some photographers let slide. It can cause messy repercussions through misunderstanding. Once you have negotiated a fee, make sure it is clearly understood by both parties. For stock usage, ask the buyers if they will be sending a purchase order. Assignments often

25

include complex and detailed estimates as part of the negotiating process. In addition to asking the clients to sign-off on your final estimate and to provide you with a purchase order, send your own follow-up memo confirming specific aspects of the assignment, such as who handles what—researching locations, booking models, making travel arrangements, and so forth.

Note that the exact license of usage rights must be spelled out in your invoice both for stock and assignments. At this stage you are merely summarizing what you will be billing for later.

Follow up. Letting a client know that you are interested in the outcome of an assignment or the results of a stock usage is important. On an assignment, call shortly after the finished work has been received to see if the client is as pleased as you were with the photographs. Check in again later, once the materials are printed. Use that as an opportunity to request tearsheets. Ask about the success of the project, learn how others in the corporation viewed the work, and possibly find out about future plans.

Following up is a way of letting your clients know that you value the relationship with them, that you are serious about your work, and that their success is important to your satisfaction with the job; you don't just take the money and run.

Value of Photographs

Photographs have value to users only to the degree that they solve a visual problem for them, whether it's illustrating a magazine article or advertising a product. The amount they will pay to assign a shoot or to reproduce a stock photograph depends on what they perceive as the value of that particular photograph to their project.

The value of a stock photograph or assignment, to you, is much more complex. There are economic, aesthetic, and emotional components that sometimes cloud the pricing issue. Photographers may hesitate to charge enough for a stock photograph they especially like, not wanting to risk having their price turned down.

Assignment photographers may be tempted by the opportunity to shoot in an exotic location and may dramatically lower

their fee in the mistaken belief that they shouldn't be well paid for something they love to do or that the only way to secure the job is to charge little. Take a cool-headed look at the economic value of your photography. When quoting an assignment, understand that any special equipment, techniques, or skills you have to offer add value that affects the fee. You are charging for your creative and technical abilities, not just your time.

In stock, you can and should place greater value on some photographs than on others. Measure your photographs, and price them based on their cost to produce and on their unique quality—not only on the client's intended use or ability to pay. (See chapter 5 for a list of those factors that affect pricing of stock.)

Negotiating Conversations

Having absorbed these principles of negotiation, you must now believe; believe that you have the right and the ability to negotiate a fair price. Once you are a believer, it's simply a matter of expressing these negotiating methods in your own style. There are many rhetorical devices that can be used in a negotiating conversation, as you'll see in chapters 4 and 5. No matter what words you choose, remember to communicate the following:

- You want to help the client, to work it out, to conclude a deal.
- You understand the client's problems.
- You hope the client understands your situation.
- You are disappointed when you can't reach an agreement.
- You hope that there will be another opportunity to help the client out.

Your tone is accommodating. A polite but firm manner must be shown when you have reached your bottom price. Regardless of how you really feel about the negotiation, you must project an earnest desire to solve the client's problem. In fact, you do want to conclude a deal, and you are disappointed when you can't answer the buyer's needs. Not only is an accommodating atti-

tude smart negotiating, but it usually has the additional merit of being true.

Negotiating in Hard Times

Price cutting is not the answer to a tight economy. It's easy to say, because it's true, that to get work in a tough climate you must be better, more original, and more creative than the next photographer. It certainly helps. However, in assignment work personal attributes are valuable to a client as well. Being perceived as someone who is easy to work with will give you an edge, perhaps even over a very creative but arrogant hot shot. Competence and dependability are highly valued, especially when money is in short supply. Make sure you let clients know your ability to meet deadlines and solve problems. Buyers may be less likely to take risks during hard times, so promote your dependability, along with your creativity quotient.

Finally, remember that negotiation is not at odds with the creative aspects of photography. Believe it or not, there are many photographers who are good photographers, skilled negotiators, and nice people.

Summary: Steps in Negotiation

Establishing rapport: Create a friendly climate for doing business. Open or respond in a pleasant manner. Express interest in the project. Set the tone as professional and cordial.

Gathering information: Whether you are negotiating an assignment or a stock reproduction fee, it is critical to get enough information before beginning a pricing discussion. Find out the usage: for what purpose, where, how big, for how long, how many times, and so on.

Educating the client: This may be necessary when you suspect that the buyer is new to the field. Before quoting a price, make sure that the client is aware of industry standards. In a concise, polite way, set out the factors that affect a stock price or assignment fee.

Quoting the price: Do not talk money until you have all the information available about usage and production requirements. Do not be rushed. Assignment estimates can be complicated—you need time to give a responsible quote. If possible, find out the client's budget before you answer the query, "What do you charge?" Quote a price range to encourage the client's response. Know your bottom line, the figure below which it's not worth making a deal.

Closing the deal: When you have agreed upon a fee, expenses, and a production budget, make sure everything you have negotiated is clearly understood. Request a purchase order. Confirm in writing, by fax if necessary, by sending your own estimate form and a memo confirming your understanding of all the details of an assignment.

Following up: Checking in with clients, particularly after you've turned in an assignment, is a useful way to let them know that you value the relationship and are serious about your work. You can request tearsheets, ask about the success of the project, learn how others in the corporation viewed the work, and find out about future plans.

Negotiating Assignment Photography

When you determined your daily overhead, it was done with some precision through mathematical analysis; negotiating, unfortunately, is far less scientific. However, your creative blending of the two—pricing and negotiating—will largely determine your future financial success.

Imagine the following:

Hello, this is Susan, art buyer with High Tech Advertising. We really liked seeing your portfolio the other day. We have a client that needs photography for an annual report, and we'll possibly use some in trade advertising. Can you be in Seattle on the ninth to photograph an ABC Company executive and in Chicago on the tenth to photograph a special manufacturing process that only their XYZ Division does? Sarah Q. will help you out in Seattle and Joe B. in Chicago. Let's see, that ought to do it. What's your day rate?

Flattered, thrilled, you doodle on a pad of paper hoping desperately to be able to arrive at a price, while Susan waits on the other end of the phone. Stop! Hold it! Don't throw everything you've learned out the window now. At this stage of the negotiation, you need to review the six steps in negotiation set forth in chapter 3 and apply them to an assignment. To repeat (once more), those stages are:

1. Establishing rapport
2. Gathering information
3. Educating the client
4. Quoting the price
5. Closing the deal
6. Following up

It's important to understand how to apply negotiating principles. Negotiating the price for an assignment differs from negotiating a stock price, as you'll see in the following chapters. For starters, a stock photograph already exists. The major factors influencing its pricing will be usage and the unique qualities that give it additional value. Assignment photographs, on the other hand, are still on the drawing board and exist only as ideas in the mind of the client. In addition to the factors of client usage, assignment pricing has the added complexity of variables such as weather, transportation, location scouting, set construction, casting models, and locating props, to name just a few. All involve logistical coordination, and the cost must be estimated and scheduled into the time available for the shoot.

The unwary photographer may end up volunteering days of time—serving without fee, for instance, as a travel agent, casting director, or corporate coordinator for a client. Also, the inexperienced photographer may forget the axiom that the less time you have (for preproduction), the more it will cost (to make the deadline). Rush charges exist in every area of business, whether typesetting, printing, binding, or prop acquisition. If you are not precise and thorough in your pricing estimate, or if you are not brave enough to include all costs, you will estimate and negotiate yourself right out of business.

Controlling the Negotiation

Knowing and asking the right questions, not allowing yourself to be intimidated, learning to control time, and being sensitive to subtle signals will allow you to begin to control, and not be a victim of, the negotiating process.

Gather all of the assignment information you can think of. Exactly who or what are you to photograph? What's the time schedule? Who is to meet you? When? Where? Who will make the arrangements? If your client represents another firm (e.g., advertising agency, graphic designer, audio visual firm . . .) who will use the images? How will they be used—cover, inside pages, major display, or just insert photos? Is there additional use contemplated? Don't assume anything, and don't leave anything to chance.

Be wary of clients who won't allow you reasonable time to ask questions or prepare an estimate. Sometimes they just don't have much time, but more often they are trying to control you, even if they don't realize it. Buyer: "Because the assignment is tomorrow morning I'm pretty jammed up. The photography shouldn't take long . . . We just need a few shots?" Look out! This client is pressuring you into a fast answer because of an impending deadline. Or, maybe the client is implying that the job has little value, due to needing only "a few shots." Or, perhaps the blasé referral to the assignment is simply another way to control you and thereby cause you to undervalue the assignment.

If you aren't scared off, you need to immediately ask some probing questions. Not only will you better protect yourself, but a subtle message will be sent that you are a professional, and a professional job is much more than a "few snaps." If the prospective client doesn't treat you and your work with respect, you may not want this company as a client.

Establishing Rapport

Do you want an edge when negotiating? It's simple: You may not think so, but your client may be even more uncomfortable discussing money and negotiating than you are. You can help yourself immeasurably and improve the negotiations by establishing a genuine sense of rapport by putting everyone at ease. A positive outlook about the job, about your business, about life in general will help instill confidence in you and make your client more secure.

Rapport is often a major element in the decision about which photographer to use. One woman was chosen over several others, all equally qualified for a plum assignment. After talking to a number of photographers, the publisher felt that, due to the many days of the overseas assignment combined with the prickly personality of the art director going on the shoot, someone with an even temper and professionally cool demeanor was needed. The other candidate for the assignment was known to be somewhat opinionated and undiplomatic. Take note— emphasize every advantage and asset you possess! Turn what makes you unique into a winning advantage; it will improve client rapport by making you better known and less of a stranger.

Gathering Information

As we must repeat and repeat, in order to accurately price a licensing transaction you will need to gather information. Obviously some negotiator/photo licensees will openly discuss these things with you. Others, however, will try to guard the information as a bargaining ploy or will simply not realize the importance of it to you. Don't forget to say, "So that I can keep my estimate as accurate and as reasonable for you as possible, I need to know. . . ." It is too easy, and the stakes too high, either to forget or to neglect to ask something about the assignment for which you are being considered. If you aren't experienced, use the "Telephone Information Form" in this chapter to assist you.

Find out how the photographs will be used, where they will appear, the size (e.g., one-fourth, one-half, full-page, or x percent of the advertisement) and how long your work will be run (e.g., one edition, one month, a year). Determine the media buy or the production budget for the job, either of which should give you some idea of the value of this job to the client. It's easily done by asking the client something like, "So that I can quote you a more accurate price, tell me, in what magazines will this ad appear?"

You need to know exactly where you must go, when and whom to meet, and what you are going to photograph. Also ask if there are any potential problems you should be aware of. Some years ago, a photographer traveled to a brewery where workers were on the verge of a strike, and tensions were extremely high. Workers refused to be in the photographs, and the assignment was delayed until management people were brought in from another plant. You can't anticipate everything, but a few questions might have elicited information to sound a warning—for example, "Who will our models be? Are they employees? Has it been cleared with them?"

Some extra thought in posing the right questions can go a long way toward making your pricing efforts—and subsequent assignment—run smoother.

BID OR ESTIMATE?

Have you asked your clients if they wanted an estimate or a bid? Many people, clients and photographers alike, find the terms

confusing. An estimate is generally your offering of price for a specific assignment with the understanding that there is an acceptable trade allowance of plus/minus 10 percent, although frequently more flexibility is possible. (But don't assume. Ask.) A bid is essentially an estimate except that you are offering it as a firm price, probably in competition with others, with price being a major part of the client's decision-making process.

Because many terms are misused or are defined differently, ask if your client wants an estimate or a firm price. Also, because term definitions are not well understood, and because not all clients are completely honest, you may be asked to bid even when you aren't being considered for a job. This latter type of bid is commonly called a comparative bid, usually given out to validate a price that the client already has, is generally happy with, and may have already accepted. Occasionally your client, usually an ad agency, will ask for comparative bids in order to prove to a client or boss that a desired photographer's price is not out of line. Always ask what type of bidding situation you are in. You should know so that you don't waste precious time preparing a detailed bid if the decision has essentially been made. On rare occasions it may be okay to submit such a bid to help a really good client, especially if the job is not your specialty and it's clear you're preparing a bid as a favor.

It is also helpful to ask whom you are bidding against; it could be that the art director really wants you because of your creative abilities. And, it could be that price isn't a major factor. If you inadvertently and necessarily believe you need to engage in a price-cutting/bidding war you may end up depriving yourself of any profit and damage your reputation in the process.

Finally, to ensure that all parties are preparing bids based on the same information, request that all competitors meet jointly to receive the information or, if this isn't practical, ask that everyone be sent identical written specifications.

Expectations

Clients are, on the surface, interested in a number of things, but chiefly they want to get a good photograph(s) for their project at the most reasonable cost. You, on the other hand, are more concerned about creating exciting images for the maximum possible income.

Try to find out your client's real expectations. In our hypothetical assignment, is Susan, the art buyer, really concerned with this job, or is it just a nuisance, something she hopes to dispense with quickly? You might be able to capitalize on it by taking on (and, of course, charging for) some of the burdens she hopes to get out from under. Could it be that she is thinking more about her career than in making this a successful creative collaboration? If so, you might face unusual pressure and unrealistic demands. Is her concern with the budget related more to looking good to her bosses, or are there real budgetary problems? If the former, you might be able to help her by working within her budget constraints (but don't make a habit of it). This is subtle information that can be very important and useful, but it won't be delivered on a platter.

Most often, the people you work with will primarily expect a good job; however, always listen carefully, and read between the lines. If a client harbors unspoken expectations that you fail to learn, ultimately you will be the one who will be left unhappy. One photographer was told he was selected by a graphic designer because of his use of color-gelled lights in one of his portfolio samples. When the designer specifically mentioned using gelled lights in one of the six setups that were discussed, a partial reshoot was required because the photographer hadn't understood that the designer had expected gelled lights in every setup. In this case, the problem—caused by a simple lack of information—had a simple answer.

Educating the Client

An important issue is the ongoing education of those who buy the rights to and use your photography. Not only can you improve your negotiating prospects, but you can cement a long-term relationship by educating a client. It should be obvious that you will be walking a fine line—always treat your client with respect when you explain industry practices or the law. Just as important, take time to educate your fellow photographers. Many of them are not well versed in these issues and could use your assistance and ideas. If all of you become knowledgeable, skilled business people, you will have made the playing field a far better place.

AND WHAT DO CLIENTS NEED TO KNOW?

Explain the value of your work in relation to the assignment. "I suspect it may seem like a lot of money, but let's keep it in perspective. My photography will occupy 80 percent of the space in your ad, yet it is costing you less than 5 percent of the total project!"

Clients also need to know when pinching pennies can actually be more expensive. "I understand a helicopter is more money, but, if we have to move a crane for a different angle, as I suspect we will want to, it will take longer, therefore costing more." Here is a favorite of tight-fisted buyers: "You don't need an assistant—I'll help you." The reality is that clients always drift off during photo sessions to use the phone, talk to someone, or do whatever it is that they need to do. You can't leave your equipment to chase the client down. Also, let buyers know the safety factors gained by having an assistant on hand. Cutting pennies by cutting assistants is generally more expensive in the long run. You are required to do things you normally count on your assistant to take care of. Your attention is divided when worrying about mundane tasks (like running extension cords for lighting). Instead, you should be thinking creatively, concentrating on the images you need to make. Explain it to your client in just this way.

Educate clients by letting them know you can make their life easier: Convince them that it will be to their advantage to call you first for an estimate of photography time and costs *before* they prepare their project estimate. This idea has the added advantage of giving you the first foot in the "assignment door."

USAGE RIGHTS

An area where conflict commonly arises, conflict that can be avoided by education, is the issue of how the photographs may be used. Since assignment clients pay for the materials involved (i.e., film and processing), many mistakenly assume they own all right and title to the images.

Photographic reproduction rights licensing is little different from many other types of business, where often great sums may be spent, but ownership doesn't change hands. When confronted with the challenge, "I bought it! Why don't I own it?"

you might point out that the law says, although you may have been reimbursed for the costs of the film and processing, the client has not bought the photograph or the rights to it. When a client objects to the idea of being charged again for additional use or reuse, ask, "Doesn't your printer charge you for additional or longer press runs?" Or try, "Licensing photography is something like when you rent a car. It's only for a day, or a week, and not forever, isn't it?" You can also remind these clients that magazines charge each time the client's advertisement runs; one payment, no matter how great, isn't entitlement to unlimited ad insertions.

Sometimes, some clients will try to carry reuse concerns to extremes. "But if you move, I won't be able to find you," or, "I don't have time to negotiate additional use. . . ." When confronted in this way, don't hesitate to point out that you are a professional and in business for the long haul. It's usually best to accept that these client concerns are real—at least to them, and offer a creative solution. Don't argue, don't ignore them, and don't obstinately hold your ground. "I understand your concerns. Let's determine what you need now and what you might need in the future. Perhaps we can work out a beneficial rate for future use, but there simply isn't any point in your having to pay for uses you will probably never need." "Perhaps I can have duplicate images or a digital file made for your files, so long as only your company uses them."

Should a client insist on open-ended or extremely long-term rights—sometimes called a "buyout" or "all rights" (see "Caution About Terms" in chapter 8)—let them know that their demands will, of necessity and unnecessarily, cost more. Clients who try to shield their uncertainty with all-rights or buyout agreements are trying to take the easy way out. Ask when the last time was that they reused a photograph after a year or so had gone by. It doesn't happen often, and you can easily grant additional use without giving up all right and title to your work. And don't forget that you are in business, so additional use means the client has to pay something. Doing favors for clients usually means they come to expect it as the norm. Business is business.

What happens when clients say they need an open time frame or possibly all rights in order to protect a corporate or prod-

uct image that will be developed through the use of your photography? Don't be afraid to explain that paying for all rights is unnecessary. Being a good negotiator, you will immediately suggest some alternate form of protection, such as agreeing not allow the client's competitors to use the photographs, or possibly offering to withhold the assignment images from stock licensing for a specified period of time.

Of course, just like actors who agree to contracts that don't allow them to work for other advertisers, you too will have to charge an additional fee as compensation for the loss of income that could have come through stock licensing during the period when use of the image(s) was reserved. Satisfy client concerns, save them money, but always charge for their requests.

WORK-FOR-HIRE

An issue that many clients continue to force is that of work-for-hire. Very simply, the Copyright Act of 1976 gives authors limited monopoly power over the work they produce. This means that authors can decide who can use their work, what it will cost to use it, and that no one can reproduce it without the author's permission. If copyright protection weren't extended to authors, as soon as their work was made public, some unscrupulous operator could freely reproduce the work and make money from the author's efforts. The exceptions to author's copyright protection are those cases where work is created by employees. The employer owns the copyright under a principle known as works made for hire. The work-for-hire provision was added to the Copyright Act to satisfy publishers who claimed that, because they because paid salaries and benefits, they should own the copyright to works created by employees. It didn't take creative publishers very long to realize that they could make independent creators employees by contract under the work-for-hire provision. In this way publishers can obtain both the copyright and the title to photographs. During the 1980s it was common to be told with no room for negotiation, "This is a work-for-hire assignment. Take it or leave it." Authors, including photographers, often were told this after they had produced and delivered the job—the "This is a work-for-hire" statement appeared on the back of a paycheck. As a result of the 1989 Supreme Court deci-

sion favoring creators, clients must obtain your prior written authorization that the photographs you are going to produce will be works made for hire. Please note: Stock images made by an independent, nonemployee photographer can't retroactively be called works made for hire. (Consult chapter 1 and the books in the bibliography for a larger discussion of work-for-hire.)

What does work-for-hire really mean for you, as an independent author? The client is legally viewed to be the author of the work; it's as if you never existed. You have no claim to the work, and you can't use it in any way, not as stock images and not even in your portfolio. If clients try to lure or force you into work-for-hire contracts—and they may—it is incumbent upon you to explain why work-for-hire doesn't work to anyone's advantage. Remember, many clients' problems revolve around:

- Not wanting commissioned photographs to be used by competitors—or by anyone else during the time the client uses them
- Reuse: being able to reuse images without having to negotiate
- Not having to pay extra for reuse

Work-for-hire is negative in every aspect as far as you are concerned. It costs you the opportunity to make additional money from stock licensing. If you are a good businessperson, you know that someone has to make up for missed opportunities, so you will have to charge your client more for the work-for-hire assignment. You may also find those same work-for-hire images infiltrating the stock photography field, competing against your own stock images as licensees (your client companies) try to capitalize on the many images they hold in their files. As you near retirement, you may find that you have little to show for your past efforts, and little to depend upon in terms of an annuity from your photography!

It's more than likely, however, that clients demand work-for-hire merely because they don't know any alternatives. As discussed previously, it's reasonable and beneficial to both you and your client to offer to withhold the photos from stock licensing for some mutually agreeable period, to keep the images from use

by competitors, and to negotiate reuse up front, thereby avoiding uncertainty.

Never forget, work-for-hire is too expensive a proposition for either client or photographer.

Quoting the Price

Photographers should give careful thought to how they present pricing information to their clients. Only you can determine a way that won't damage your own position or trigger excessive concerns in the client. One unbreakable rule you should have is that every estimate or bid should be submitted in writing. It is the single best way to eliminate confusion and guessing.

If time is short, send it overnight express. If time is really short, a fax takes only ten seconds, and e–mail is even faster. (Be careful: Many people check e-mail infrequently and carelessly. E-mail is often claimed to not have arrived, so you might back up e-mail with a fax or phone call letting the client know the message was sent over the Internet.)

BREAKDOWN OF FEES AND JOB COSTS

Every estimate, delivery memo, and invoice should include a statement briefly describing the assignment as you understand it. It should clearly state the usage rights being granted, a statement of your image ownership and copyright retention, and other factors that may affect payment, like a service charge for rebilling, and so on.

However, it probably isn't advisable to itemize each and every job cost. Your paperwork will become too complex, and there can be distinct disadvantages. One has to ask what can be gained by a fully itemized approach? Will your client be made any happier knowing exactly what you paid for things? One photographer, for example, who itemized everything, even down to every roll of film, had an invoice rejected and lost a client when a corporate "bean counter" realized how much less he could buy film for at a parking lot/one-hour photo lab processor. How can you really make your client understand that your film, a more expensive professional emulsion, that was refrigerated by your dealer, tested by you, and stored again in your freezer costs so much more than film from Wal-Mart?

Have you ever considered what makes clients think they own the images? Perhaps it's seeing film and processing costs detailed on your paperwork? Some photographers find it better simply to list expense items under broader, more general categories. Under this method, all film, processing, prints, Polaroid for testing, and other related costs may be best combined under a single heading like "Film & Processing" or "Sensitized Materials." According to Automobile Association of America and other surveys, it costs close to one dollar per mile to own and operate a large car. Reimbursement of your true costs could spark a debate, so why not simply group mileage and local transportation costs under "Location Expenses." If your client doesn't trust you enough to see a single amount representing an entire category, perhaps you should reconsider whom you work for.

It can work to your benefit if you include a standardized list of expense categories on every invoice and estimate you submit. Even though not all jobs will find entries in every expense category, you can subtly tell your clients that they can be responsible for reimbursing many kinds of job-related expenses. See the appendix for sample forms.

BOTTOM LINE PRICE ONLY

Some photographers quote a bottom line price only, finding it to be an advantageous way to price and a logical extension of their concerns about expense itemizing.

Prepare your estimate of fees and costs in great detail, but only for yourself. Your client receives, instead, a proposal showing only the total amount for which you expect to be able to do the assignment.

Ultimately, shouldn't clients really be concerned with just two things: whether or not you can provide the photographs they need, and at a price they can afford? If you invite a client to become involved in your pricing decisions by providing too much information, who will decide how many assistants or how much film you need? And who will assume the blame if the decision is wrong? If you break down expenses, some clients will attempt to negotiate (or dictate) every item. You just can't afford to let this happen.

Clients always have the right to reject a quote if it is too high for their budget. Should that occur, the bottom-line-only estimate offers an advantage. It allows you to adjust your calculation of fees and expenses without tipping your hand as to what might have been cut. An estimate showing only the total price can save many explanations and let you to run your business as you feel it should be run.

RECEIPTS

A related problem is the one of presenting receipts to clients for expenses incurred in the production of an assignment. Why open yourself to criticism for paying "too much" for expenses? Instead, good-naturedly ask your client if printers tell what they paid the paper supplier. This one always brings a smile: "Did Ford tell you what it cost to manufacture your car?" If you decide that you won't release receipts and your client says, "When you bill us, make sure to include the original receipts," why not counter with, "Normally I'd like to help but my accountant demands that we keep them for the IRS." Here is another good reason for using the bottom-line price method; you can add, "Besides, I've quoted a firm price based on the job as you described it. It shouldn't matter what I pay for supplies because I'm only going to charge the amount we've agreed upon." That usually works—don't be afraid to try it.

Some ad agencies inflexibly demand original receipts, and you may have to decide if you are willing to play along with them. If pressed for receipts, you might add, "If my actual expenses run lower than what I've estimated, I'll charge you less." Seldom will a client refuse that trade-off. One of the authors worked this way with major ad agencies across the country, explaining that his business policy was to not release receipts, and it never caused a problem.

PRICING ON A PER SHOT BASIS

Certain types of photography are more commonly priced by the "shot." Catalog photography is typically done this way, where lighting and background setups usually remain the same, or virtually so, as one product after another is photographed. Photographers who charge this way usually have good control over the amount of time it will take to produce every image and what expenses will be incurred. This is why you will find mostly studio photographers, whether advertising still life or catalog studios, charging this way. Location and people photographers, lacking the same level of control, seldom find it wise to price their work on a pure per-shot basis. There are a few other clients who request per shot estimates, including some publishers. You need to scrutinize the photo list, the number of locations, and production complexity before agreeing to a per shot agreement. Do your calculations both ways. First, estimate a creative fee based on the standard way of handling an assignment. Second, divide your creative fee by the number of shots in the job to figure what you must charge per shot to remain profitable. Of course, clients may not want to pay this much, or they may reduce the number of shots you are to do after you have agreed upon a per shot rate. Be very wary. Don't work for less than the amount you need to charge to remain profitable, and if you agree to a per shot rate based on a specified number of shots to be made, make sure you state this in an assignment agreement, and get it signed by your client! If the number of shots is reduced, you must increase the per shot rate to make up for it. For example, assume you need to make $500 per day in overhead, and you factor in another $500 in pricing factors. Your client wants you to do ten shots, and you determine you can photograph them in one day, plus another half day for editing, shipping film, and so on. You may be looking at $750 total overhead, plus $500 pricing factors, plus $300 editing and shipping time. Your per shot rate is therefore $155. If your client later reduces the number of shots to five, you still have to spend most of the day preparing backgrounds, setting lights, and part of the second day editing film, and so on. If you keep your rate at $155 per shot (i.e., $775 total) you won't make any money for the time you will have to put into the job.

Because of the repetitive nature of catalog photography, you may find it advantageous to charge slightly less, but only if you know you can make it up in volume. Never forget, your overhead remains constant and will likely be more next year. Reduce your price only if it gains you some advantage in return,

not merely because it assures that you'll get the job. Don't give away the store, and don't do it for only a day or two of work or for only a few shots!

Closing the Deal

Don't be surprised or pessimistic—your quote may be right on the mark and instantly accepted. If not, renegotiate, and renegotiate again, if you can.

Because many people are unsure of themselves during a negotiation, they allow themselves to be pressured into cutting price without a concomitant offer from their opposition. This sends the message that you aren't terribly sure of your business needs, that you aren't a skillful negotiator, and that you can be easily manipulated in the future. Always have a valid reason for price reductions or for anything you give up in a negotiation, and always get something in return.

What if your client rejects your estimate as too expensive? First, ask yourself, is this estimate really accurate? If it is, and if you do have to renegotiate your price, you are still in a good position. Don't worry and don't give up. Simply tell your client that, since your estimate is fair and accurate, your client, too, will have to give up something—the extra rights requested, image variations, number of models, etc.—to achieve a lower price. It is poor negotiating, not to mention illogical, unreasonable, and irrational, to give up something without also requiring the same of your client. That is why many negotiators prepare a comprehensive proposal covering every possibility in their first offer, knowing they can then trade away what isn't absolutely essential.

Every aspect of an assignment estimate is negotiable. Don't dwell only upon the monetary facets, or you may set up roadblocks to success. Ask yourself whether your client really needs all of the usage rights requested. You can probably charge less by reducing the rights. Or, perhaps you can offer more efficient and less costly ways to accomplish the assignment. Someone should ask, "Is it really necessary to travel to every division of the company?" If you get to the point where you can't change the assignment's parameters, and you don't have room to move monetarily, don't be afraid to say so. Letting clients know you are

unable to further reduce the price tells them one of two things: It is time for them to either accept your proposal or that they can't afford you (and you can't afford them)!

Let's face it: You won't be able to get every assignment, nor will you be able to afford to do every assignment. Being an astute businessperson, you will reject some as being unaffordable. By saying *no,* you retain control of your own destiny; by acquiescing to client demands, you put your future in the hands of others—and your well-being is not their first priority!

In a negotiation never forget that you must be committed to an amount below which you will not go. Learning to say *no* gracefully is a negotiation skill that must be practiced and used. "I'm sorry we can't come to terms on this one assignment. Perhaps some other time we'll be able to work things out."

A successful negotiator is always conscious of when there is a goal worth striving for, and when there isn't, and that there are many paths available to reach the target. Still, you can't give it away. It's difficult to do your best work when you know you aren't being paid fairly. No matter what happens, make sure your client understands that quality of the images you are to produce remains under your control. If cost cutting will negatively affect quality, you need to say something, or you need to bow out.

CARVING IT IN STONE

As hoped, your estimate, whether verbal (hopefully, not) or written, was accepted, and you've received the go-ahead. Your next step is to obtain written confirmation of your agreement. This can be done in a number of ways: verbal confirmation (please, don't!); asking for a purchase order (PO); or sending a confirmation to your client.

Let's not even waste time discussing verbal confirmation of any agreements. If a dispute ever arises, it becomes your word against the client's remembrance of the agreement. If your client contact leaves the company (is fired, or dies—don't laugh, it happens all too often), and the client company disputes your version, what do you think you can do to prevail? You've been spending money, and the client may argue you've done it without authority to do so. Don't put yourself in this position—it's too easy to obtain a written confirmation.

The PO is issued by your client usually contains a brief description of the job, probably a client order number and the agreed-upon amount. Generally, the PO will not describe your agreement in great detail; rather it is your client's commitment to proceed and to pay. Be aware, the PO may include terms and conditions you must read and understand. Be on the lookout for language transferring copyright or language you haven't agreed to. If the PO does have such language, you have a couple of ways to proceed. You can cross out the offending language and place your initials next to the corrections, or you can renegotiate it with your client. If you were careful to state your terms and conditions on your estimate in the first place, this shouldn't be much of a problem. It's likely your client contact isn't fully aware what language is on the company PO. The wrong thing to do is ignore incorrect language in the hope it will go away or won't become an issue. Make sure things are crystal clear at the outset. The one great advantage to a PO is that it confirms the client's view of your agreement in the client's own words.

Whether or not you receive a PO, and most times you won't, get in the habit of sending a job confirmation in which you describe the job (as per your estimate if you issued one), the usage rights, and anything else you think to be pertinent to the assignment, including the price. The confirmation, and all of your paperwork, should include the same set of terms and conditions, except for some things that are pertinent only to certain paperwork (e.g., delivery memos do not require the same set of terms and conditions as an invoice or estimate). Although not the same strong evidence as a PO, your confirmation serves as your declaration of what you and your client have agreed to and the responsibilities you have to each other. Should your client request any changes (more models, more setups, more time), always submit a revised assignment confirmation (indicated by a progressive number, like "Revision 1" or by successive dates) or issue a change order noting requested changes or alterations and how it affects estimated fees and expenses.

In this day and age, even if called late in the day to begin early the next morning, you can still fax, express, or e-mail a confirmation. Your client will have your paperwork no later than by midmorning and can call you wherever you are if there are any questions or problems.

Always, get it and express it in writing! And try to get it signed!

Follow-Up

Consider follow-up as part of the negotiation process, because it shows you care about the client's needs and about your photography. Call to ask how the job turned out, whether they were pleased with the results, when samples will be sent to you By doing so, you indicate that you value your work and your relationships with your clients and that you hope to be considered for their next assignment.

Never forget, negotiations never stop for successful businesses.

Assignment Telephone Information Form

Name _____ Date _____

Company _____ Assignment Date _____

Street _____ Deadline Date _____

City _____ State _____ Zip _____

Telephone _____ Estimate sent ❏ Yes ❏ No Date _____

Fax _____ PO # _____ received ❏ Yes ❏ No Date _____

Confirmation sent ❏ Yes ❏ No Date _____

Final Client: _____

Use Rights: ❏ Advertising ❏ Corporate ❏ Editorial ❏ Other _____

Description (of assignment and rights granted) _____

Print Media:

Placement: _____ Size: ❏ ¼ page ❏ ½ page ❏ Full page ❏ Double page ❏ Other _____

Number of uses: Circulation _____ Press run _____ Insertions _____

Translations (languages) _____

Distribution: ❏ Local ❏ Regional ❏ National ❏ Other _____

Other Media: ❏ Package ❏ Billboard ❏ Other _____

Distribution: ❏ Local ❏ Regional ❏ National ❏ Other _____

Time (period of use) _____

Location: ❏ Studio Location Address _____

Number of Clients at Shoot (names) _____

Other(s) _____

Assignment Telephone Information Form (continued)

	Name	Business Telephone	Fax Number	Home Telephone
Art Director:	_____	_____	_____	_____
Client contact:	_____	_____	_____	_____
Location contact:	_____	_____	_____	_____
Other(s):	_____	_____	_____	_____

Film: ❑ Transparency ❑ Color Neg ❑ Black & White **Film Size:** ❑ 35mm ❑ 2¼ ❑ 4 × 5 ❑ 5 × 7 ❑ 8 × 10

Polaroid type _____ **Proofs:** ❑ Contact ❑ Prints

Prints: ❑ 5″ × 7″ ❑ 8″ × 10″ ❑ 11″ × 14″ Other: _____

Lighting: ❑ EXTERIOR ❑ INTERIOR ❑ Flash/Strobe ❑ Quartz/tungsten ❑ HMI ❑ Existing on location

Crew: ❑ Assistant(s) ❑ Stylists ❑ Location Scout ❑ Others _____

Insurance Provision: ❑ Self ❑ Included in Policy ❑ Rider ❑ Other _____

Product Description: _____

Pickup from: _____ Date: _____

Delivery to: _____ Date: _____

Props Description: _____ Pickup ❑ Yes ❑ No Date _____

_____ Return ❑ Yes ❑ No Date _____

Rental Equipment: _____

Set Description: _____

Talent: Approvals needed ❑ Yes ❑ No By whom _____ Invoice to _____

Travel: _____

Miscellaneous: _____

39

Negotiating Stock Photography

As you approach negotiating for stock, keep in mind that you are not alone, nor are you the first. Many have gone before you over the difficult terrain of setting stock prices and terms. Since the earliest days of the stock photography business, for well over fifty years, stock agents and photographers worked to forge the prices and business practices we now consider common. The term "industry standards" sums up these practices, which include everything from holding fees and research fees to the full range of usage rights that command a fee. When you consider a first negotiating encounter with a client, know that you have on your side this body of experience from both buyers and sellers that empowers you in the marketplace to charge a fair price and maintain protection of your images and your copyright.

Start your stock negotiating, just as you did assignment pricing, using the same six steps of negotiating set out in detail in chapter 3:

1. Establishing rapport
2. Gathering information
3. Educating the client
4. Quoting the price
5. Closing the deal
6. Following up

By sticking with these principles, you will know you've done everything possible to achieve a successful, fair, and amicable negotiation.

Negotiating for stock differs from assignment in one very significant way: The photographs already exist. Since a stock buyer negotiates with you for specific pictures, you should base your price on the following factors:

- Usage
- Value of the photograph to the client's project
- Value of the photograph to you

Usage

There are different prices for specific uses depending on the purpose, where it will appear, how big, for how long, how many times it will be used, the territory (distribution), the language (translation), and so on. Also refer to the box "Pricing Factors" in chapter 2 and the rights terms definitions in chapter 8.

Value of Photographs

Photographs have value to users only to the degree that they solve a visual problem for them. It's important to find out just what that value is. It may not, as it seems on the surface, depend on the size of the company or their advertising budget. Imagine that you get a call from a small manufacturer of widgets wanting to use your photograph for a cover of a small print run brochure. It is the company's single mailing piece for the year and the most important promotion it runs. In this instance the photograph has extraordinary value. The same photograph used by a major credit card company, on the other hand, for one of numerous direct mail promotions done monthly, may have less relative value in this company's promotion world.

When setting a price, find out as much as you can, then integrate all the factors you learn from a client. Keep in mind that your perception of how crucial the photo is to this user will be influenced by the reality of the client's budget. But knowing the relative value will help you negotiate to the upper limits of this budget.

Value to You

Keep in mind the actual value of your stock. You can and should place greater value on some photographs than on others. Evaluate your photographs, and price them based on their cost

to you and on their unique quality—not only on the client's intended use. It is reasonable to charge more for any photograph that involves factors beyond those considered in normal pricing.

Remember your overhead, calculated in chapter 2, and use it as an incentive to maintain your price level. Place a note near your telephone with a summary of your daily overhead costs. This is the basic outlay you must cover before other value factors, listed below, are added.

Stock Factors

The following are those factors that will allow your photo to command a higher than standard price.

1. Expenses:
 • Normal costs: shooting time, film, equipment, overhead, etc.
 • Extra costs: model fees, location fees, props
 • Travel costs: domestic, foreign, exotic (out-of-the-way)
 • Extraordinary costs: helicopters, plane, or balloon rentals; underwater fees
 • High risk: for shooting from aircraft, bridges, high buildings, rock climbing, or anything that places photographer in jeopardy

2. Unique Quality: unable to be repeated

3. Uncommon: hard-to-find photographic topics

4. Freshness: new material, never-before published

Use these factors to decide how to price your photographs, and mention them in discussions with clients when an explanation seems appropriate.

You can't expect that clients will always understand everything that goes into a good photograph. If you make it look effortless, they may not be ready to pay for your effort unless you make it clear what was involved.

You won't want to tell war stories to every client on every stock sale you negotiate. Just keep clear in your mind the cost,

effort, and special vision that go into your photographs. An acute awareness of these factors will build your confidence when negotiating, and you'll be well prepared for those occasions when it is appropriate to share the information with a client.

Premium Pricing

Prompted by this understanding of the varying value of photographs, you may want to use a technique some photographers call "premium pricing" to distinguish photographs that are worth more than usual. You may have photographs that might appear similar to a buyer in content and style—a family group at dinner, for example. But you know that considerable extra cost and effort was needed to produce one of those family dinner scenes. It may have required extra model fees, transportation for models, meal costs, or a location fee. Further, perhaps the photographs are fresh material—not previously published.

You can charge more for these photographs and set them apart by stamping "premium price" on each slide mount or by placing them in a separate "premium" folder in your CD delivery. You could then provide an explanation on the delivery memo that "premium" photographs carry an additional percentage above the standard reproduction fee for the usage. 25–50 percent is a common range for the surcharge, but it depends on the value you place on the photos.

If the photographs have a similar look and the same value to prospective buyers, why should they be willing to pay more? They might not. It is their choice, although you can surely influence them. If they don't perceive any additional value in the premium photo, they will choose another. But if they get the benefit of the freshness, extra costs, or effort in a premium photo, then they will be willing to give you a fair price for its use.

Quoting Stock Prices

Prices are sometimes discussed when the buyers are making the initial photo requests. Other times, such a discussion occurs when they actually have your photographs in front of them, either under consideration or actually chosen for use, an ideal time because they are already predisposed to your picture!

Avoid getting locked into a hypothetical price, because different photographs command different prices based on the specific usage and on their differing production costs. Although offering a price in the abstract may seem innocent the price may become solidified in your client's mind, thereby endangering later negotiations.

Before entering a negotiation, set a bottom price below which you will not go. It may be tempting to make a deal at any cost. However, saying, "No, thank you," and walking away with your bottom price intact is one form of successful negotiation and the only way to ensure that your work doesn't become devalued.

Talking price can be simple and straightforward. Sometimes buyers will state the usual fee they pay for a usage, and it will be well within your range and industry standards. Or you may receive a billing request letter or purchase order stating their price. Again, if it is reasonable, the transaction becomes merely paperwork.

At other times, you may have to seize the initiative. If, after discussing the photo request, the buyer doesn't mention money, you should open the subject with, "Let's talk for a moment about the reproduction fees." That will usually bring you to one of the two most common approaches to price: The buyer asks, "What do you charge?" or says, "This is what we pay." Some photographers state a price at this point—a foolish move. The buyer will occasionally have a higher budget than you anticipated, so you may have given away an extra percentage by jumping in prematurely.

TAKING TIME

You don't need to rush a price quotation. Are you obliged to give an immediate answer on a price? Not at all! And don't fall for the old line, "Just give me a ball park figure." That ball park could become your prison.

If you need time to think, get off the phone. Tell them you'll get back to them. Give it ten minutes while you consult the charts in this book, calculate your value factors, or call a photographer friend. Use any ploy you must to get breathing room. If you can't think of anything else, there's always the old standby, "I'm involved at the moment. Let me get right back to you."

But first, find out how long you can take to get back to the client without jeopardizing a sale. Listen to the client's signals. If your comment, "I'll call you before the end of the day," provokes hesitation in the buyer's voice, counter with, "Look, let me see if I can cut this meeting short. Maybe I can have something for you in a few minutes."

It is important for you to see what you can learn about the client's budget before you commit yourself. Don't ask what the client can pay. That puts you in a yes or no situation.

If the client asks, "What do you charge?" try to find out, *without asking directly*, what the client has budgeted before you answer the question. Then, to get a response, float a trial balloon. Quote a price range. If you hear a gasp, you've learned something useful, but make sure it isn't because you set your lower price too low! You should quote a wide range so that the client's price is likely to fall somewhere within your own. Also, you need room to maneuver. The buyer may even blurt out the company's budget at that point. If clients hedge when you take that approach, you can ask them to give a price range. Here's how you might answer the typical buyer's question, "What do you charge?"

PHOTOGRAPHER: "Well, my fees vary depending on a lot of factors, including usage, the difficulty to produce the picture we're talking about, and so forth. In my experience, a fee to cover your requested usage can range from $400 to $1,000, depending on the reproduction size, the intended circulation, and the number of pictures you are using from our file."

BUYER: "We never pay more than $200."

Oops! Now it's time for the good cop/bad cop technique. It's been said that there are always four people in any negotiation: the buyer and his or her boss (the authority who approves the money) and the photographer and his or her boss. If you have a partner (or an accountant or a financial manager) you can use the following technique. Professional negotiators say that you should never negotiate with someone who isn't in a position to make decisions. In reality, that may not be possible. Either way, you can still use the good cop/bad cop position on your end.

You become the good cop: "I wish I could give it to you for that fee, but I have to check with my partner. We've agreed on a rate schedule, so let me see what I can do."

Get off the phone. Make your decision, and call back with an answer. If you can't live with the buyer's budget, blame it on the bad cop, your partner, your business manager.

If you do choose to work within the client's limits, take credit for doing so. Always give a reason, and if you lower your price, make sure you get something in return, whether it is reduced usage on the part of the client or a number of tear sheets for your portfolio. Never leave the impression that the buyer's take-it-or-leave-it intimidation worked.

Until you get right down to a decision, keep the discussion open and fluid. Present options. Imply to the caller that there is always a possibility for agreement.

Negotiating Conversations

In picking your approach to negotiating, no matter what words you choose, remember to communicate that you want to conclude a mutually satisfying deal.

Here are some phrases from hypothetical negotiations. Find the ones that are comfortable for you, that adapt well to your situation, and then translate them into your own language.

One important phrase is: "As I'm sure you understand" It's especially useful when you suspect that the client doesn't really understand the business. You are attributing to your listeners an education or awareness that they may not actually have, and it prepares them to receive your information in a more neutral way.

That brings us to the next most valuable phrase, "Let's see how we can work this out" Often this is most effective when ended with a pause that shifts the pressure to respond over to your negotiating opponent, who may blurt the answer that you both need. The buyer may well answer with something similar to "I could probably get them to go up to $xx, but I'll have to check."

Pose some questions: "Let's see how we can make this work . . . [pause] . . . Are you planning to use more than one picture? Do you have other picture needs on this project? Are we

speaking of a volume of photographs? How about upcoming projects, do you know your needs in the next months?"

Once the buyer picks up on one of those questions, your negotiation is still alive, and you've steered clear of the "take it or leave it" waters.

WHAT TO SAY WHEN THEY RUSH YOU

I'd like to give you a fast quote, but I need to have a bit more information. I want to be accurate about the rights you need. As you know, that affects the price, and there is no reason to charge you for anything you don't really need."

EXPRESSING CONCERN OVER PRICE

"As much as I'd like to help you out, I simply can't go much lower. It's because this particular picture is one of my XX collection. They have to command a higher fee because of the expense of extra model fees, props, travel" Or try, "Since it's going to be tough to come down much further, let's see what else we might work out"

Always give a reason when you adjust your price: "In this one case we're going to bend the rules a bit to help you out. The project sounds interesting and out of the ordinary, and you are using quite a volume of work. After you've published the photographs, the reprints will help with our promotional efforts. I'll call you and tell you how many we'll need."

EDUCATING THEM TO THE REALITIES

"I'm sure you're aware that generally the fees in the industry for this usage can run as high as $2000. Since I understand that you have a low budget, I'll try to accommodate. I can go as low as $1600, but I'm not sure how much more I could do"

When you have to enlighten them about your costs of business, try: "I'd really like to help you out, but one reason it's tough to go as low as you want is that I need to keep reinvesting in my stock. I hope that each time you come back to me, I'll have fresh new material for you. It's impossible for me to continue investing in new photography if I don't maintain a certain price level. I'm sure you understand."

These approaches must avoid any hint of whining. References to your high costs must be unemotional and matter-of-fact, not bids for sympathy—one businessperson to another.

WHEN YOU HAVE TO SAY NO

"I'm afraid that is lower than I can afford to go. Thanks so much for calling. Sorry I couldn't help you out this time. Hope I'll be able to provide something for your next project. Do you have one of my updated stock lists? Let me send you one."

Myths

When going into a negotiation, remember that there are some myths held by clients (and some photographers) that need to be dispelled. Here are a few:

MYTH ONE

An individual photographer should charge lower rates than a stock agency. The reasoning from a client goes like this: "If you work through a stock agency, you'll only get 50 percent of the fee, so why are you charging me full price?" This argument doesn't cut it—clients pay what the photograph is worth to them: for the usage they are requesting and for the pragmatic problems the image solves. It has an established value to the buyer's project regardless of its source—your files or an agency's. Questioning your right to the additional 50 percent on the basis that your overhead may be lower is presumptuous and erroneous. When you provide photographs directly to a client, you are bearing all the costs of captioning, labeling, filing, logging images in and out, remounting, and billing, as well as using your expensive office equipment, just as an agency would. Though you may not be located in New York's Photo District, the Near North in Chicago, or Wilshire Boulevard in Los Angeles, your overhead must be covered. Why should a buyer consider it acceptable for a photo agency to recoup these costs but not an individual photographer? Perhaps it is merely a client-negotiating technique to save a company some money? Keep in mind that you are running a stock business that has its own overhead, with expensive, ever expanding digital capabilities. Don't be afraid to explain that to clients.

MYTH TWO

Bartering makes sense if I gain access to a good location for stock shooting. This is faulty thinking. In the long run you may be taking a deep cut in your stock sales. Some photographers trade rights to a portion of a shoot, turning over a certain number of actual images, including all usage rights, to companies that provide the opportunity for photographing on their premises. This is a very dangerous practice because it sends the wrong message about your photography and its value when you trade off all rights to any photograph. Instead, you can offer complimentary prints, limited reproduction rights, and other means as a fair exchange with the administrators at an institution or location, all without giving away the rights to your work.

Be wary of turning over a segment of the shoot for nothing more than access to a location—you could end up competing against yourself someday. Imagine that you did some barter photography in order to get permission to shoot stock photographs at the facility of a friendly small company in your city. Later, that plant merges with a huge corporation. Your "freebie" photographs are then swallowed up in the vast corporate photo file, for use without payment by every subsidiary of the corporation, to be given away free to outside photo buyers for public relations purposes, or even to be sold (licensed) through a photo agency! And you won't receive a penny's share of those reproduction fees. The Copyright Act of 1976 gave photographers ownership of their work. But the law can't protect you from giving it away foolishly.

MYTH THREE

A beginner has to take what he or she can get and give away work in order to be published. Before accepting that premise, ask yourself if you are a professional and want to be perceived as one. Remember that the minute you sell (license) a photograph, you are in the profession, even if it's not your full-time job. What you owe to the profession you are entering is respect for your own photographic work. One way of showing that respect is to require it in turn from editors and art directors.

Should you make more concessions on fees than an established pro? That's the nature of breaking in. But make your price

adjustment with a professional's cool appraisal, understanding that this is the reality of starting out.

Finally, whether you are beginner in the field or an established pro, let's put an end to the notion that it is reasonable or necessary to accept whatever you are offered, especially a bottom-of-the-barrel price, for the use of a stock photograph.

One danger in accepting any price in order to break in is the difficulty you'll encounter later on in trying to change the buyer's perception about your value. How are you going to convince the buyer who got your photo for peanuts last year that it's worth diamonds now?

Assess each situation on an individual basis. Everyone recognizes that there is a difference between the price an advertiser can pay for a photograph that will sell a product and what a small circulation magazine can pay for editorial use. Beginners may choose to charge somewhat less, both for the experience and the tear sheets, but not because they are forced into accepting the lower rate. Your concept of the photographer/client relationship is an important clue as to how you view your position (power and rights) in a negotiation. You charge; you don't accept. You can give a lower price, but you don't take a lower price. You can offer, but you aren't forced.

MYTH FOUR

Since the picture already exists, it's better to get something than nothing. The "it's just sitting in the file so why shouldn't I take whatever I can get for it" premise is dead wrong. That attitude always communicates a subtle message to the client—that each time, you'll accept a little less, because "it's better than no money." Clients will begin to force you down to zero. Remember the farmer who thought he was being so canny when he trained his horse to eat a little less each day? He had just about succeeded in getting the poor animal down to nothing when the durn critter died.

Telephone Stock Request Form

Request Date _____ Photos needed by (date) _____

Name _____ Tel _____

Company _____ PO # _____

Address _____ Job # _____

For (end user) _____

PROJECT TITLE _____

USE: ❑ Advertising ❑ Editorial **FORMAT:** ❑ Color ❑ Horizontal

❑ Corporate ❑ Other _____ ❑ BW ❑ Vertical

CONCEPT/SUBJECT _____

USAGE/RIGHTS **SHIPPING VIA:**

Use in _____ Client Courier # _____

Size _____ Date Sent _____

How many copies _____ Via _____

Where (United States) _____

Other _____

❑ English Language ❑ Other Language(s) _____

Media Buy _____

PRICE: Our Quote _____ Client Budget _____

FINAL PRICE _____

Pricing Assignments

Y ou have learned new techniques and are ready to begin honing your negotiation and pricing skills. Now come the final steps: putting it all together to create an assignment price. To do this, you will have to add together the results of a number of other calculations, all of which are vital. Creative fee, other fees, billable expenses and any applicable miscellaneous charges will be combined to help you arrive at a total assignment price.

First, you need a road map. Sit down with paper and write out everything you can think of about the assignment, including:

- What is needed
- Where is it to be done
- When you will do it and when your client needs it
- How you will do it—that is, what it will take and how much time it will take
- Usage rights required by your client
- Any other specifications that help define the assignment

Second, draft a few simple declarative sentences or paragraphs describing the assignment. By referring to this statement (that you will include in all paperwork to your client) and the Telephone Information Form, you can remain focused on the vital elements that will affect your pricing decisions.

Creative Fee

As you remember (you have read the entire book up until now, haven't you?), overhead consists of many fixed and variable costs that you must be compensated for so that you remain financially viable. Let's review how a creative fee is calculated.

1. Determine your annual overhead total.
2. Divide the total number of assignment photography days you estimate you will have this year into your annual overhead. This is your daily overhead, the amount of overhead you must recover each day you are doing photography for clients.
3. Multiply the daily overhead amount by the number of days you will engage in photography during a specific assignment. This gives you a base creative fee. Never charge less than this amount, or you will lose money!
4. This result is then adjusted by the factors found in the box "Value Factors" in this chapter, and the result becomes your creative fee for the assignment. We diagrammed the equations needed for pricing an assignment in a more visual manner on the "Assignment Price Calculation" page later in this chapter.
5. Applying values to these pricing factors is made possible through experience, a knowledge of the industry, and, especially and importantly, by talking to other photographers. The pricing charts in chapter 9 will also help you better determine whether or not you are in the range of what other photographers have found to be required to run a viable business. The price charts take into account overhead, assignment time, and the value factors.

Other Fees

There are additional fees to be charged that will compensate the photographer for time spent on behalf of the client's assignment— keeping you away from family and other paying work. All or some of these fees may apply, although usually not on every job.

When it comes to invoicing other fees, there are different schools of thought. One is to keep your paperwork simplified by showing only the fees that are actually charged; or, you might list all of the fees that could be charged as a way of educating your clients about fees. There is no right or wrong way, but it's worth considering. One thing you shouldn't do is combine your creative fee with other fees. It will make your creative fee appear to be excessive, even if you are competitive at the bottom line.

Assignment Fees and Expenses

The checklist below contains many, but not all, of the fees and expenses traditionally billed for assignments. When estimating, be sure to include any that are applicable. Use this chart as a checklist when estimating assignments.

Fees

Photography
- ❏ Creative Fee
- ❏ Reuse Fees

Nonphotography
- ❏ Pre/Postproduction
- ❏ Casting
- ❏ Travel
- ❏ Weather delays

Expenses

Casting
- ❏ Director
- ❏ File usage
 (use of information from)
- ❏ Transportation
- ❏ Film

Crew
- ❏ Assistants
- ❏ Wardrobe stylist
- ❏ Makeup/hair stylist
- ❏ Home Economist
- ❏ Prop Stylist
- ❏ Security
- ❏ Model maker

Insurance
- ❏ Liability
- ❏ Binders/riders
- ❏ Special

Film/Lab
- ❏ Film
- ❏ Prints (any)
- ❏ Special charges
- ❏ Processing
- ❏ Proofs
- ❏ Polaroids
- ❏ Stats

Location
- ❏ Transportation
- ❏ Customs/carnets
- ❏ Car/truck rental
- ❏ Air freight/baggage
- ❏ Labor
- ❏ Mileage/park/tolls
- ❏ Usage/rental
- ❏ Camper/dressing room
- ❏ Scout
- ❏ Permits
- ❏ Gratuities

Messengers/shipping
- ❏ Messengers
- ❏ Overnight express
- ❏ Shipping
- ❏ Trucking

Props
- ❏ Purchase
- ❏ Preparation
- ❏ Rental
- ❏ Stylists (also see Crew)
- ❏ Food

Rental
- ❏ Lighting
- ❏ Filters
- ❏ Lens
- ❏ Special effects
- ❏ Camera
- ❏ Overtime

Sets
- ❏ Carpenter/painter
- ❏ Hardware/lumber
- ❏ Backgrounds
- ❏ Home Ec supplies
- ❏ Product prep
- ❏ Set Strike/labor
- ❏ Design
- ❏ Paint/walls

Studio
- ❏ Rent—build/strike
- ❏ Power/light
- ❏ Storage
- ❏ Rent—shoot
- ❏ Telephone
- ❏ Overtime
- ❏ Supplies

Talent
- ❏ Billed direct
- ❏ Adults
- ❏ Fitting (clothing)
- ❏ Per diem
- ❏ Air fares
- ❏ Billed to studio
- ❏ Minors
- ❏ Animals/trainers
- ❏ Hotels
- ❏ Extras
- ❏ Overtime
- ❏ Meals

Transportation (local)
- ❏ Car
- ❏ Parking
- ❏ Bus
- ❏ Tolls
- ❏ Subway

Travel
- ❏ Per diem
- ❏ Air fares
- ❏ Hotels
- ❏ Meals

Wardrobe
- ❏ Purchase
- ❏ Seamstress
- ❏ Costume designer
- ❏ Wigs/makeup
- ❏ Rental

Miscellaneous
- ❏ Gratuities
- ❏ Long distance phone
- ❏ Meals/catering

PRE- AND POSTPRODUCTION FEES

You need to be compensated for significant time spent by you on behalf of your client and the assignment before and after the actual photography. Pre- and postproduction fees cover: meetings with the client, time spent making arrangements, editing and captioning large amounts of film, set or location restoration and cleanup, and so forth. Most photographers' creative fees incorporate a certain amount of time for normal pre- and postproduction time; it is your decision when to begin charging additional fees for excessive time. Don't be intimidated into not charging, and don't give preparation time away.

CASTING FEES

Time spent by the photographer when involved in locating and booking models and talent is compensated through casting fees. You could incorporate casting fees into preproduction, but it may be best to separate them. Staff time for casting, however, should be expensed, including that of an independent casting director. The casting fee represents only the photographer's time.

TRAVEL TIME FEES

Photographers frequently bill all or a percentage of an assignment "creative fee/day" for travel, the "day" being calculated as the creative fee total divided by the number of photography days during the assignment. For example, if the creative fee for a two-day assignment is $5,000, the hypothetical creative fee/day will be valued at $2,500. There are no set rules to calculating travel time charges, but 50 percent of the creative fee/day is commonly charged by many photographers. Whatever you do, charge something. Your time is valuable, and clients should not expect you to give it away. Remember, client employees are salaried, so they are not additionally compensated for time spent traveling. You aren't salaried, and you need to be compensated. As with casting, staff time for travel is always expensed.

Watch your terminology! Travel generally means a journey greater than fifty miles from home base or an overnight stay, and includes airfare, hotel, meals, mileage if driving to the site, and so on. Transportation, on the other hand, is local conveyance, e.g., cabs, commuting in your car, and so on. If you journey to another city and rent a car at the airport to drive to the photography location, that's transportation.

WEATHER DELAY FEES

Photographers going on location may find themselves waiting for weather: for weather to pass by or for specific weather to occur. Depending upon the size of the job or your relationship with the client, you can choose to absorb a small amount of weather delay, possibly a half-day or so. Weather delays are often billed at 50 percent of the fee. Either way, you must be compensated for time spent on behalf of your client.

Billable Expenses

The following expenses, incurred in the process of completing an assignment, are commonly billed to the client. It is generally wiser to group expenses, like "Sensitized Materials" rather than listing the separate costs of film, processing, Polaroid film, prints, and so on. If quoting a bottom line price only, always note on your forms that all expenses are included in the total number.

The following are commonly acknowledged expense categories:

- *Casting.* Any costs involved with locating and signing models—Polaroids, casting director, research, staff time, and so on.
- *Crew.* Assistants—photo and otherwise, including carpenters, stylists, model makers.
- *Sensitized Materials.* Cost of all film, processing, Polaroids, prints, contact proofs, scanning, digital printing, other digital materials.
- *Insurance.* The actual cost if obtained for the assignment or prorated per billable day if you routinely carry the policy for the client's benefit, for special liability or special coverage like film stock defects, camera failure, processing damage, and so on.
- *Location.* Scouting, transportation, fees and permits, and staff time.

- *Miscellaneous*. Gratuities, phone calls, and meals for crew and models during photography.

- *Props*. Purchased or rented items required for photography but not the actual subject of photography. If props are purchased or owned by you, consider "renting" them back to yourself for the assignment, charging the client accordingly. Note: Charging for items you own, never create fake invoices or receipts from real or imagined stores. That constitutes fraud. Be honest in your invoicing practices. If asked by your clients, admit to owning props, if you do, and don't be afraid to tell them you have to be compensated for their use, so long as you haven't already incorporated the cost of the props in your overhead calculations.

- *Rentals*. Anything that is rented for an assignment (other than props), from fog machines to studios to longer or wider lenses than you own. If you do own specialized or highly expensive equipment, and you haven't accounted for their purchase in your overhead calculations, recoup your outlay by "renting" them back to yourself.

- *Sets*. Any costs associated with planning, constructing, maintaining, and using sets where photography takes place.

- *Studio*. Expenses associated with studio operation applicable to the assignment—rental, utilities, percentage of insurance(s), and so forth, unless they were included in overhead.

- *Shipping*. Any costs incurred transporting information or materials related to the assignment.

- *Transportation*. Local commuting—cabs, auto, parking, tolls, and so on; these expenses are sometimes placed under "Location" if related to a location assignment.

- *Travel*. Generally transit over fifty miles away from home or that requiring overnight lodging—includes airfare, meals, lodging, meals, phone calls home, and so on.

- *Talent*. People (models) and/or animals used in photography. Because these costs can be quite high, it may be best to obtain an advance; even better, have your client pay these costs directly.

Miscellaneous Charges

These charges are vital to your economic health and should not be ignored. Other professionals in other industries don't hesitate to charge for them, or to use them as a point of negotiation, so why don't photographers?

MARKUP

A growing trend among photographers is one of applying a markup on billable expenses to compensate for the period in which the photographer's money is paid out on behalf of a client, not earning interest or not available to work for the photographer in other ways. While some clients may balk (and why would you tell them?), markup is a routine business procedure in virtually every other industry. Photographers have been slow to recognize it and thus have lost untold amounts throughout the years by paying credit card fees or bank finance charges for the use of money. They have been, in effect, financing their clients' projects. If clients object to a markup, the not unreasonable trade-off is to have them prepay expenses with an advance paid to you. You could use the issue of markups as a negotiating tactic by offering clients a choice: Pay the markup or pay your assignment expenses estimate in advance. Tell them, "If you'd like to save money by avoiding an expense markup, I'll need an advance, in full, on all expenses, before we begin the photography."

As to how much to mark up billable expenses, again it is an individual decision. Advertising agencies mark up your photography and the other services they supply to their clients an average of 17 percent. Don't be afraid to mark up expenses, but don't necessarily flaunt that you are doing it.

POSTPONEMENTS AND CANCELLATIONS

Postponements and cancellations are two sensitive areas and, when they occur, will cause you great unease. However, business is business. When your client postpones or cancels an assignment, charges are levied to compensate you for lost booking time (that you can't easily replace with another job) and for time already spent making arrangements on behalf of the assignment. Charge them for any expenses you have incurred, or that are charged, if they are canceling. Expenses, as well as fees, will be recovered after a postponement when you invoice the completed job.

Be aware. You, in turn, may be similarly charged by assistants, stylists and others whom you, in turn, booked to work on the assignment for you. Your client must also be made aware that they will be liable for any postponement or cancellation charges of crew members or other personnel you have engaged.

A postponement is generally considered to be a temporarily cancelled assignment that will be rebooked within thirty days. Always obtain a signed confirmation that there will be a rebooking (e.g., their purchase order or your form); otherwise, consider it a cancellation and bill accordingly—postponements have a strange way of becoming cancellations.

RESHOOTS

Equally sensitive is the question of rephotographing an assignment. It can come at the request of the photographer, the client, or by mutual agreement.

Conversely, if the photographer wants a reshoot or the opportunity to do more photography, there won't be any additional creative fee, although additional expenses may be negotiated with the client. However, if the photographer has actually failed to produce usable photographs, additional reshoot expenses will be the photographer's responsibility.

If the client requests a reshoot you must first determine what is wrong and agree upon why it happened. If it was due to the client's failure to perform in some way, then additional creative fee and all extra expenses are usually paid. This is also true if the client requests changes or variations in the assignment that were not originally specified. If you were at fault, the cost of a reshoot will likely come out of your pocket.

Postponement/Cancellation Charges

In the event of a postponement or cancellation, you can be partially or fully reimbursed for lost time and opportunity. Multiply the agreed-upon creative fee by the appropriate percentage to arrive at an equitable solution.

All sums expended in support of the assignment, up to the time of the postponement or cancellation, including items you have charged, are reimbursable in full.

Time Before Assignment	Postponement	Cancellation
24 hours or less	100%	100%
48 hours or less	50%	100%
72 hours or less	25%–50%	75%
96 hours or less		50%

Example:
You receive a postponement thirty-seven hours before you were to fly to Monaco to do a fashion assignment for a magazine. Your estimated creative fee is $4200, and by the time you receive the postponement, you have spent $958 on the assignment. You have booked two models that the client wanted on the trip and your freelance assistant. The trip was to have taken a day to fly each way, to be reimbursed based on 50 percent of a creative fee/day, and two days on location.

Creative Fee	$4200 × 50%	=	$2100
Travel Time	$2100 × 50% × 2	=	$2100
Expenses to this point	$958	=	$958
Assistant	$300 × 50%	=	$150
Travel Time	$150 × 50% × 2	=	$150
Total billed for postponement		=	$5458

There often is a middle ground, where both parties are dissatisfied to some degree and agree to share in the risk of trying again. This situation commonly arises when film stock is bad, there has been faulty processing, or camera or lens problems existed.

One good way to guard against loss caused by reshoots is to purchase insurance against film or processing problems. This kind of coverage may be available through agents who deal with motion picture production companies, and ASMP has made it available, although it may be a members-only benefit.

All of the above assumes, of course, that you can reshoot the job. If that is impossible, and you and your client are still in general agreement that neither side was directly responsible for the lack of success, then it is traditional for the photographer to accept half of the creative fee and all expenses.

In the event that the bottom totally drops out and you and your client can't even agree on what day it is, you may have to resort to arbitration, a lawsuit, or pistols at dawn. All, however, will prove to be expensive, time consuming, or very messy.

Assignment Price Calculation

OVERVIEW

To determine an assignment price total, calculate and add together:

+ Creative Fee (see section A)
+ Other Fees subtotal (see section B)
+ Billable Expenses subtotal (see section C)
+ Miscellaneous Charges subtotal (see section D)
= Assignment Price total

A: Creative Fee equation

Billable Day Overhead × Assignment Billable Days
+ Pricing Factors = Creative Fee

B: Other Fees equation

+ Pre- and/or Postproduction
+ Casting
+ Travel Time
+ Weather Delay
= Other Fees subtotal

C: Billable Expenses equation

+ Casting
+ Crew
+ Sensitized Materials
+ Insurance
+ Location
+ Miscellaneous
+ Props
+ Rentals
+ Sets
+ Studio
+ Shipping
+ Transportation
+ Travel
+ Talent
= Billable Expenses subtotal

D: Miscellaneous Charges equation

+ Expense Markup
+ Postponement/Cancellation Fee (if needed)
+ Reshoot Fee (if needed)
= Miscellaneous Charges subtotal

Pricing Stock

"Well, enough talk, finally we've gotten to the prices. And since stock is much less complicated than assignment pricing, I can just skip right to the charts and find a price. That's handy."

What's wrong with that thought? Everything. Stock is different from assignment, but not less complicated. And, it is equally fraught with dangers, like the impulse to sell at any price just because it's "better than having it sitting in the file." You cannot repeat to yourself often enough—it should be a mantra in the business—"Something is not better than nothing! Something is not better than nothing!"

Is it handy just to go to a price chart? Yes, it would be an easy way to price, but anyone making a living as a photographer knows there is no easy way. Photography is a challenging and interesting profession. But you will never understand the dynamics of the business if you just grab the prices from the chart without first understanding and practicing the advice in the preceding chapters.

You will hear many of us preach this doctrine of negotiating. It's tedious to hear it over and over again. Negotiating is complicated work, but it's the only way to a successful business.

Looking Foolish

If the economic arguments don't convince you, then maybe the possibility of being embarrassed will. If you grab a price from the chart without understanding the reasons for it, and can't articulate your reasoning with conviction to a client, you could find yourself in an awkward situation.

How will you respond to the client who says, "Why on earth would you charge me that much when I can get this sort of picture anywhere?" If you've carefully reviewed the value factors for the photograph in question, it will be easy to answer: "Well, it may seem that pictures of businesspeople are relatively common, but this photo features Hispanic executives (which I know from other requests is not an easy photo to find). Also, it was more expensive than normal to produce because of extra model fees, as well as a location fee. Finally, it has never been published before, it's fresh, never before seen." Without this kind of information in mind, you could be mumbling an embarrassed retreat when confronted about your price.

Also, remember your overhead figures (posted above your desk) to give you further incentive to calculate the price that is appropriate for the usage.

How to Use the Price Charts

The price charts in this book are a handy reference intended to show you the range that other photographers are using. Once you have figured your own price on the "Pricing Worksheet" at the end of this chapter, look to see where you fall in the charts. If you are dramatically off, in either direction, go back and reconsider the factors that affect value and price. There's no reason why you shouldn't price higher than the charts if the picture warrants it. But if you're being guided more by wishful thinking than by realistic value, you may lose credibility with a client.

Remember our premise, stated in various ways in this book:

- A price list is only a framework.
- Prices are not carved in stone.
- This price list only provides a range from which to negotiate.

VALUE ADDED FACTORS

The various factors that give each stock picture different and often additional value, above the usage fee, are listed in chapter 5. They are also listed again on the stock pricing worksheet. Don't ignore them. They represent valid charges that may be the very things that keep you in business.

PAPER TRAIL FOR PRICING

Once you and a client have come to verbal agreement on a price, get it in writing. Ask the client for a purchase order. If that's not the client's policy, then just send your invoice with the granted usage rights carefully spelled out. If you do get a purchase order, consult your notes on the pricing worksheet to check if the price and usage rights on the PO are what you agreed upon in discussion. It happens that strange, unaccountable terms sometimes appear in boilerplate language on purchase orders. Corporate accounting policies may be the reason, but you should accept only what you've agreed upon with the photo buyer.

Be sure to use professional forms (see the appendix and bibliography), which include terms and conditions.

Usage

You'll see in chapter 8 a rundown of most usages and terms that are commonly used in the business. And, as you'll recall, chapter 2 offers pointers on constructing a usage rights grant of license.

Stock Pricing Worksheet

Use the form at the end of this chapter to make notes of the factors that affect your price. There are three general areas to consider which will influence your pricing:

- Usage
- Value factors of the photograph
- Client factors

Usage information should have been noted on your telephone form in your initial conversation with the client. These items, which include rights, size, circulation, and so forth, are more easily quantified, and the common percentage of increased fee charged by most photographers is listed in the price charts in chapter 9.

Value factors are calculated using a combination of objective and subjective elements. You add to the fee to cover a proportion of any unusual costs incurred while producing the photograph, such as extra equipment rental, foreign travel, and so forth. You would also add something for a photograph that is hard to find or that involved great risk. A unique photo would command even more.

Client factors influence prices in both directions. Your price may go down a bit because you may want to give a break to a good, repeat client (but never below what it costs to be in business; see chapter 2). Also, you'll be likely to offer a package price when a large number of pictures are purchased from you for one project. At what figure the so-called volume discount comes into play is an individual call. Some photographers start with ten photos for a small percentage off, while others don't begin a discount until twenty-five or fifty photos are used.

The client factors that push a price upward relate to the photo's importance to the project and to the size of the media buy. It takes more fortitude to deal with these aspects of pricing; clients may not want to share the information ("What do you need to know that for? Just tell me how much."), and photographers are often too intimidated to pursue the subject. Do you have enough gumption to persist? You have every right to ask.

How do you determine the importance of the photo to the project? There are many clues, such as prominence of use and how many other photos are being used. For instance, will the photos be used on the cover, or just inside? Will they be used in a consumer ad, or in a small brochure? What will the size relationship be between the photo(s) and the rest of the piece? Ask to see the layout.

Imagine that your photo is being used as a double-page spread in an ad for a national magazine. Imagine further that the entire copy is one line of 10-point type along the bottom of the spread. Now, that is a photo that has importance to the ad; it is the ad!

The media buy figures are very important to know. It helps if you can see the relationship between what the client pays to run the ad and what the client is, in turn, willing to pay you for the use of your photograph. How would it affect you to know that you are being offered $1,000 for the use of a photograph that will occupy $200,000 worth of advertisement space? It helps to be able to quote to the buyer that the price you are asking is actually only a small percentage of the total production costs and surely an even smaller portion of the total media buy.

Perspective

Go to the library and look up in *Standard Rate & Data* the cost to advertise in the magazines your advertising clients deal with most often.

Similarly, when selling to an editorial or corporate client, find out the circulation of the magazine, the number of copies of the book a publisher is printing, or the level of distribution of a corporate brochure. You are seeking not just the numbers but their significance—their relationship to the total value of the overall production.

You say, "If I thought I was confused before" Yes, it can be tough to figure out how much money to add for some of the value factors mentioned here. Not everything can be done with mathematical precision. Sometimes intuition, simply your gut feeling about the photograph and what it's worth, will influence the price.

To help you in this gray area, you might follow a method used by other photographers. Go down the list of factors and put a series of plus (+) marks in the right-hand column of your stock pricing worksheet to represent the value, in each of the categories, that you perceive should be added to your photographs. Conversely, you might put some minus (–) signs when you choose to give a break to the client. A look at that visual summary of pluses and minuses should help clarify your value of the photograph. It may also help you decide where you should be in the low-high range of our price charts. The worksheet that concludes this chapter will help bring you to the right price range, so you can determine your asking fee as well as calculate your bottom line figure. Most important of all, when you talk to the client, your reasons for charging a certain price should then be absolutely clear in your mind. When negotiating, you'll have, in front of you, all the aspects of the particular photograph that make it valuable, and you can use them to discuss it more clearly with a client if they balk at your price. Use a worksheet for each different photograph or group of photos, because they may have different relative values.

Preparing to Use the Price Charts

Prices were gathered from a wide range of professional photographers and stock photo agents. For each category there is a low-mid-high price as well as a section for commonly requested additional usages that will affect your price. To the right of the prices are blank spaces for each usage, where you can keep track of the fees you are charging in each category.

Before you fill in the worksheet on the following page and then turn to the next chapter, know that you do yourself a grave disservice if you haven't prepared to negotiate. Pleasant, firm, informed negotiating is what will make the chapter 9 price charts most useful.

Stock Pricing Worksheet

Photo Description (Story/set) ❏ Domestic ❏ Foreign

Client Name _____

Telephone _____

USAGE

Base Price	Low	Medium	High
Type: Editorial			
Advertising			
Corporate			
Other			

Rights needed _____

Size/Placement _____

Circulation/Print Run _____

Insertions (ad) _____

Distribution: ❏ Local ❏ Regional ❏ National

CD-ROM _____

VALUE ADDED

Normal costs (in base price) _____

Extra costs:

 Released photo/model fees paid _____

 Released photo/property fees paid _____

Travel Costs _____

Extra equipment/rentals _____

Extraordinary costs _____
 (helicopter, plane, balloon rental, etc.)

High-risk _____

Extra Insurance _____

Unique (unable to be repeated) _____

Uncommon (not easily found) _____

Fresh (new material, never published) _____

CLIENT FACTORS

Importance of photo to Project (+) Valued/repeat client (–)

Client status/media buy (+) Volume photos used (–)

Your first price _____

Client offer _____

Final price billed _____

Introduction to the Price Charts

Unlike other pricing sources, this book presents prices that photographers need to charge in order to remain profitable. Other sources typically offer prices that a single or a few photographers have received. Those prices then unrealistically reflect only the downward trend in pricing, where there may not have been a true appreciation of overhead, often by people who largely compete on price alone. Other types of businesses don't operate this way—they calculate overhead, determine a fair profit margin, and price accordingly. If there is one caveat in this book, it is: *Don't price like other photographers!* In fact, after reading this book, you will have become one of a small number of photographers who actually understand pricing—teach your colleagues how to price.

The prices in this book reflect those of professional photographers who are respected for their business acumen, and they are prices this group believes they must charge in order to remain profitable. They are not prices photographers are currently charging, so they aren't unrealistically low. In thinking about pricing, it is worth noting that the Consumer Price Index has gone up 29 percent since the first printing of this book in 1993, yet photographers' prices have continued to drop. It doesn't have to be that way!

Terms on the Pricing Charts

Various terms are found on the pricing charts that you should know:

- *Avg.* Means average price.
- *Min.* A minimum price.
- *NA.* Not applicable or not enough information was received from the surveys to report.
- *Negotiable or Neg.* Means a rate is to be negotiated.

Cautions About Terms

Before trying to use the Price Charts and, indeed, before entering into a negotiation, you need to understand some of the terms that are commonly used in the industry.

Care must be exercised when quoting rights terminology, because not all of the term definitions have wide acceptance throughout the trade. Too often and too late, many photographers and clients realize that while they have been using the same word, each has been assuming vastly different things! You must clarify everything; always ask your clients what they mean, especially if they use the following terms:

- All rights
- Buy–out
- Exclusive rights or exclusivity
- First rights
- Nonexclusive rights
- One-time rights
- Unlimited rights
- World rights

To help reinforce the concept that you are partially basing your price on usage rights, and for clarification if you use the above terms, always specify in your confirmation letters, delivery memos, and invoices what the above use terms include *and don't include*. For example, don't just say, "The Jones Company is granted one-time rights to the photo of Paris." Instead, be more specific: "The Jones Company is granted one-time book publication rights to the photo, #147898, the Louvre main entrance, Paris, France, for ½ page, inside, editorial usage, publication in the title "Europe: Art and Culture," to be published by John Doe Press, a subsidiary of The Jones Company."

Specifying Reproduction Rights

Reproduction rights are just that: the temporary rights that allow the client to reproduce your photo—e.g., in a book, magazine, brochure, or T–shirt. There is no one right way to describe the reproduction rights you are granting. The most important thing is to write succinctly and clearly; include everything you think has relevance to limiting the rights grant. The goal is to limit the rights to only what the client needs and will pay for. Avoid vague language or generalizations that might mislead clients to believe they are allowed much wider use than you intend. Based on the

first (and way too vague) license in the examples above, The Jones Company might have thought it could print the photo of Paris as large and as many times as it wanted. How would you argue your case if you saw the book after publication, and your photo appeared as a full page chapter opener, as well as a half page in the text, and, again, postage-stamp size in the margins of the table of contents page? Would you be able to defend any limitations in the first example license?

If you are unsure how to limit rights in a license, review "Writing a Usage Rights Statement" in chapter 2. Also, talk to other photographers, join a professional photographer's society and read its publications, and attend business seminars aimed at photographers. Also, see the bibliography and resources section for books and organizations providing information about photographic business practices.

The Price Charts—Assignments

The assignment price chart pages are divided alphabetically into the rather broad and commonly accepted categories of advertising, corporate, and editorial photography. Along the left side of each page are subcategories reflecting assignment usage, also listed alphabetically. Throughout the middle of the page, you will generally find prices listed as low, middle, and high, reflecting varying experience and skill levels, geographic location, client size, willingness or ability to pay, and many of the other factors shown in the box "Pricing Factors" in chapter 2. On the right of the price chart pages are blank areas where you can pencil in your own rates. Finally, along the bottom of the page are commonly (but certainly not all) requested additional usages that may affect your final price.

The Price Charts—Stock

The stock price pages are similar to those for assignments, except the high-medium-low categories are shown in a vertical layout as opposed to the horizontal arrangement for assignments. The low category is on top; the high price is on the bottom.

Space Rate Pricing

Never forget, price charts can be seductive. It will be a temptation to depend solely on them to determine pricing, but don't

succumb. *Price charts should be used as guides only.* Always calculate the price you think you should charge, and then, and only then, consult charts to see how you compare.

But what if you have faithfully calculated your own price, checked the charts, and are still unsure? You might call other photographers to see what they would charge, but they likely know less than you do. In case you just can't summon up enough courage, here is one last way to look at pricing, at least for the advertising sector. It may provide some guidance for magazine editorial pricing, also. Some photographers price advertising photography based on the space-rate/media-buy method (i.e., the page rate advertisers pay). Consult the Advertiser's Red Book to determine what the publication in question charges for advertising space (the space rate). Determine a percentage that seems appropriate, and multiply it against the space rate. For example, say that the space rate in a publication is $50,000 per page, and you have determined that 10 percent is the amount your client use. Your basis will then be $5,000, to be adjusted by the other pricing factors that may apply, to determine your creative fee.

Note: You may have to use a percentage based on a sliding scale. Advertisers may not be willing to pay the same percentage for an extremely high space rate as they would lower rates. For instance, 10 percent of $50,000 per page would be $5,000 but 10 percent of $500,000 ($50,000) would probably be a higher rate than most advertisers would be willing to pay for photography. Why not start your scale at 10 percent on the low end, say for any space rate below $50,000 per page, and slide down to 5 percent for any space rate above $200,000 per page.

Although the space rate method may not work easily for editorial or corporate photography, at least let the publication's space rate influence what you charge for editorial work in a publication. Remember, too many photographers price their work worrying if they are low enough to get the job. Photographers instead should think, *Have I priced my work high enough to cover my overhead and incorporate all relevant pricing factors?*

Pricing Factors

As you learned in chapter 2, pricing factors are elements that affect your price. These factors add value to your pricing. We

suggest percentages for some of the different rights commonly requested by clients. They are shown directly on the pricing charts.

For example, the charts show a one-year use price of $2,000 for Stock-Advertising-Brochures/Catalogs, for a press run of 50,000–100,000. If the client wants to make this a wrap-around cover, add 75 percent (the pricing factor value) of the cover fee, for a total of $3,500—or $2,000 multiplied by 175 percent (i.e., 1.75).

Note: The additional usages listed on the price chart pages do not, of course, constitute all of the pricing factors that may affect your stock or assignment photography. They are just some of the more commonly requested usages.

PLACING A VALUE ON ADDITIONAL RIGHTS REQUESTS

When quoting fees for additional rights, like world rights, exclusive rights, or perhaps language (translation) rights, photographers may calculate either a percentage or a dollar amount and add it to their price. A fixed dollar amount often doesn't work in your best interest because it may not accurately reflect the value of pricing factors to different clients. For example, suppose you might charge $500 for editorial usage but $3,000 for advertising use of the same image. Is it really wise policy to charge the two clients the same amount for, let's say, worldwide use of the photo? On the other hand, levying a percentage may not fairly compensate you, either, if it isn't great enough. For example, consider that you have received a rights request that removes an image from the marketplace by editorial and advertising clients. Further assume that you charge 200 percent for this request. Are you fairly compensated by the additional $1,000 from the editorial client, when you could possibly have made far more had the photograph remained available for use by others? Should you allow a client to restrict licensing by others for a mere $1,000?

A better approach might be to charge the greater of a minimum rate *or* a percentage of the original fee total. Assume you have established a $2,000 minimum or a 200 percent (double) charge for this kind of broad rights request. The editorial client above would therefore pay $2,500 total (i.e., the $500 fee and $2,000 for the extra rights request), while the advertiser would pay $9,000 total: $3,000 for the fee and another $6,000 (i.e., 200 percent, or twice the fee) for the additional rights. Remember,

you can't afford to have your work tied up by low-paying clients. You are in business, after all.

Miscellaneous Notes About the Charts

The rates shown in the charts reflect the most basic rights and use: one-time, nonexclusive, U.S. distribution only, English language only.

In the assignment price charts, all digital imaging fees are in addition to those for regular photography. If you are pricing a digital imaging assignment, which also includes original photography by you, add the digital imaging price to that for photography for your total fee.

Warning!

If you use the price charts as your sole method for pricing you will do yourself a major disservice. Just as detrimental will be to use them in an attempt to undercut what others charge in hopes of securing work by competing on price. In the past, too many photographers have looked at price surveys and adjusted their own prices to be lower. The end result has been that photographers themselves create lower and lower fees, and they then attempt to justify this irrational behavior by saying, "If I don't lower my prices, someone else will."

Combine the negative things photographers do to themselves, like failing to become capable negotiators and not knowing their actual overhead, with the general cost-cutting attitude of clients, and it is no wonder that photographers' fees are in a downward spiral. Photographers have made it, and allowed it, to happen. What else can you expect when photographers blurt out, "This is my price, but it's negotiable," or simply, "What's your budget?" If you are always competing by price-cutting, if you are always willing to bend, then fees will never move upward or even stay abreast with the cost of living. When the buyer's budget is formulated the next year, and you continue to work with ever-lower rates, buyers feel safe in cutting the following year's budget, and the next, and the next

Once again, before you turn this page, know that the raw figures listed in chapter 9 will be of little avail if you haven't prepared to negotiate. Your future is in your own hands.

Assignment and Stock Photography Price Charts

The price charts in this chapter are only a framework. They provide a range from which to compare and to negotiate, based on your level of expertise, reputation, geographical area, and the market, usage, and client.

Remember, prices are not carved in stone.

Those "Other" Assignment Fees

Photographers have always had to be concerned about ensuring that they are compensated for their time. Your time has value. Accordingly, you will be charging a creative fee that includes time spent doing creative things like photography and fees for other time spent on behalf of your clients—the "other" fees. But, how do you charge for that time that isn't spent doing photography but that still has great value to you and to the client you are working for?

For the following activities you can charge either a flat rate or a percentage of your creative fee. This can be done by setting a fixed hourly or daily fee (that will be greater than your daily overhead, remember). Or the other fees can be calculated by dividing the creative fee by either the number of assignment days or the number of photography days. Let's call those calculations *creative fee/days*. For example, say an assignment creative fee is $3,000, and it will take two days to photograph the job. Each creative fee/day is worth $1,500. You could charge something less for nonphotography days that are spent working for the assignment client, say two-thirds of each creative fee/day, 75 percent, or any other percentage that works for you. (In the case above, two-thirds of the creative fee/day would equal $1,000/day.) Remember: Before doing this, you must know what your daily overhead is so that you don't charge less than what you need to stay in business!

WARNING: A creative fee/day is NOT a "day rate"!

Pre- and Postproduction Time:

The creative fees in the pricing charts presume a reasonable amount of time for simple preproduction: equipment checks, a few phone calls, etc.; and a reasonable amount of time for postproduction: film editing, film shipping, equipment checking and cleaning, and so on. The big question is, when should you begin to charge separate fees for the activities below, and how much should you charge?

MY FEE

$ _____

PREPRODUCTION

Many photographers begin charging once preproduction time goes over four hours. Fixed amounts range from $60 per hour to $125 per hour.

POSTPRODUCTION

Similarly, once the time is greater than four hours, photographers begin to charge from a minimum of $60 per hour to $125 per hour.

CASTING

Photographers usually charge for casting if their own time is involved, whether or not they have also hired a casting director. Some charge flat rates of $75 per hour, $350 per half day, or $750 per day, and, again, most people reported basing this charge on 50 percent of the creative fee/day for their time.

TRAVEL TIME

Because travel time assumes going beyond a home base area, almost all photographers reported charging for it. Some reported charging less if they could travel at times convenient to them, if they could go earlier or return later so that they could also take stock photographs or show potential clients their portfolio at the travel destination. The charges reported were usually 50 percent of the creative fee/day for every day of travel.

MY FEE

$ _____

$ _____

$ _____

$ _____

WEATHER DAYS

Most photographers were willing to wait one day for weather, but they begin to charge after that. Weather days include waiting for inclement weather to pass, or waiting for good or specific weather to occur—when you can't work for other clients. The fees levied generally range around 50 percent of a creative fee/day for each weather day. If they are on location, or handling larger productions, photographers are more inclined to charge without giving the client a free day.

HALF-DAYS

Traditionally, a half-day was considered to be any photography taking less than three hours, with the photographer always charging a premium price (frequently two-thirds of a "day rate") for that time. However, times have changed, and photographers are more realistic about pricing. Not one photographer reported doing half-days, and their comments emphatically ranged from "No," "Never," and, "Nothing in this business takes a half day!" When you figure pre- and postproduction time, even just for editing and film shipping, a determination *not* to do half-days seems to be good advice. (Despite that, we are including a space to list half-day rates because some of you may have businesses that acknowledge short assignment time—for example, publicity photos in a large city where you only range a few blocks from your office or studio.)

MY FEE
$ ____
$ ____

Commonly Requested Rights

The percentages shown are added to your creative fee.

- *Reuse after one year.* The lowest rate reported was 75 percent of the original creative fee.

- *Exclusive up to one year.* Photographers occasionally prevent photo(s) published by one client from being used by another client, especially for advertising accounts; clients requiring exclusive use should expect to pay an amount at least 200+ percent (double) in addition to the creative fee.

- *Unlimited up to one year.* No photographer surveyed felt that this open-ended rights request should be allowed for less than 275+ percent of the creative fee. However, the majority said that they wouldn't do it for any amount. If you allow it, charge an amount, say, of 300 or 400 percent of the creative fee.

- *Buyout/all rights.* The lowest amount reported was 500+ percent over the creative fee; however, few photographers felt they would consider it for any amount. Remember, the money may seem good at first, but if a client is willing to pay this amount, shouldn't you be considering what the potential earnings of the images could be if you were to retain ownership?

Digital Imaging

The listed digital imaging fees are in addition to any photography fees. They represent moderate amounts of imaging: scanning, manipulation, color matching, output to film or digital media, and so on. Extensive manipulations would call for greater fees, and you might charge lower amounts for less work, like minor retouching.

Calculating Percentages in the Price Charts

When a percentage is given for additional use (e.g., "4 to 10 additional" insertions), multiply the creative or stock fee you calculated for one insertion by the percentage given.

65

For example, you are pricing a national consumer magazine, single-page advertisement (see page 67), and you are charging $3600 for a single insertion. The client wants to run the ad for six months in a specific magazine. Multiply 175 percent and $3,600. The amount you will charge for six insertions has now gone up to $6,300.

Or, assume you are licensing a photo for the back cover of an advertising brochure and the percentage given is 75 percent. The press run will be 40,000, and the cover rate that you would charge—if you were doing the cover—is $1,775. To calculate the back cover fee, multiply 75 percent (i.e., .75) by $1,775. The back cover charge is $1,331.25.

For ease of use, when you are just looking at the charts and don't want to resort to a calculator, think of the percentages you see in this way:

- 200 percent is double whatever fee you are charging. If charging a creative or stock fee of $2,600, you would add $5,200 (i.e., 200 percent times $2,600), for a total of $7,800. (Note: 300 percent is three times, and so on.)
- 50 percent times a fee is one-half of the fee (e.g., 50 percent of $2,600 is $1,300); if the percentage represents an additional charge, add the two figures (the fee and the additional calculated percentage) together for a total of $3,900.

ASSIGNMENT PRICES—ADVERTISING NATIONAL

Base Fee: one year, exclusive	Low	Medium	High	Digital Imaging*	Your Base Fee
Advertorial	$ 2300	$ 3500	$ 6000	$ 2400	$
Billboard, kiosk, transit display	2500	3700	6000	4500	
Catalog:					
Numerous setups/photos per day	2500	3000	8000	4000	
Per setup	800	1100	5000	1200	
Free-standing inserts	2100	3000	5000	3500–5000	
Magazine (consumer):					
Single page	2500	3600	8000	4000	
Spread	4000	5800	10,000	6500	
Cover (back/inside)	5000	7500	15,000	10,000+	
Newspaper	1800	3200	6000	2800	
Packaging	2500	3500	5000	4600	
Point of purchase	2500	3100	5000	4000	
Television:					
Photomatics	1800	2500	3500	2800	
Stills for commercials	2400	3300	5000	4000	
Publicity stills	1200	2200	5000	2600	

Additional Usage		Multiply by Original Fee		Revised Fee
Insertions:	1 to 3 additional	140%		$
	4 to 10 additional	175%		
	More than 10	250%		
Rights:	Reuse after 1 year	(depends upon usage)	____ %	
	Exclusive	(depends upon usage)	____ %	
	Unlimited	(depends upon usage)	____ %	
	Buy-out/All Rights	(depends upon usage)	____ %	

*Digital Imaging list contains figures that should be *added* to original photography fee.

ASSIGNMENT PRICES—ADVERTISING
LOCAL

Base Fee: one year, exclusive	Low	Medium	High	Digital Imaging*	Your Base Fee
Advertorial	$ 2400	$ 2800	$ 5000	$ 2500	$ ☐
Billboard, kiosk, transit display	2000	3200	5000	2000	☐
Catalog:					
Numerous setups/photos per day	1750	2500	5000	2600	☐
Per setup	325	600	900	600	☐
Free-standing inserts	1400	2200	3500	2000–3000	
Magazine:					
Single page	2500	3500	5000	2000	☐
Spread	2900	3800	7500	3200	☐
Cover (back/inside)	3000	3800	10,000		
Newspaper	1700	2250	4000	1700	☐
Packaging	1800	2500	3500	3200	☐
Point of purchase	1700	2550	4000	2800	☐
Television:					
Photomatics	1800	2200	3500	2400	☐
Stills for commercials	1900	2400	3500	2600	☐
Publicity stills	1700	2200	3000	2300	☐

Additional Usage		Multiply by Original Fee		Revised Fee
Insertions:	1 to 3 additional	140%		$ ☐
	4 to 10 additional	170%		☐
	More than 10	240%		☐
Rights:	Reuse after 1 year	(depends upon usage)	☐ %	☐
	Exclusive	(depends upon usage)	☐ %	☐
	Unlimited	(depends upon usage)	☐ %	☐
	Buyout/All Rights	(depends upon usage)	☐ %	☐

*Digital Imaging list contains figures that should be *added* to original photography fee.

ASSIGNMENT PRICES—ADVERTISING
TRADE

Base Fee: one year, exclusive	Low	Medium	High	Digital Imaging*	Your Base Fee
Catalog:					
Numerous setups/photos per day	$ 1800	$ 2300	$ 6000	$ 2400	$
Per setup	275	500	750	4000	
Free-standing inserts	1700	2300	3500	2000–3000	
Magazine:					
Single page	2400	3900	6000	2800	
Spread	3100	3700	9000	4000	
Cover (back/inside)	3100	4300	12,000	3000	
Newspaper	2350	2650	5000	1800	
Packaging	1500	2400	3500	3200	

Additional Usage		Multiply by Original Fee	Revised Fee
Insertions:	1 to 3 additional	150%	$
	4 to 10 additional	200%	
	More than 10	250%	
Rights:	Reuse after 1 year	(depends upon usage) ☐ %	
	Exclusive	(depends upon usage) ☐ %	
	Unlimited	(depends upon usage) ☐ %	
	Buyout/All Rights	(depends upon usage) ☐ %	

***Digital Imaging list contains figures that should be *added* to original photography fee.**

ASSIGNMENT PRICES—CORPORATE

Base Fee: one year, exclusive	Low	Medium	High	Digital Imaging*	Your Base Fee
Annual report:					
Major multinational company	$ 2500	$ 3500	$ 8000	$ 5000	$ ___
National company	1800	2500	7500	2500	___
Small or local company	1500	1800	3500	1000	___
Brochures	1500	2200	3500	2200	___
CD-ROM: used as product, not source of photo clip art	2000	2500	3500	3000	___
House publications:					
Internal: for employees, not as general public relations	1250	1600	3500	1400	___
External: for use as public relations possibly advertising	1800	2100	7000	2100	___
Internal/external: for employees and as promotion	1800	2400	7000	2500	___
Presentation:					
Prints: display in lobbies, trade shows, etc.	1750	2100	3500	2650	___
Slide show: in-house for employees, sales staff, etc.	1100	1800	3500	1400	___
Trade: public relations, advertising, etc.	1800	2200	7000	2500	___
Video: part of a larger video tape production	1800	2400	7000	2800	___
Public relations	1000	1300	7000	2400	___

Additional Usage	Multiply by Original Fee		Revised Fee
Rights: Reuse after 1 year	(depends upon usage)	___ %	$ ___
Exclusive	(depends upon usage)	___ %	___
Unlimited	(depends upon usage)	___ %	___
Buyout/All Rights	(depends upon usage)	___ %	___

*Digital Imaging list contains figures that should be *added* to original photography fee.

ASSIGNMENT PRICES—EDITORIAL

Base Fee: one time, nonexclusive	Low	Medium	High	Digital Imaging*	Your Base Fee
Books:					
Consumer (trade)–picture, general	$ 500	$ 750	$ 1000	$ 800	$
Textbooks, encyclopedias	500	750	1200	800	
CD-ROM (interactive or not)	450	500	1000	800	
Magazines:					
News and general feature	600	800	1500	1000	
Specialty magazines	600	550	1500	1000	
Corporate/house publications—not used for advertising or public relations	800	1000	1500	2200	
Newspapers:					
Daily	500	600	700	800	
Sunday supplements/magazines	600	700	900	800	

Additional Usage		Multiply by Original Fee		Revised Fee
Rights:	Reuse after 1 year	(depends upon usage)	%	$
	Exclusive	(depends upon usage)	%	
	Unlimited	(depends upon usage)	%	
	Buyout/All Rights	(depends upon usage)	%	

***Digital Imaging list contains figures that should be *added* to original photography fee.**

STOCK PRICES—ADVERTISING
ADVERTORIAL

Base Fee: one time, nonexclusive*	¼ Page	½ Page	Full Page	Back Cover	¼ Page	½ Page	Full Page	Back Cover
Circulation								
	$ 500	$ 625	$ 800	$ 1275				
Less than 100,000	550	650	900	1350	$	$	$	$
	600	675	1000	1475				
	600	700	1100	1500				
100,000–500,000	650	750	1150	1700				
	675	775	1275	1900				
	700	800	1325	2100				
500,000–1,000,000	725	850	1400	2200				
	740	875	1500	2300				
	750	900	1500	2300				
1,000,000–3,000,000	825	1050	1800	2500				
	1000	1200	1900	2800				
	1150	1300	2050	3200				
More than 3,000,000	1225	1475	2175	3500				
	1375	1600	2250	3800				

Additional Usage		Multiply by Original Fee		Revised Fee
Insertions:	1 to 3 additional	125%		$
	4 to 10 additional	150%		
	More than 10	175%		
Rights:	Reuse after 1 year	(depends upon usage)	%	
	Exclusive	(depends upon usage)	%	
	Unlimited	(depends upon usage)	%	
	Buyout/All Rights	(depends upon usage)	%	

***Contrary to other types of advertising, advertorials usually appear only in one issue of one magazine.**

STOCK PRICES—ADVERTISING BILLBOARDS

Base Fee: one time, nonexclusive	Up to 6 months	Up to 1 year	Up to 6 months	Up to 1 year
Distribution—locations				
	$ 1600	$ 2500		
Local—city or less than 10	1750	2750	$ _____	$ _____
	2000	3000		
	2000	3000		
Regional—up to 100	3600	4000	_____	_____
	5000	6000		
	3500	5000		
National—over 100	5000	6500	_____	_____
	7000	8500		

Additional Usage		Multiply by Original Fee	Revised Fee
Rights:	Reuse after 1 year	(depends upon usage) _____ %	$ _____
	Exclusive	(depends upon usage) _____ %	_____
	Unlimited	(depends upon usage) _____ %	_____
	Buyout/All Rights	(depends upon usage) _____ %	_____

STOCK PRICES—ADVERTISING BROCHURES/CATALOGS

Base Fee: one time, nonexclusive	¼ Page	½ Page	Full Page	Cover	¼ Page	½ Page	Full Page	Cover
Press Run								
	$ 500	$ 550	$ 700	$ 1250				
Less than 25,000	525	600	750	1500	$	$	$	$
	575	650	1000	1600				
	575	700	800	1650				
25,000–50,000	650	800	1000	1775				
	700	950	1250	1900				
	700	850	1450	2000				
50,000–100,000	850	1000	1550	2500				
	1000	1200	1700	2600				
	850	1150	1400	2700				
100,000–500,000	1000	1300	1800	3200				
	1100	1500	2000	3400				
	1200	1400	2200	3500				
More than 500,000	1450	1750	2500	4000				
	1600	2000	3000	5000				

Additional/Alternative Usage		Multiply by Original Fee		Revised Fee
Double page		(based on full-page fee) 175%		$
Back cover		(based on cover fee) 75%		
Wrap-around cover		(based on cover fee) 125%		
Rights:	Reuse after 1 year	(depends upon usage)	%	
	Exclusive	(depends upon usage)	%	
	Unlimited	(depends upon usage)	%	
	Buyout/All Rights	(depends upon usage)	%	

STOCK PRICES—ADVERTISING

CALENDAR (Usually given away for promotion of product or service. Also see Calendar in Corporate and Miscellaneous sections.)

Base Fee: one time, nonexclusive	Insert Photo	Main Photo	Insert Photo	Main Photo
Distribution	(per photo)	(per photo)		
Single Hanger				
	$ 900	$ 1200		
Less than 50,000	1000	1900	$ _____	$ _____
	1200	2300		
	1500	2200		
More than 50,000	1750	2500	_____	_____
	2000	3000		
Multi-sheet: 12 months				
	600	950		
Less than 50,000	700	1200	_____	_____
	800	1700		
	800	1800		
More than 50,000	900	2000	_____	_____
	1000	2200		
Multi-sheet: 52 weeks				
	500	600		
Less than 50,000	550	650	_____	_____
	600	700		
	600	800		
More than 50,000	650	900	_____	_____
	700	1000		

Additional Usage	Multiply by Original Fee		Revised Fee
Rights: Reuse after 1 year	(depends upon usage)	_____ %	$ _____
Exclusive	(depends upon usage)	_____ %	_____
Unlimited	(depends upon usage)	_____ %	_____
Buyout/All Rights	(depends upon usage)	_____ %	_____

STOCK PRICES—ADVERTISING
MAGAZINES—CONSUMER LOCAL

Base Fee: one insertion, one publication	¼ Page	½ Page	Full Page	Back Cover	¼ Page	½ Page	Full Page	Back Cover
Distribution								
	$ 700	$ 900	$ 1000	$ 3000				
Less than 100,000	775	1000	1450	3500	$ ____	$ ____	$ ____	$ ____
	850	1200	1500	4000				
	900	1000	1500	3500				
100,000–250,000	950	1100	1850	4000	____	____	____	____
	1000	1275	2000	5000				
	1050	1200	1750	5750				
250,000–500,000	1100	1300	2200	6000	____	____	____	____
	1150	1400	2500	6500				
	1100	1300	2200	6000				
More than 500,000	1200	1450	2500	6500	____	____	____	____
	1300	1800	3500	7000				

Additional Usage		Multiply by Original Fee		Revised Fee
Insertions:	1 to 3 additional	125%		$ ____
	4 to 10 additional	150%		____
	More than 10	negotiable	____ %	____
Rights:	Reuse after 1 year	(depends upon usage)	____ %	____
	Exclusive	(depends upon usage)	____ %	____
	Unlimited	(depends upon usage)	____ %	____
	Buyout/All Rights	(depends upon usage)	____ %	____

STOCK PRICES—ADVERTISING
MAGAZINES—CONSUMER REGIONAL

Base Fee:

one insertion, one publication	¼ Page	½ Page	Full Page	Back Cover	¼ Page	½ Page	Full Page	Back Cover
Distribution								
	$ 700	$ 1000	$ 1600	$ 4000				
Less than 250,000	875	1200	1800	5000	$	$	$	$
	1000	1275	2000	5000				
	1100	1325	2150	6000				
250,000–500,000	1200	1400	2300	7000				
	1300	1500	2400	8000				
	1200	1475	2300	7000				
500,000–1,000,000	1300	1550	2500	8000				
	1400	1700	2600	9000				
	1400	1650	2525	8000				
More than 1,000,000	1450	2000	2800	9000				
	1500	2500	3000	10,000				

Additional Usage		**Multiply by Original Fee**		**Revised Fee**
Insertions:	1 to 3 additional	125%		$
	4 to 10 additional	150%		
	More than 10	175%		
Rights:	Reuse after 1 year	(depends upon usage)	%	
	Exclusive	(depends upon usage)	%	
	Unlimited	(depends upon usage)	%	
	Buyout/All Rights	(depends upon usage)	%	

77

STOCK PRICES—ADVERTISING
MAGAZINES—CONSUMER NATIONAL

Base Fee: one insertion, one publication	¼ Page	½ Page	Full Page	Back Cover	¼ Page	½ Page	Full Page	Back Cover
Distribution								
	$ 1000	$ 1300	$ 2100	$ 6000				
Less than 500,000	1100	1400	2300	6500	$ ☐	$ ☐	$ ☐	$ ☐
	1200	1600	2500	7000				
	1200	1475	2300	7000				
500,000–1,000,000	1400	1700	2550	8000	☐	☐	☐	☐
	1600	1900	3000	9000				
	1600	2000	2800	8000				
1,000,000–3,000,000	2000	2350	3150	9000	☐	☐	☐	☐
	2400	2600	3700	10,000				
	2500	3050	3600	10,000				
More than 3,000,000	2700	3750	5100	12,000	☐	☐	☐	☐
	3200	4500	6000	15,000				

Additional Usage		Multiply by Original Fee		Revised Fee
Insertions:	1 to 3 additional	125%		$ ☐
	4 to 10 additional	150%		☐
	More than 10	175%		☐
Rights:	Reuse after 1 year	(depends upon usage)	☐ %	☐
	Exclusive	(depends upon usage)	☐ %	☐
	Unlimited	(depends upon usage)	☐ %	☐
	Buyout/All Rights	(depends upon usage)	☐ %	☐

STOCK PRICES—ADVERTISING
MAGAZINES—TRADE

Base Fee:
one insertion, one publication

Distribution	¼ Page	½ Page	Full Page	Back Cover	¼ Page	½ Page	Full Page	Back Cover
Less than 250,000	$ 750	$ 1800	$ 2500	$ 2500	$ ☐	$ ☐	$ ☐	$ ☐
	875	1825	2600	3000				
	900	1950	2675	3500				
250,000–500,000	950	2000	2800	3000	☐	☐	☐	☐
	1050	2100	2950	4000				
	1150	2150	3175	5000				
500,000–1,000,000	1250	2200	3150	5000	☐	☐	☐	☐
	1300	2250	3275	5500				
	1400	2350	3350	6000				
More than 1,000,000	1500	1750	3375	6000	☐	☐	☐	☐
	1600	2200	3500	7000				
	1700	2400	3600	8000				

Additional Usage		Multiply by Original Fee		Revised Fee
Insertions:	1 to 3 additional	125%		$ ☐
	4 to 10 additional	150%		☐
	More than 10	175%		☐
Rights:	Reuse after 1 year	(depends upon usage)	☐ %	☐
	Exclusive	(depends upon usage)	☐ %	☐
	Unlimited	(depends upon usage)	☐ %	☐
	Buyout/All Rights	(depends upon usage)	☐ %	☐

STOCK PRICES—ADVERTISING
MISCELLANEOUS

Base Fee: one time, nonexclusive	Flat Fee $	% of Normal Fee (*1)	Flat Fee $	% of Normal Fee (*1)
	N/A	50		
Artist Reference (*2)	N/A	75	$ ▢	$ ▢
	N/A	100		
	N/A	50		
Art Rendering (*3)	N/A	75	▢	▢
	N/A	100		
	250	N/A		
Presentation/Layout (*4)	300	N/A	▢	▢
	400	N/A		

Additional Usage

None apply—usage for the above are one-time only

(*1) Percent of the normal fee you would have charged had your photograph been used for the job instead of artwork.

(*2) Use of a photograph, by an artist, for technical and/or detail reference. The resultant artwork will not be so complete as to render the photograph as recognizable within the artwork. See category of use where advertising will appear and charge a percentage.

(*3) Use of a photograph, by an artist, to produce a recognizable rendition. The fee charged may be a percentage of the normal fee as if the photograph had been used in the advertising. See category of use where advertising will appear and charge a percentage.

(*4) Use of a photograph, by an ad agency, for presentation to a client for approval. Reproduction rights, beyond this use, are not granted. If photograph is used in final advertising, see appropriate category for usage fee.

STOCK PRICES—ADVERTISING NEWSPAPERS

Base Fee: one time, nonexclusive	¼ Page	½ Page	Full Page	¼ Page	½ Page	Full Page
Circulation						
	$ 550	$ 900	$ 1400			
Less than 250,000	650	1000	1450	$ ☐	$ ☐	$ ☐
	700	1150	1750			
	700	1100	1800			
250,000–500,000	800	1200	2900	☐	☐	☐
	900	1300	3100			
	950	1350	3200			
More than 500,000	1000	1400	3500	☐	☐	☐
	1200	1575	4000			

Additional Usage		Multiply by Original Fee		Revised Fee
Insertions:	1 additional	125%		$ ☐
	2 to 7 additional	175%		☐
	8 to 28 additional	200%		☐
	More than 28	negotiable	☐ %	☐
Rights:	Reuse after 1 year	(depends upon usage)	☐ %	☐
	Exclusive	(depends upon usage)	☐ %	☐
	Unlimited	(depends upon usage)	☐ %	☐
	Buyout/All Rights	(depends upon usage)	☐ %	☐

STOCK PRICES—ADVERTISING PACKAGING

Base Fee: one time, nonexclusive	Spot Use	Major Use	Overall Design		Spot Use	Major Use	Overall Design
Distribution							
	$ 800	$ 2000	$ 3000				
Local	1000	2500	3500		$ _____	$ _____	$ _____
	1100	3000	4000				
	1200	2500	3500				
Regional	1400	3100	4200		_____	_____	_____
	1800	3400	4400				
	1400	4000	5000				
National	1800	4500	6000		_____	_____	_____
	2000	5000	7000				
	600	1500	2500				
Test	800	2000	3000		_____	_____	_____
	1600	2400	3500				

Additional Usage		Multiply by Original Fee		Revised Fee
Rights:	Reuse after 1 year	(depends upon usage)	_____ %	$ _____
	Exclusive	(depends upon usage)	_____ %	_____
	Unlimited	(depends upon usage)	_____ %	_____
	Buyout/All Rights	(depends upon usage)	_____ %	_____

STOCK PRICES—ADVERTISING
POINT OF PURCHASE

Base Fee: one time, nonexclusive	Spot Use	Major Use	Overall Design	Spot Use	Major Use	Overall Design
Distribution/Press Run						
	$ 625	$ 1000	$ 1100			
Local (under 10,000)	725	1300	1200	$	$	$
	800	1600	1900			
	750	1500	2200			
Regional (10–25,000)	900	1700	2400			
	1250	1800	2900			
	1500	2000	2500			
National (over 25,000)	1850	2350	3500			
	2000	3000	5000			

Additional Usage		Multiply by Original Fee		Revised Fee
Rights:	Reuse after 1 year	(depends upon usage)	%	$
	Exclusive	(depends upon usage)	%	
	Unlimited	(depends upon usage)	%	
	Buyout/All Rights	(depends upon usage)	%	

83

STOCK PRICES—ADVERTISING

POSTERS (Although they may be sold, the intent is to advertise a product or service.)

Base Fee: one time, nonexclusive	U.S.	World	U.S.	World
Press Run: 16″ x 20″ or smaller				
Less than 10,000	$ 1250	$ 1500	$ ____	$ ____
	1325	1800		
	1350	2500		
10,000–50,000	1400	1600	____	____
	1475	2800		
	1550	3200		
More than 50,000	1575	2000	____	____
	1750	3200		
	1900	4500		
Press Run: larger than 16″ x 20″				
Less than 10,000	1425	1900	____	____
	1500	2500		
	1600	2700		
10,000–50,000	1650	1900	____	____
	1800	3100		
	1950	3500		
More than 50,000	2025	2600	____	____
	2100	3800		
	2200	5000		

Additional Usage		**Multiply by Original Fee**		**Revised Fee**
Rights:	Reuse after 1 year	(depends upon usage)	____ %	$ ____
	Exclusive	(depends upon usage)	____ %	____
	Unlimited	(depends upon usage)	____ %	____
	Buyout/All Rights	(depends upon usage)	____ %	____

STOCK PRICES—ADVERTISING
TELEVISION—COMMERCIALS

Base Fee: nonexclusive	Local/Cable	Regional	National	Local/Cable	Regional	National
Circulation						
	$ 550	$ 700	$ 800			
1 month	600	750	900	$ []	$ []	$ []
	650	850	1000			
	660	900	1100			
1 cycle/13 weeks	750	1000	1200	[]	[]	[]
	850	1150	1300			
	900	1100	1400			
2 cycles/26 weeks	1000	1200	1500	[]	[]	[]
	1100	1300	1700			
	1250	1300	2200			
1 year/52 weeks	1400	1500	2300	[]	[]	[]
	1500	1800	2400			

Additional/Alternative Usage		Multiply by Original Fee	Revised Fee
Public service announcement/commercial		75%	$ []
Test:	on-air	75%	[]
	off-air	50%	[]
Rights:	Reuse after 1 year	(depends upon usage) []%	[]
	Exclusive	(depends upon usage) []%	[]
	Unlimited	(depends upon usage) []%	[]
	Buyout/All Rights	(depends upon usage) []%	[]

85

STOCK PRICES—CORPORATE
ANNUAL REPORTS

Base Fee: one time, nonexclusive	¼ Page	½ Page	Full Page	Cover	¼ Page	½ Page	Full Page	Cover
Distribution								
	$ 450	$ 550	$ 800	$ 1250				
Less than 50,000	500	600	900	1300	$ ____	$ ____	$ ____	$ ____
	600	750	1100	1600				
	600	800	1100	1800				
50,000–100,000	700	900	1300	2000	____	____	____	____
	900	1000	1400	2400				
	950	950	1400	2500				
100,000–1,000,000	1000	1025	1500	2700	____	____	____	____
	1150	1275	1700	2950				
	1000	1100	1650	2750				
More than 1,000,000	1150	1200	1800	3400	____	____	____	____
	1200	1300	2000	3600				

Additional/Alternative Usage	Multiply by Original Fee		Revised Fee
Double page	(based on full-page fee) 175%		$ ____
Back cover	(based on cover fee) 85%		____
Wrap-around cover	(based on cover fee) 150%		____
Rights: Reuse after 1 year	(depends upon usage)	____ %	____
Exclusive	(depends upon usage)	____ %	____
Unlimited	(depends upon usage)	____ %	____
Buyout/All Rights	(depends upon usage)	____ %	____

STOCK PRICES—CORPORATE
AUDIOVISUAL (in-house use only)

Base Fee: one time, nonexclusive	1 Showing	1 Showing
Number of Images	(per photo)	(per photo)
1	$ 200 250 300	$ []
2–25	175 200 225	[]
25–100	125 150 175	[]
over 100	75 100 125	[]

Additional/Alternative Usage		Multiply by Original Fee		Revised Fee
Trade slide show (for promotion)		175%		$ []
Extra showings:	2–10	140%		[]
	More than 10	150%		[]
	Up to 1 year	170%		[]
Rights:	Reuse after 1 year	(depends upon usage)	[] %	[]
	Exclusive	(depends upon usage)	[] %	[]
	Unlimited	(depends upon usage)	[] %	[]
	Buyout/All Rights	(depends upon usage)	[] %	[]

87

STOCK PRICES—CORPORATE CALENDAR*

Base Fee: one time, nonexclusive	**Insert Photo**	**Main Photo**	**Insert Photo**	**Main Photo**
Distribution	(per photo)	(per photo)		
Single Hanger				
	$ 600	$ 1125		
Less than 50,000	700	1725	$ ____	$ ____
	800	1900		
	800	2100		
More than 50,000	900	2600	____	____
	1000	2700		
Multi-sheet: 12 months				
	600	900		
Less than 50,000	700	1250	____	____
	800	1550		
	700	1675		
More than 50,000	800	1750	____	____
	900	1900		
Multi-sheet: 52 weeks				
	400	700		
Less than 50,000	500	750	____	____
	600	900		
	500	975		
More than 50,000	600	1100	____	____
	700	1250		

Additional Usage			**Multiply by Original Fee**		**Revised Fee**
Rights:	Reuse after 1 year		(depends upon usage)	____ %	$ ____
	Unlimited		(depends upon usage)	____ %	____
	Exclusive		(depends upon usage)	____ %	____
	Buyout/All Rights		(depends upon usage)	____ %	____

Royalties: After a 50,000-copy press run, charge the following cents per calendar: Promotional, $0.50 ____ ; Resale, $0.75 ____

***Primary use is promotion; if sold, royalty fees may apply. Also see Posters in Advertising and Miscellaneous.**

STOCK PRICES—CORPORATE
HOUSE PUBLICATION—EXTERNAL (promotional/public relations)

Base Fee: one time, nonexclusive	¼ Page	½ Page	Full Page	Cover	¼ Page	½ Page	Full Page	Cover
Circulation								
	$ 350	$ 400	$ 550	$ 900				
Less than 25,000	450	450	700	1100	$	$	$	$
	500	500	1000	1500				
	400	450	675	1100				
25,000–50,000	500	525	700	1300				
	600	550	800	1400				
	525	550	775	1200				
50,000–100,000	600	600	825	1400				
	700	800	950	1500				
	500	600	900	1300				
More than 100,000	800	1200	1275	1800				
	1200	1800	2000	3000				

Additional/Alternative Usage	Multiply by Original Fee		Revised Fee
Double page	(based on full-page fee) 175%		$
Back cover	(based on cover fee) 80%		
Wrap-around cover	(based on of cover fee) 150%		
Rights: Reuse after 1 year	(depends upon usage)	%	
Exclusive	(depends upon usage)	%	
Unlimited	(depends upon usage)	%	
Buyout/All Rights	(depends upon usage)	%	

89

STOCK PRICES—CORPORATE
HOUSE PUBLICATION—INTERNAL (employees only)

Base Fee: one time, nonexclusive	¼ Page	½ Page	Full Page	Cover	¼ Page	½ Page	Full Page	Cover
Circulation								
	$ 250	$ 300	$ 375	$ 600				
Less than 5,000	300	350	450	700	$⬚	$⬚	$⬚	$⬚
	350	400	600	800				
	275	325	450	700				
5,000–25,000	325	400	550	800	⬚	⬚	⬚	⬚
	350	450	650	900				
	300	350	525	775				
25,000–50,000	325	450	600	850	⬚	⬚	⬚	⬚
	400	525	675	950				
	350	400	600	1100				
50,000–100,000	350	500	650	1200	⬚	⬚	⬚	⬚
	400	550	700	1400				
	375	425	625	1400				
More than 100,000	400	500	675	1800	⬚	⬚	⬚	⬚
	500	600	725	2200				

Additional/Alternative Usage		Multiply by Original Fee		Revised Fee
Double page		(based on full-page fee) 175%		$⬚
Back cover		(based on cover fee) 75%		⬚
Wrap-around cover		(based on cover fee) 150%		⬚
Rights:	Reuse after 1 year	(depends upon usage)	⬚ %	⬚
	Exclusive	(depends upon usage)	⬚ %	⬚
	Unlimited	(depends upon usage)	⬚ %	⬚
	Buyout/All Rights	(depends upon usage)	⬚ %	⬚

STOCK PRICES—CORPORATE POSTERS*

Base Fee: one time, nonexclusive	U.S.	World	U.S.	World
Press Run: 16″ x 20″ or smaller				
	$ 975	$ 1100		
Less than 10,000	1100	1300	$ _____	$ _____
	1150	1425		
	1200	1375		
10,000–50,000	1375	1500	_____	_____
	1500	1625		
	1425	1550		
More than 50,000	1500	1680	_____	_____
	1650	1875		
Press Run: larger than 16″ x 20″				
	1050	1375		
Less than 10,000	1225	1500	_____	_____
	1300	1625		
	1375	1550		
10,000–50,000	1425	1680	_____	_____
	1725	1875		
	1675	1800		
More than 50,000	1800	2000	_____	_____
	1925	2200		

Additional Usage		Multiply by Original Fee		Revised Fee
Rights:	Reuse after 1 year	(depends upon usage)	_____ %	$ _____
	Unlimited	(depends upon usage)	_____ %	_____
	Exclusive	(depends upon usage)	_____ %	_____
	Buyout/All Rights	(depends upon usage)	_____ %	_____

Royalties: After a 50,000-copy press run, add the following per poster: Promotional, $0.50 _____; Resale, $0.75 _____

***Primary use is promotion; if sold, royalty fees may apply. Also see Posters in Advertising and Miscellaneous.**

91

STOCK PRICES—CORPORATE RECORDING—PROMOTIONAL*

Base Fee: one time, nonexclusive	Tapes/CDs/Laser Disks	Tapes/CDs/Laser Disks
Back cover	$ 575 800 1200	$ []
Front cover	700 1200 1600	[]
Wrap-around cover	1000 1600 2000	[]
Enclosures	350 600 750	[]

Additional/Alternative Usage	Multiply by Original Fee		Revised Fee
Tests	70%		$ []
Usage on both tape and CD	125%		[]
Rights: Reuse after 1 year	(depends upon usage)	[] %	[]
Exclusive	(depends upon usage)	[] %	[]
Unlimited	(depends upon usage)	[] %	[]
Buyout/All Rights	(depends upon usage)	[] %	[]

Royalties: after _____ -copy press run, add the following per unit: $ []

***Primary use is promotion; if sold, royalty fees may apply. Also see Calendar in Advertising and Miscellaneous.**

STOCK PRICES—EDITORIAL
BOOKS—CONSUMER/TRADE

Base Fee: one time, nonexclusive	¼ Page	½ Page	Full Page	Cover	¼ Page	½ Page	Full Page	Cover
Hardcover, including Trade Books								
	$250	$275	$400	$1000				
Less than 40,000	275	325	450	1200	$ ____	$ ____	$ ____	$ ____
	300	375	475	1700				
	275	325	450	1500				
More than 40,000	300	375	525	1700	____	____	____	____
	325	400	600	2000				
Picture Books								
	400	500	900	1200				
Less than 40,000	500	600	1000	1500	____	____	____	____
	600	700	1100	1800				
	600	700	1000	1500				
More than 40,000	700	800	1100	2500	____	____	____	____
	800	900	1200	3000				
Paperback Books								
	225	275	350	800				
Less than 40,000	275	325	450	900	____	____	____	____
	300	375	600	1000				
	275	300	500	1000				
More than 40,000	325	350	600	1200	____	____	____	____
	375	425	700	1300				

Additional/Alternative Usage	Multiply by Original Fee	Revised Fee	Additional/Alternative Usage	Multiply by Original Fee	Revised Fee
Author head shot	(depends on usage) ____ %	$ ____	Wrap-around cover	(based on cover fee) 150%	$ ____
Chapter openers	125%	____	**Book Rights:**		
Double page	175%	____	Distribute U.S. edition abroad	150%	____
Dummy books	75%	____	One-time world rights: one language	200%	____
Revisions	75%	____	Each additional language	125%	____
Unit openers/frontispiece	125%	____	All languages	250%	____

STOCK PRICES—EDITORIAL
BOOKS—EDUCATIONAL

Base Fee: one time, nonexclusive	¼ Page	½ Page	Full Page	Cover	¼ Page	½ Page	Full Page	Cover
Encyclopedia	$ 225	$ 275	$ 375	$ 800				
Less than 40,000	275	350	425	1100	$⬚	$⬚	$⬚	$⬚
	300	400	500	1300				
	250	300	400	900				
More than 40,000	325	350	475	1200	⬚	⬚	⬚	⬚
	375	425	550	1400				
Textbooks								
	225	225	325	750				
Less than 40,000	275	275	400	1100	⬚	⬚	⬚	⬚
	325	350	500	1300				
	225	250	350	900				
More than 40,000	300	325	550	1300	⬚	⬚	⬚	⬚
	350	375	625	1500				
Textbook Supplementary Materials								
				700				
Cassette/CD Cover				850	⬚	⬚	⬚	⬚
				900				
Instructor's Manual/Study Guide/Workbook*								
	75	175	200	700				
More than 40,000	100	225	250	800	⬚	⬚	⬚	⬚
	125	300	350	900				

Additional/Alternative Usage	Multiply by Original Fee		Revised Fee
Variables are the same as for consumer books (see previous page)			
Rights: Reuse after 1 year	(depends upon usage)	⬚ %	$⬚
Exclusive	(depends upon usage)	⬚ %	⬚
Unlimited	(depends upon usage)	⬚ %	⬚
Buyout/All Rights	(depends upon usage)	⬚ %	⬚

***Fees shown apply if photos are the same as in textbooks; if new, or if study guide is not free distribution, price same as or no less than 75% of textbook fee.**

STOCK PRICES—EDITORIAL
CD-ROM DISK (not for retail sale)

Base Fee: one time, nonexclusive	1–10 Images	1–10 Images
Number of Pressings	(per photo)	(per photo)
Less than 10,000	$ 200 250 300	$ []
10,000–50,000	250 300 350	[]
More than 50,000	300 350 400	[]
Test pressing less than 1,000	200 250 300	[]

Additional/Alternative Usage		Multiply by Original Fee		Revised Fee
Number of Images:	10–50	90%		$ []
	50–100	80%		[]
	over 100	Negotiable	[] %	[]
Rights:	Reuse after 1 year	(depends upon usage)	[] %	[]
	Exclusive	(depends upon usage)	[] %	[]
	Unlimited	(depends upon usage)	[] %	[]
	Buyout/All Rights	(depends upon usage)	[] %	[]

Royalties: After a 10,000-copy press run, add the following per disk: $0.05 []

WARNING: Since these photos are intended for education, and not reproduction, do NOT allow photographs to be saved on disk at more than 72 dpi or larger than 3½″ × 5″ in on-screen size. NEVER enter into an agreement involving digital imaging UNTIL you fully understand the relationship between digital image resolution and image or file size.

STOCK PRICES—EDITORIAL
DISPLAY PRINTS* (Public locations—business, stores)

Base Fee: one time, nonexclusive	Exhibit Fee	Exhibit Fee
Exhibit **/Decorative Fine Prints		
	$ 500	
1	600	$ [____]
	700	
	800	
2–4	900	[____]
	1000	
	1000	
More than 5	1250	[____]
	1500	
	1500	
Permanent exhibition (per print)	2000	[____]
	2500	
	1200	
Traveling exhibition (1 year, per print)	1400	[____]
	1600	

Additional/Alternative Usage	Multiply by Original Fee		Revised Fee
Personal—home & office use	75%		$ [____]
Print size: Smaller than 16″ × 20″	75%		[____]
Larger than 16″ × 20″	150%		[____]
Rights: Reuse after 1 year	(depends upon usage)	[____] %	[____]
Exclusive	(depends upon usage)	[____] %	[____]
Unlimited	(depends upon usage)	[____] %	[____]
Buyout/All Rights	(depends upon usage)	[____] %	[____]

***These prints are for exhibit only; if for retail sale, see Miscellaneous .**

****Exhibit Fee assumes public is charged admission fee. If not, lower fee by 10–15%.**

STOCK PRICES—EDITORIAL
MAGAZINES—TRADE

Base Fee: one time, nonexclusive	¼ Page	½ Page	Full Page	Cover	¼ Page	½ Page	Full Page	Cover
Circulation								
	$ 200	$ 300	$ 500	$ 900				
Less than 50,000	250	350	550	1100	$	$	$	$
	275	400	600	1200				
	250	350	550	1025				
50,000–100,000	300	400	575	1200				
	350	450	650	1500				
	300	350	700	1200				
100,000–250,000	350	400	775	2000				
	400	500	825	2500				
	350	450	750	2000				
250,000–500,000	400	525	850	2500				
	450	575	950	3000				
	400	525	850	3000				
More than 500,000	450	575	950	4000				
	500	650	1000	5000				

Additional/Alternative Usage	Multiply by Original Fee		Revised Fee
Double page (spread)	(based on full-page fee) 175%		$
Back/Inside cover	(based on cover fee) 70%		
Rights: Reuse after 1 year	(depends upon usage)	%	
Exclusive	(depends upon usage)	%	
Unlimited	(depends upon usage)	%	
Buyout/All Rights	(depends upon usage)	%	

97

STOCK PRICES—EDITORIAL
MAGAZINES—CONSUMER

Base Fee: one time, nonexclusive	¼ Page	½ Page	Full Page	Cover	¼ Page	½ Page	Full Page	Cover
Circulation								
	$ 250	$ 325	$ 600	$ 1000				
Less than 100,000	275	400	625	1100	$ []	$ []	$ []	$ []
	325	450	675	1725				
	300	400	675	1525				
100,000–500,000	375	475	725	2000	[]	[]	[]	[]
	400	525	825	2500				
	375	500	800	2500				
500,000–1,000,000	400	550	825	3000	[]	[]	[]	[]
	450	650	925	3500				
	450	550	950	1875				
1,000,000–3,000,000	475	575	1025	1925	[]	[]	[]	[]
	525	700	1100	4000				
	500	575	1025	2100				
More than 3,000,000	575	625	1200	2500	[]	[]	[]	[]
	700	800	1300	6000				

Additional/Alternative Usage	Multiply by Original Fee		Revised Fee
Double page (spread)	(based on full-page fee) 175%		$ []
Back/Inside cover	(based on cover fee) 70%		[]
Rights: Reuse after 1 year	(depends upon usage)	[] %	[]
Exclusive	(depends upon usage)	[] %	[]
Unlimited	(depends upon usage)	[] %	[]
Buyout/All Rights	(depends upon usage)	[] %	[]

STOCK PRICES—EDITORIAL
MAGAZINES—DUMMY

Base Fee: one time, nonexclusive	¼ Page	½ Page	Full Page	Cover	¼ Page	½ Page	Full Page	Cover
Copies Printed								
	$ 100	$ 150	$ 200	$ 400				
1	125	175	250	500	$ ____	$ ____	$ ____	$ ____
	150	200	300	575				
	150	200	250	500				
2–250	200	250	300	575	____	____	____	____
	250	300	375	625				
	200	250	300	600				
More than 250	250	300	375	700	____	____	____	____
	300	350	425	800				

Additional/Alternative Usage		Multiply by Original Fee		Revised Fee
Double page (spread)		(based on full-page fee) 175%		$ ____
Back/Inside cover		(based on cover fee) 70%		____
Rights:	Reuse after 1 year	(depends upon usage)	____ %	____
	Exclusive	(depends upon usage)	____ %	____
	Unlimited	(depends upon usage)	____ %	____
	Buyout/All Rights	(depends upon usage)	____ %	____

STOCK PRICES—EDITORIAL
MISCELLANEOUS

Base Fee: one time, nonexclusive	Flat Fee	% of Normal Fee (*1)	Flat Fee	Fee based on % of Normal Fee (*1)
	$ 150	N/A		
Artist Reference (*2)	200	75	$ _____	$ _____
	272	N/A		
	N/A	N/A		
Art Rendering (*3)	N/A	75	_____	_____
	N/A	N/A		
	175	N/A		
Presentation/Layout (*4)	200	N/A	_____	_____
	250	N/A		

Additional Usage: Not applicable—usage for the above is one time only

(*1) Percent of normal fee you would have charged had your photograph been used for the job instead of artwork.

(*2) Use of a photograph, by an artist, for technical and/or detail reference. The resultant artwork will not be so complete as to render the photograph as recognizable within the artwork.

(*3) Use of a photograph, by an artist, to produce a recognizable rendition. The fee charged may be a percentage of the normal fee. See category of use where work will appear, and charge a percentage depending upon how it may be used.

(*4) Use of a photograph for presentation for approval. Reproduction rights, beyond this use, are not granted. If photograph is used in advertising, see appropriate Advertising category for usage fee.

STOCK PRICES—EDITORIAL
MULTIMEDIA/AUDIOVISUAL (non-commercial, in-house use only)

Base Fee: one time, nonexclusive	1 Showing	1 Showing
Slide Show Images	(per photo)	(per photo)
1	$ 200 250 275	$ []
2–25	175 200 250	[]
25–100	150 175 200	[]
More than 100	100 125 150	[]
Stills in Filmstrips/Video		
1	175 200 225	[]

Additional Usage		Multiply by Original Fee		Revised Fee
Showings:	2–10	125%		$ []
	More than 10	175%		[]
	Up to 1 year	200%		[]
Additional images (filmstrips/video):				
	2–10	125%		[]
	More than 10	175%		[]
Rights:	Reuse after 1 year	(depends upon usage)	[] %	[]
	Exclusive	(depends upon usage)	[] %	[]
	Unlimited	(depends upon usage)	[] %	[]
	Buyout/All Rights	(depends upon usage)	[] %	[]

STOCK PRICES—EDITORIAL NEWSPAPERS

Base Fee: one time, nonexclusive	¼ Page	½ Page	Full Page	Cover	¼ Page	½ Page	Full Page	Cover
Circulation—Daily								
	$ 225	$ 250	$ 300	$ 600				
Under 100,000	250	300	350	650	$ _____	$ _____	$ _____	$ _____
	275	350	400	700				
	250	325	500	650				
100,000–500,000	275	375	550	700	_____	_____	_____	_____
	300	400	600	750				
	300	400	600	800				
Over 500,000	325	425	650	850	_____	_____	_____	_____
	375	450	700	900				
Sunday Supplements								
	300	350	500	850				
Under 1,000,000	350	400	600	900	_____	_____	_____	_____
	400	450	700	950				
	350	400	600	1100				
1,000,000–3,000,000	400	475	700	1175	_____	_____	_____	_____
	425	525	800	1275				
	400	450	800	1325				
Over 3,000,000	450	500	900	1350	_____	_____	_____	_____
	500	550	975	1400				

Additional/Alternative Usage	Multiply by Original Fee		Revised Fee
Double page	(based on full-page fee) 175%		$ _____
Rights: Reuse after 1 year	(depends upon usage)	_____ %	_____
Exclusive	(depends upon usage)	_____ %	_____
Unlimited	(depends upon usage)	_____ %	_____
Buyout/All Rights	(depends upon usage)	_____ %	_____

STOCK PRICES—EDITORIAL
RECORDINGS—EDUCATIONAL

Base Fee: one time, nonexclusive	Tapes/CDs/Laser Disks	Tapes/CDs/Laser Disks
Back cover	$ 500 750 1050	$ ☐
Front cover	700 1150 1450	☐
Wrap–around cover	1000 1500 1700	☐
Enclosures	300 400 500	☐

Additional/Alternative Usage		Multiply by Original Fee		Revised Fee
Tests		60%		$ ☐
Usage on both tape and CD		150%		☐
Rights:	Reuse after 1 year	(depends upon usage)	☐ %	☐
	Exclusive	(depends upon usage)	☐ %	☐
	Unlimited	(depends upon usage)	☐ %	☐
	Buyout/All Rights	(depends upon usage)	☐ %	☐

103

STOCK PRICES—EDITORIAL TELEVISION

Base Fee: one time (or a specific period), nonexclusive

Area of coverage	Local	Regional	National	Local	Regional	National
	$ 250	$ 300	$ 400	$ ___	$ ___	$ ___
Editorial use	300	350	500	___	___	___
	400	500	600	___	___	___

Months of usage*	Less than 2	2–6	More than 6			
	200	400	600	___	___	___
Background editorial	250	500	700	___	___	___
	300	600	800	___	___	___

Additional Usage		Multiply by Original Fee		Revised Fee
Rights:	Reuse after 1 year	(depends upon usage)	___ %	$ ___
	Exclusive	(depends upon usage)	___ %	___
	Unlimited	(depends upon usage)	___ %	___
	Buyout/All Rights	(depends upon usage)	___ %	___

*Editorial use is usually one-time use; if usage is for a period of time, make sure that it is for editorial use—if for advertising or promotion (especially for station promo), see Advertising.

STOCK PRICES—MISCELLANEOUS AUDIOVISUAL

Base Fee: one time, nonexclusive	**1 Showing**	**1 Showing**
Number of Slide Show Images	(per photo)	(per photo)
	$ 200	
1	250	$ ☐
	275	
	175	
2–25	200	☐
	250	
	150	
25–100	175	☐
	200	
	100	
More than 100	125	☐
	150	
Stills in Filmstrips/Video		
	175	
1	200	☐
	225	

Additional Usage		**Multiply by Original Fee**		**Revised Fee**
Shows:	2–10	125%		$ ☐
	More than 10	175%		☐
	Up to 1 year	200%		☐
Additional images (filmstrips/video):				
	2–10	125%		☐
	More than 10	175%		☐
Rights:	Reuse after 1 year	(depends upon usage)	☐ %	☐
	Exclusive	(depends upon usage)	☐ %	☐
	Unlimited	(depends upon usage)	☐ %	☐
	Buyout/All Rights	(depends upon usage)	☐ %	☐

105

STOCK PRICES—MISCELLANEOUS CALENDAR*

Base Fee: one time, nonexclusive	**Insert Photo**	**Main Photo**	**Insert Photo**	**Main Photo**
Distribution	(per photo)	(per photo)		
Single Hanger				
	$ 500	$ 800	$ ☐	$ ☐
Less than 50,000	700	1200		
	800	1500		
	800	1600		
More than 50,000	850	1900	☐	☐
	900	2300		
Multi-sheet: 12 months				
	450	800		
Less than 50,000	600	1075	☐	☐
	750	1200		
	650	1300		
More than 50,000	800	1850	☐	☐
	1050	2100		
Multi-sheet: 52 weeks				
	400	450		
Less than 50,000	500	600	☐	☐
	600	950		
	500	800		
More than 50,000	700	950	☐	☐
	800	1200		

Additional Usage	**Multiply by Original Fee**		**Revised Fee**
Rights: Reuse after 1 year	(depends upon usage)	☐ %	$ ☐
Unlimited	(depends upon usage)	☐ %	☐
Exclusive	(depends upon usage)	☐ %	☐
Buyout/All Rights	(depends upon usage)	☐ %	☐

Royalties: After a 50,000-copy press run, add the following cents per calendar: Promotional, $0.50 ☐ ; Resale, $0.75 ☐

***If calendars are sold, royalty fees may apply. Also see Calendar in Advertising and Corporate.**

STOCK PRICES—MISCELLANEOUS
CARDS—GREETING & POST

Base Fee: one time, nonexclusive	Fee*	Fee*
Greeting Cards	$ 575	
Retail sale	700	$ []
	800	
	800	
Advertising or promotional use	900	[]
(or see Advertising—brochure rates)	1000	
Postcards		
	600	
Retail sale	700	[]
	800	
	800	
Advertising or promotional use	900	[]
(or see Advertising—brochure rates)	1000	

Additional Usage		Multiply by Original Fee		Revised Fee
Rights:	Reuse after 1 year	(depends upon usage)	[] %	$ []
	Exclusive	(depends upon usage)	[] %	[]
	Unlimited	(depends upon usage)	[] %	[]
	Buyout/All Rights	(depends upon usage)	[] %	[]

Royalties: After a 10,000-copy press run, add the following cents per card: promotional, $0.10 [] ; resale, $0.50 []
***Press run, Distribution and Translation Rights requests will affect Fees significantly.**

STOCK PRICES—MISCELLANEOUS
CD-ROM—CONSUMER (retail sale)

Base Fee: one time, nonexclusive	1–10 Images	10–50 Images	50–100 Images	over 100 Images	1–10 Images	10–50 Images	50–100 Images	over 100 Images
Press Run	(all per photo)				(all per photo)			
	$ 400	$ 300	$ 250	$ 200				
Less than 10,000	475	350	300	250	$	$	$	$
	500	400	375	300				
	500	375	350	275				
10,000–50,000	550	450	400	325				
	600	500	450	375				
	600	525	400	300				
More than 50,000	675	575	450	400				
	700	600	525	475				
Test Pressing								
	350	275	250	200				
Less than 1,000	400	350	300	275				
	450	400	325	300				

Additional Usage	Multiply by Original Fee		Revised Fee
Rights: Reuse after 1 year	(depends upon usage)	[] %	$ []
Exclusive	(depends upon usage)	[] %	[]
Unlimited	(depends upon usage)	[] %	[]
Buyout/All Rights	(depends upon usage)	[] %	[]

Royalties: * After a _____ -copy press run, add the following per disk: promotional, [] ; resale, []

***There were no reported royalty arrangements; however, it is something that should be considered.**

STOCK PRICES–MISCELLANEOUS
DISPLAY PRINTS (Framed reproduction 16″ × 20″)

Base Fee: one time, nonexclusive	Press Run Fee*	% of Retail**	Press Run Fee*	Fee Based on % of Retail**
Reproduction Press Run				
	$ 500	N/A		
Less than 5,000	800	10	$ _____	$ _____
	1000	N/A		
	750	N/A		
5,000–25,000	1200	15	_____	_____
	1700	N/A		
	1500	N/A		
More than 25,000	2000	20	_____	_____
	2400	N/A		

Murals—Length of Display (24″ x 30″ or larger)		Fee	Fee
		800	$ _____
Up to 6 months		1200	_____
		1600	_____
		1200	_____
Up to 1 year (longer periods to be negotiated)		2000	_____
		2400	_____

Additional Usage	**Multiply by Original Fee**		**Revised Fee**
Educational study prints	125%		$ _____
Print size (not murals): Smaller than 16″ × 20″	125%		_____
Larger than 16″ × 20″	150%		_____
Rights: Reuse after 1 year	(depends upon usage)	_____ %	_____
Unlimited	(depends upon usage)	_____ %	_____
Exclusive	(depends upon usage)	_____ %	_____
Buyout/All Rights	(depends upon usage)	_____ %	_____

Royalties: After a 10,000-copy press run, add the following cents per piece: promotional, $1.00 _____ ; resale, $0.75 _____

*If pricing by size of Press Run, also think about royalties.

**If pricing by charging a percentage of the retail sales price be aware that items will be frequently and drastically discounted.

109

STOCK PRICES—MISCELLANEOUS POSTERS—RETAIL*

Base Fee: one time, nonexclusive	U.S.	World	U.S.	World

Press Run: 16″ x 20″

	U.S.	World	U.S.	World
	$ 650	$ 800		
Less than 5,000	700	900	$ _____	$ _____
	775	1250		
	800	1000		
5,000–25,000	950	1200	_____	_____
	1050	1500		
	1025	1250		
More than 25,000	1100	1325	_____	_____
	1200	1750		

Alternative/Additional Usage		Multiply by Original Fee		Revised Fee
Print size:	Smaller than 16″ × 20″	80%		$ _____
	Larger than 16″ × 20″	125%		_____
Rights:	Reuse after 1 year	(depends upon usage)	_____ %	_____
	Exclusive	(depends upon usage)	_____ %	_____
	Unlimited	(depends upon usage)	_____ %	_____
	Buyout/All Rights	(depends upon usage)	_____ %	_____

Royalties: After a 10,000-copy press run, add the following cents per poster: $0.75 _____

*These posters are for retail sale; although they may also promote or advertise a product or service, the intention is to realize profit through sales. Be sure that you understand the main purpose—sales versus promotion—before you come to an agreement. If for promotional or advertising use, see Advertising or Corporate.

110

STOCK PRICES—MISCELLANEOUS
RECORDINGS—RETAIL (Tapes/CDs/Laser Disks)

Base Fee: one time, nonexclusive*	Back	Front	Wrap-Around	Back	Front	Wrap-Around
Press Run						
	$ 600	$ 950	$ 1000			
Less than 5,000	675	1075	1150	$	$	$
	750	1200	1250			
	700	1275	1200			
5,000–10,000	750	1400	1475			
	825	1550	1700			
	1025	1600	1800			
10,000–20,000	1225	1750	1900			
	1300	1825	2000			

Additional Usage	Multiply by Original Fee		Revised Fee
Tests (very small runs only)	150%		$
Usage on both tape and CD	150%		
Rights: Reuse after 1 year	(depends upon usage)	%	
Exclusive	(depends upon usage)	%	
Unlimited	(depends upon usage)	%	
Buyout/All Rights	(depends upon usage)	%	

Royalties:** After a _____ -copy press run, add the following cents per poster: $ ☐

*Price heavily dependent upon print run, shelf life of product, retail price per unit, whether or not recording artist is a major name, as well as the other usual pricing factors.

**Number reporting was too low for accuracy.

STOCK PRICES—MISCELLANEOUS

Base Fee: one time, nonexclusive	Fee*	Fee*
Apparel—shirts, bags	$ 650	$ ☐
Background—movies, TV	1200	☐
Bank checks	900	☐
Credit cards	1200	☐
Life-size personalities	1000	☐
Logo (corporate)	1500	☐
Novelty—tags, etc.	500	☐
Phone book covers	1500–5000	☐
Place mats	600	☐
Plates—mugs, etc.	600	☐
Playing cards	550	☐
Puzzles	750	☐
Stamps	1000	☐
Stationery	600	☐
Other	N/A	☐

Additional Usage		**Multiply by Original Fee**		**Revised Fee**
Rights:	Reuse after 1 year	(depends upon usage)	☐ %	$ ☐
	Unlimited	(depends upon usage)	☐ %	☐
	Exclusive	(depends upon usage)	☐ %	☐
	Buyout/All Rights	(depends upon usage)	☐ %	☐

Royalties:** After a _____ -copy press run, add the following per item: Promotional $ ☐ ; Resale, $ ☐

***Prices for these usage categories varies widely, depending upon project scope, photo uniqueness, and other pricing factors.**
****Not enough data was collected for accuracy.**

The Opportunities and Perils of Electronic Media

Technology is changing photographers' lives in innumerable ways and drastically fast. These days it seems that every article on technology starts or ends with an amalgam of the following thoughts:

- Technological change is truly revolutionary.
- Technology creates exciting new opportunities.
- We must participate or perish.
- There are many grave dangers.
- No one knows exactly where it's going.

What it all comes down to is the simple fact that photographers will have to become knowledgeable about the marriage of digital technology with photography and image making—for the simple reason that it affects not just your art but every aspect of your business.

Because this book is about pricing and negotiating, it is not our intention to cover the complete depth and breadth of the fascinating digital world. What we hope to provide is a framework outlining the major aspects of the electronic world and highlight their importance to the skills of pricing and negotiation. As you embrace digital technology, consider how it can improve your pricing and your profit.

Your Position in the Electronic World

Technology presents great creative opportunities, and it is becoming essential to photo businesses wishing to maintain a strong competitive edge. The important question has shifted from *Will I become involved?* to *In what way will I be involved and to what degree—how much investment is wise, and how will I pay for it?* Let's look at a few of the exciting opportunities technology is making available to image makers:

- Information interchange
- Marketing ease
- New markets
- New photo products and creative services

More specifically, technology now allows you to make major manipulations of images, resulting in exciting new visuals, as well as minor retouching of small imperfections. Now, not only can you do the photography—with image-processing software you can control and profit from post-photography work that once went to others. Online transmission of images to clients and printers affords greater security of original film images, improved service to clients, and additional income possibilities. Greater marketing possibilities are opening up, as are wider markets—from new online publishers to laptop and kiosk multimedia programs for business, education, and entertainment. Instant online research allows you to access travel information, film and equipment prices or reviews, or Better Business Bureau reports to check on client payment problems; these are just a fraction of the advantages of the Internet. Computers speed up mundane tasks like accounting and image retrieval and put greater power into your marketing efforts. They place in your own hands more opportunities for controlling the services your business offers. Integrated software programs combine stock photo management, client contact, accounting, and other valuable features to make computerization of your photography operation as painless as it can be and increase the effectiveness of your time. And, it will only get better.

It is clear that there is an irreversible trend toward a world market. Electronics is very much responsible for the growing democratization of the world's economy; no longer should photographers think only locally. Clients may be found around the world, and certainly your images may be seen worldwide. Photography is a universal language, perhaps the only one. As

such, it has enormous potential and value, but only if you understand and accept the challenges of the twenty-first century.

The purpose of this chapter is to introduce some of the possibilities and pricing opportunities available in the electronic era, while noting some of the perils and offering some ideas to protect your work. Of course, all of the business and negotiating principles outlined in earlier chapters apply here as well. You may be facing new technology, but you are still working in the business world.

Many photographers appear to be willing to remain on the sidelines before becoming involved with new media opportunities, and some have yet to purchase their first computer. Luckily, since this is a world that tolerates diversity and even rewards it in some cases, not everyone will have to become a proficient digital imager or marketer of imagery online. Still, if you don't have at least an understanding of these opportunities, you may be cheating yourself professionally.

One final thought: Don't indefinitely delay your entry into the electronic media world merely because of the cost of equipment or because it changes so fast. The latest and best equipment will always be the most expensive. Jump in; even if only a little bit; once you start swimming you'll warm up.

Electronic Delivery of Images

Photographers must develop their position vis-à-vis the new technologies, even if they decide to not take the plunge immediately. In analyzing your position do not become paralyzed by issues like computer speed, unauthorized image use, and so on. In any new endeavor there always are, and always will be, important issues to resolve. Some issues, like computer speed, will never be settled because technology is ever changing. To blind oneself to the future, simply because a problem has no immediate sure-fire cure, will hurt only you. Technological and legal problems are solved so rapidly that this morning's worry is probably already history.

Theories and schemes currently abound for solving new media uncertainties; here are but two examples illustrating typical problems and possible solutions.

PERCEPTION
Doubts about the financial viability of participation in—and the security of—electronic online distribution and image storage make many photographers unwilling to commit images to online databases and delivery systems.

REALITY

- Digitized images can be encrypted for safe transmission, thus creating an electronic lock on an image file. This makes the image accessible only to the person entrusted with the "key."
- You can demand that online display of your work be run small and at low screen resolution (approximately seventy-two pixels per inch) so that a "screen-dump," an electronic "snapshot" of a monitor displaying your photograph, will not yield an image large enough or of sufficient quality to be worth duplicating or using illicitly. (Pixels are small squares that make up an electronic image, much like the dots that make up halftone images. The fewer there are per inch, the coarser the image will be.)

PERCEPTION
Online transmission speed is slow for large image files, and image quality may be lost.

REALITY

- Modem speeds are increasing as rapidly as prices are tumbling.
- Fiber-optic lines, cable, and satellite dishes foster increased speed and accuracy of image transmission.
- Many photo users are not as concerned with optimum image quality as you probably are. Don't lose an opportunity to make money simply because you have problems with technology: This is business, after all.

Digital Imaging

The term "digital imaging" refers to the processes involving optically scanning and converting photographs into electronic information that is stored on a computer hard drive or on removable media like floppy, optical, Zip, Jaz, or CD-ROM disks. The image files may be viewed on a computer monitor, to be changed at will. Manipulation possibilities are unlimited: Colors may be totally changed, and portions of any photo may be erased, added to, or distorted. By adding digital imaging to your photographic repertoire, you can begin to offer services from simple retouching to skilled manipulations that could never have been captured on film. You are limited only by your imagination (and the copyright of others). Some art directors and users of photography are still not comfortable with this technology, so it may be up to you to challenge them—to provide images that only you can visualize. If you can, these images may well draw significantly higher fees, but only if you are willing to ask for them.

The drawbacks to date (and they bear repeating) are that the equipment needed to become competitive on the upper end is very costly. It is easy to invest thousands, even tens of thousands of dollars. Never entertain thoughts about entering the imaging business until and unless you have also developed a marketing scheme to complement the investment. Never overlook the fact that technological changes will necessitate equipment replacement every three to five years. Still, this is the only way to make images no one else has ever seen or even imagined. An equally valuable benefit, and one you can charge for, is the opportunity to protect original film images. Instead of sending irreplaceable film originals to clients, have the images scanned onto removable media, like a CD-ROM. Do your retouching or manipulations, save the image file to another CD, and turn that over to your client or printer.

New Markets in the New Media

New media markets are areas that never existed before. Your work may appear in CD-ROM format or on the Internet in products such as online magazines, Web site pages, and so on.

Entertainment and educational producers constantly develop new programs for the marketplace, and these presentations voraciously devour content: music, text, illustration, and photography. Photographers who already understand photo books or storytelling with photos may be able to develop their own CD-ROM productions. Others will supply images to professional multimedia producers working for corporations. This chapter of photography is still in its infancy, but it is expected that the demand for still photography and photographers who understand new technologies will be high. Corporations of all kinds will increasingly provide information via new technologies, be it CD-ROM, the Internet, or other media yet to be developed. For example, one major hotel chain produced a proprietary CD-ROM program. Each of its properties nationwide was extensively photographed: exteriors, lobbies, ballrooms, sleeping rooms, restaurants, and so on. Customers needing to book an event or room may view company facilities on a laptop computer, no matter where they are in the world. Programs like this may contain still and motion photography as well as music and voice. Virtually every business or service can find use for products like these for sales, PR, or training purposes—and they all need photographs.

THE WEB SITE AS A MARKET

There are millions of Web sites coming online, but many don't use photographs. More than likely, some of your current clients are thinking about a Web site, but they will only use the graphics recommended by a site developer you've never met. Worse, developers and their client companies too often expect to obtain images for little or no money. It therefore becomes your job to make clients aware that they expect first-class photography for print advertising, and it must be no different with their Web sites—with, of course, the correspondingly higher photo fees expected in advertising.

Photographers who make out best in this area will be those who can generate ideas, sell them to the corporate market, and then produce them. This approach not only can offer total artistic control but possibly can lead to additional Web page design or photo work.

PERILS OF CLIP ART/PHOTO DISKS

Like so many things, technology can be a two-edged sword. The most serious risk associated with CDs and Web site licensing is not the piracy of images but the foolhardiness of photographers who turn their work into "clip art."

CD-ROM "clip disks" are products containing hundreds or even thousands of photographs or other visual art for use at no cost or at very low, virtually give-away prices with few or no rights restrictions. One direct mail catalog, for example, offered a disk containing "2500 royalty free images from top photographers" for a cost of $29.95! Clip disks are also offered as incentives to promote products like computers. Whether for use on CDs or on the Web, some shortsighted photographers have been lured into selling images (this time, the word "selling" and not "licensing" is appropriate, for the images may actually be sold outright) to a clip disk producer, tempted by the immediate cash offered—but at what ultimate cost? Ask yourself: Are you in photography for a quick, few dollars or for your future? By treating your photography as clip art, you effectively reduce the value of all photography and promote the idea of photography as a consumable commodity rather than an art form requiring skill and sensitivity to produce.

ONLINE MARKETING

At this time there are two generally recognized marketing possibilities for publication: displaying a portfolio or displaying and licensing stock images. With time, variations and new ideas will be developed by photographers and other parties, so read as many photo and computer magazines as you can, attend trade shows and seminars, and talk to computer web developers.

Doing It Yourself

You need to couple your enthusiasm with a touch of reality and practicality. It may be tempting to dream about putting your own Web site online, where you will offer photography users your images and/or services as a photographer, but you need to go into this with your eyes open. A Web site can expose your work to licensees worldwide, but do you really have the knowledge and skill to produce and maintain a first class site? Those who cut corners will find little or no repeat searching by photo users. You need to frequently and periodically refresh your site with new photography. Are you ready to take the steps to ensure that your site is recognized by search engines when licensees do keyword searches for images? Are you capable of controlling online marketing and licensing? What about follow-up? Is someone always available to handle negotiations involving more complex rights licensing? How will you obtain payment from licensees worldwide? Licensees you don't know? Can you provide secure transactions so that licensees won't have to worry about computer hackers obtaining credit card numbers or other private information? If you travel, who will be in charge of the site while you are away? If licensing transactions aren't automated, are you willing to get up at three in the morning to deal with someone on the other side of the globe who has an immediate need for one of your images?

Some photographers are profitably handling stock photo licensing online, but the Web has also become a graveyard littered with the bones of undercapitalized and insufficiently planned businesses. Still and all, the Internet will become a greater factor in every home, business, and institution.

WEB SITE PORTFOLIOS

A user must be able to move effortlessly through your Web site. While developing a site, always remember: Art directors won't waste time waiting for fancy Web site graphics to load—they only want to see images. If you are not an expert, use a professional to design your site.

Most photographers who establish Web sites will judge success by how well this strategy translates into income. This is probably shortsighted, as any marketing expert will tell you, because marketing efforts cannot always be directly translated into dollars in your pocket. The results may not be seen for some time, and the success of your site may reveal itself in unknown ways.

ONLINE LICENSING

Increasingly, clients abandon the telephone and photography marketing catalogs in favor of online photography databases. Licensing rights and fees will be negotiated online, and the image will be acquired—all within a few minutes. Many clients

have stopped contacting individual photographers, and absolutely no one waits for days for a photographer to send in a few images.

By tying a database of images to keywords to facilitate image searching, a photographer can offer clients a convenient alternative to traditional photo researching. To obtain license online, the licensee will have to tell the system where, when, and for how long the image will be used and enter a credit card number or other billing information. In return, an image file will be downloaded via modem.

COMPETING WITH THE BIG BOYS

Large commercial firms, like Corbis and Getty, are now licensing online. Their databases contain hundreds of thousands of images and are a tremendous enticement to art directors. If you operate your own Web site, you need to determine how to compete with these sites. Before entering onto what can be the slippery slope of Web site ownership, ask yourself why a photo user would want to spend time locating and accessing a limited stock photo database as opposed to one containing perhaps millions of images by hundreds of photographers from around the world?

- Do you have something unique to offer?
- Will your site be attractive, efficient, and competitive?
- Are your financial resources and commitment strong enough to implement an ongoing, long-term marketing program aimed solely at enticing photo researchers to your Web site? This is a game of numbers after all, and you may have to use U.S. mail, sourcebooks, or other means simply to announce the existence of your Web site.
- Do you have the money to pay for image scanning and to purchase software?
- Do you have someone who will devote hundreds, perhaps thousands, of tedious but vital hours to entering sufficient and appropriate keywords and descriptions for each photograph so that images can actually be found by a photo researcher?

THE UPSIDE

On a more positive note, a home page on the Web may be leased from an ISP at moderate cost or sometimes for free. With some investment in good but not necessarily grandiose design, you can at least have a presence on the Internet, even if it's only to present a few of your images as a portfolio. Never discount the fact that merely having a WWW address may give you credibility with clients and that any sort of visibility may be more and better marketing than you've ever done before. Despite the work a Web site requires, growing numbers of photographers all over the world are establishing them. Be as creative here as you are as a photographer, and you can be a success. This can add value to your pricing.

Using an Agent for Online Licensing

Many photographers will decide not to spend the time or energy that is involved in establishing their own Web site. They may already have a stock agent or will engage one who offers work via the Net.

Agents are working in many ways, from traditional telephone requests and mailed submissions to online licensing and image transmission. When analyzing a relationship with a stock agent, don't forget that this agent will control virtually every aspect of licensing your stock images. You will probably receive no more than 50 percent of the gross sales and possibly even less for online transactions. Some agents may levy charges for scanning or take an increased percentage as a way of paying for technological and online costs. Still, the benefit for photographers is that the agency does most of the work of filing, sorting, sales, marketing, billing, and negotiating, as well as establishing and maintaining the Web site. Much of this work is repetitive, time-consuming, and somewhat costly. Many photographers find that it is much more profitable to spend their time taking photographs than doing administrative chores, and they are glad to turn this work over to an agent.

Electronic Rights

Clients want to pay one fee, which they believe should include print usage and "all electronic uses." Increasingly, you will find

117

that even if a client only mentions print use, electronic uses are also being considered. You need to be mindful that improperly broad licensing terminology could allow use of your photographs without remuneration. The only way to control your property is to insist that clients be specific about what they really need. In order to do this, you must know to ask about factors like product, placement, length of license needed, and so on, and you need to become knowledgeable about electronic rights, uses, and products.

ARE ELECTRONIC RIGHTS DIFFERENT FROM TRADITIONAL RIGHTS?

There is a philosophical question as to whether electronic rights are different from traditional rights. The premise of some has been that electronic rights must be priced lower because the risks of new market development is high, that photographers must share in that risk by lowering fees. Also, there has been a blurring of the traditional concepts of usage areas, long defined as advertising, corporate, and editorial. Even in print, but more so in new media, it is often difficult to know if what you are looking at is educational or promotional, selling something or informing you. Any trend in the new media market toward a one-size-fits-all price that does not recognize the disparate values of advertising, corporate, or editorial use is a dangerous simplification that will inevitably result in an undesirable, general lowering of prices.

Before accepting a producer's premise that new media ventures require new (which always means lower) pricing structures, consider first that your own business costs must always be met. Clients seldom understand or concern themselves with your business and personal needs. Don't allow yourself to be put in a position where you underwrite another's entrepreneurial spirit, unless, of course, the client is willing to agree to a payment system by which you can profit along with the client should the venture prove successful. But don't hold your breath. Always be ready to acknowledge the reality that some producers are simply unwilling or unable to pay appropriate and fair fees. When this occurs, you are then faced with the same choice that's available to you when you are pricing traditional media: Walk away (politely), or lose money.

Still, on occasion, there may be a new media venture that is so exciting or creative that you will be willing to charge a lower fee, but this can't be your general rule. Too many photographers attempt to justify lowering prices by blindly allowing themselves to be convinced there is a pot of gold at the end of the rainbow. You must learn to skillfully walk the tightrope between taking advantage of unique opportunities (that are rare) and merely being exploited. If you do decide to lower prices, always get something in trade, and document it in writing!

Pricing

Unfortunately, many photographers never develop a reasoned approach to dealing with electronic rights, so they crumble in the face of capable negotiators.

Because reliable, accurate, specific prices are not yet well established for electronic uses—and because the authors believe that photographers are best served by pricing based on their own needs and not the client's needs or problems—we have concentrated on pricing philosophy and methodology. It's critical to successful marketing, negotiating, and licensing. Photographers must not succumb to coercion to underwrite Web site experiments by lowering their prices. Apply the same principles to electronic pricing as you would to traditional uses—*and make sure that you always charge enough to sustain a healthy, growing business.*

In addition to pricing electronic reproduction rights, you may encounter a need to price new services or products—flexibility and creativity in pricing will become increasingly important. However, never forget that while digital technology has put new opportunities in the hands of image makers, it comes at a far greater cost than traditional photographic technology. Prices for digital imaging must always be determined in the same businesslike manner required for other photo work, and perhaps with even greater skill. You must know what your overhead is, and because electronic media involve different terminology and ideas, it pays to ask more questions and to use extreme care in developing your pricing.

Here is a real-life situation that illustrates how easy it is to overlook vital questions that must be asked, or to rely on

assumptions or hope. A multimedia client needed travel photos for a CD-ROM. The budget was $200,000 for 2,000 photos, or $100 each. The client found about 500 free photos from government sources, and a photographer who had an extensive collection on the subject area could provide the remainder. The photographer inexplicably negotiated a royalty only agreement because he "believed" in the project and was confident that CD sales would eventually yield at lcast $50 each, or $75,000. It is puzzling that the photographer didn't request a fee or a fee and royalties. After all, the client had budgeted $100 per image but had already acquired 25 percent of the images without charge, leaving $200,000 for the photographer's 1,500 images. Why not remind the client $200,000 was originally budgeted for 2,000 images without reference to the number of submitting photographers. Why did the photographer assume all of the risk on a project that might never generate any sales? Even if the client balked at the thought of giving one photographer the full $200,000, for large licensing volume like this, one might offer a discount of, say, $135,000, or offer to take $100,000 up front plus a royalty based on units shipped. Here was a perfect situation in which the photographer had real clout in the form of a ready supply of needed images, yet it appears he didn't press home his advantage. Always look for different ways to calculate pricing.

DIGITAL IMAGING PRICING

Becoming competitive in this area demands an extensive personal and financial commitment. The work calls for artistic and technical skills the equal of photography, as well as highly expensive equipment. Relentless technological advancement requires constant updating of skills and equipment. Don't be surprised to discover that initial costs may approach $40,000 or more, and you may find it difficult to recover that investment in the very few years before your equipment becomes outdated. Nonethclcss, many find digital imaging to be very rewarding. Some photographers get around the problem of learning digital imaging and making the financial commitment by taking their artistic ideas to someone else, generally a service bureau or a properly equipped photo lab,

to do the computer work under the photographer's guidance. Though still expensive, the costs are passed on to the client, with a markup, of course.

It is worth noting that service bureaus and photo labs are not afraid to charge for their investment. If you decide to take the plunge and purchase your own equipment, you must first commit yourself to aggressively making money with it. If it sits unused, or you end up cutting your rate in the desperate hope of attracting clients, you might as well just put this money in a deep dark hole in the backyard, or send it to us.

If you do decide to add digital imaging to your photography business, you have to be ever cognizant that your overhead commitment has and will become larger. If you don't cover that overhead, the assets of your business may be taken over by the bankruptcy court and your camera and computer equipment sold to pay off what you owe. Consult a lawyer, financial consultant, and insurance agent to find out what kind of business setup is best for you. Separate corporations for your photography business and your imaging business would protect one from the other in case of failure, but good business (and not homeowner!) insurance might be all you need. Check before you begin, however—tomorrow might be too late!

PRICING FACTORS FOR ELECTRONIC USAGE

Photographers need to realize that one of the main pricing issues facing them will be determining a reasonable balance between risk and income, both potential and actual. The greater the amount of actual income received by the photographer (usually in the form of a fixed or guaranteed minimum fee), the less risk he or she is exposed to. Conversely, the greater potential income a project offers but does not guarantee, and/or the longer period that actual income is deferred, the greater the risk becomes.

Note: Risk can take many forms, and the term is loosely used here. It can variously mean risk of nonpayment; risk of low volume sales; or failure to properly produce, market, and distribute a product. Potential, as used here, refers to a venture that can become a significant source of future income.

Remember, a photography price consists of many factors. Your overhead is a quantifiable factor, one that should already

119

have been determined. As explained in other chapters, there are other pricing factors to also consider:

- *Uniqueness of photographs.* Is your style, technique, or artistic ability capable of being translated into additional value?
- *Importance of the photograph(s) to your client.*
- *Availability.* Are you the only photographer who has the images the client wants? Do you have special access to be able to make them?
- *Usage.* How will your client use the photos? Placement, size, and number of uses offer some indication of the importance placed upon them.
- *Distribution.* What is the market where the photographs will appear? Remember, some markets, like advertising, and promotion offer greater return than others.

Once you have accounted for the pricing factors you will be able to derive your fee.

PRICING METHODS: A RECAP

In pricing you are concerned with maximizing return while minimizing risk; your challenge is to develop pricing strategies that help you achieve those goals. These strategies must remain flexible, however, because you are generally not producing a product that is capable of strict control. A manufacturer can precisely determine the exact cost of plastic in a widget, for example, know how many widgets will be sold, and in determining price can apply a percentage of overhead, shipping, handling, and other factors to each finished widget piece. Photographers, on the other hand, will seldom encounter licensing transactions that are perfectly alike. Pricing largely remains a custom exercise, and market pressures and personal needs place demands upon photographers that they often find impossible to reject or ignore.

The following offers insight into various methods of pricing—differing solutions to variable pricing problems. Spend some time thinking about each, play around with them, and don't be afraid to combine more than one method, if needed. Remember, you need to develop solutions for your business that also meet the needs of your clients. Be creative.

Fixed Fee—Low Risk. The fixed or flat fee has been the norm in assignment and stock licensing. This method generally offers the greatest security and is the one you might consider if the client is unknown to you or if the venture looks to be risky in some fashion. (The ability to discern this only comes with experience. If you are new to the business, talk to more experienced practitioners.) Your fee is set and not dependent upon a client's future performance. The flat fee method like any other pricing method must take into account overhead and profit, as well as pricing factors like distribution, production, value to client, and so on. However, while this is a good system for minimizing risk, it doesn't allow for future reward should your photograph(s) be associated with a successful product or other venture.

Royalty—High Risk. Under a royalty only arrangement, photography fees are fully dependent upon product success. This method is often encountered in sales of products like photography books, framed prints, posters, calendars, and greeting cards. Here, the photographer receives either a percentage of each unit or a fixed amount per unit sold or licensed. The percentage or fixed amount can be applied to any number of units from one to thousands of units sold. For example, a multimedia CD-ROM selling in stores for $30 might have a wholesale price of $15. If a 5 percent royalty on the wholesale price is negotiated and 1,000 CDs are sold, a royalty fee of $750 is earned. Or, the royalty amount can be expressed as a fixed amount—say, $0.75 per unit shipped.

Royalties can, for example, be based on the retail or wholesale price, number of units ordered or shipped, profit, and other weird combinations of factors. Keep it simple: base your royalty payments on the number of units shipped, and if this isn't possible then use the wholesale price. Why? When units shipped is the standard, you will typically receive a flat amount per unit shipped, irrespective of the wholesale or retail price. The whole-

sale price of units shipped may be the next best method. Other ways of pricing are not too dependable. The retail price may drop precipitously, so you need to think about tying royalties to dropping prices. Royalties based on profit are too difficult to define or monitor—ask any movie actor who has never been paid by a film studio claiming it didn't make a profit. The best royalty basis for most photographers will be a fixed amount per unit shipped: If the project is a hit, the company probably won't complain about paying you, and if it struggles, you are protected from falling prices or sales.

Generally, the pure royalty structure exposes a photographer to the greatest risk because success remains in the hands of others. Clients may have great intentions but poor implementation in vital areas like marketing, distribution, and sales that can doom any venture. (What if only one hundred units were sold?) Still, you may find it to be the only pricing structure a client, especially one venturing into the uncharted waters of electronic media, will be willing to accept. This kind of pricing strategy is generally not in your best interest. It makes you an inadvertent partner in a venture over which you have little or no control. Instead, try to return some balance to your pricing by negotiating a guaranteed minimum plus a percentage of sales; that is, the combination fixed fee and royalty method.

In negotiating to reduce or remove risk posed by a "pure" royalty structure, don't be afraid to point out that your client contacts probably aren't risking their own wages in the project. Similarly, you can't assume such risk, either. Although it may be tempting, it's probably not wise to offer to share the same level of risk as your client unless you are very sure of the project's success or the client's previous success rate with similar projects.

Combination Fixed Fee and Royalty—Minimizing Risk and Optimizing Potential. In a sliding scale method, combining a fixed fee and royalty payments, a photographer receives a fixed fee and royalty income in the future based on sales or production. This system may serve better in those instances where distribution and/or production are unknown factors or are being estimated, either because of the nature of the venture or because your

client is new to the business. For example, while a photographer might charge $2,500 as a fixed fee, what if the application in question appears to hold considerable potential as a bestseller? Why not charge something less as a guaranteed minimum and charge a royalty for additional use? The client might welcome an initial fee of $2,000 for the first 10,000 copies, $750 additional for the next 10,000, $400 for the next 10,000, and $250 for each additional 10,000 exceeding 30,000 copies. Royalty payments can also be based on some fixed amount or percentage per unit. For example, you might receive $0.50 per unit shipped or 8 percent of the wholesale price. Staying with the previous example, one might negotiate a guaranteed minimum, perhaps $1,500, with a royalty percentage of 10 percent based on the wholesale price. You would receive $1.20 for each $12.00 unit sold by the manufacturer at wholesale.

The tradeoff using the sliding scale method is slightly increased risk for an application that might prove unsuccessful, while still offering the potential for reward if the venture should prove otherwise. Clients might contest this kind of arrangement for a number of reasons. They might claim to need a bottom line price to avoid future uncertainty or "surprises." Simply explain there are no hidden surprises—make your pricing system easy to understand and print out your offer for them. Clients often insist it is too difficult keep track of royalty arrangements. Gently remind them that they have to pay other suppliers in different ways and that any modern company must be capable of monitoring sales and periodically paying you additional sums. Remember, despite what is said, you are really being told that they are either unfamiliar with the idea—so you have to carefully explain it, or that they don't want you to share in their success should it happen. In that case, be prepared to explain how you, too, are also ready to share in some level of the risk by reducing your up-front fee.

A couple of other things to think about: A royalty agreement creates a future obligation, so if you are concerned about the effects of inflation, consider including a contract clause allowing changes in the fee schedule. But don't get too worked up over this issue, unless the economy becomes far less stable.

Before considering any compensation plan that includes royalty payments, you must first try to assess the potential risks:

- Is this product well conceived and produced?
- What level of market research was done in advance to predict project viability?
- Will it be aggressively marketed? How can you be sure?
- Is there a good market strategy? Or, is this just some harebrained scheme?

Remember, the client's failed venture tax write-off may become your financial or photographic loss if you aren't paid or if your images aren't returned.

In sum, put your faith in a project, but always protect your business first and foremost. Always negotiate to receive as much as you can up front, in a fixed fee, and negotiate royalties based on units shipped. Of course, always try to negotiate royalties in addition to an appropriate fixed fee. Go for the gold as much as you can.

ELECTRONIC REPRODUCTION FEES

Detailed pricing of electronic use is not included here because it's an area remaining in a state of flux. Reliable numbers are not yet available for a number of reasons. Few photographers have extensive experience in this area, and even fewer photographers have developed any consistency of approach to electronic pricing. Moreover, to date, pricing in the electronic world appears to be more client than photographer controlled: Clients are dictating the prices they will pay, and too many photographers are tripping over themselves to make any kind of agreement, whether it makes financial sense or not. Nevertheless, the good news appears to be that electronic pricing has begun to improve.

Prices are available from other sources, but the authors believe that those sources may be misleading. We recommend that you develop your own pricing.

The way to use the price charts in this book for electronic pricing is to ask detailed questions of your client. Figure out where the requested work fits within the traditional concepts of

advertising, corporate, or editorial use—it will. Then try to determine how it will be used within that category and refer to the appropriate chart. Choose the amount that you believe is most appropriate as your beginning figure for negotiating, and adjust it as needed, considering the circumstances. For example, if a publisher wants to put a magazine online, refer to the Stock/Editorial/Magazine price chart and price the work according to size and number of "hits" or accesses (i.e., circulation) of the Web site containing the electronic magazine. Or, perhaps a corporation wants you to photograph the annual report for both print and online use. The Assignment/Corporate price chart contains the information you need. You could ask how many "hits" occurred on the client's Web site or annual report Web pages during the previous year. You could add a percentage of your print-based annual report creative fee for the additional online use, or you could price online use as stock in addition to the print assignment.

Remember, the value of your work is not lessened simply because it is produced or transferred electronically instead of physically. In fact, the value of your work is probably increased because of the greater potential for far more people to see it, thereby increasing the overall value of your client's advertisement, corporate communication, or editorial message.

Contracts

Licensing terminology can be a whole other ball game in the electronic media world. You may be presented with a contract containing wide-ranging terms and conditions that far exceed anything required in a print licensing situation. Multimedia is an amalgam of the film and entertainment industries, where projects are not individual but group efforts. Recognizing individual copyright rights in such complex projects can create an entangled network of competing rights, so producers often require transfer of copyright ownership to the production company. The terms and conditions in film and multimedia contracts can snag the imprudent photographer who signs before reading or fully understanding every clause.

So how should you proceed? First, call a lawyer who is copyright knowledgeable. ASMP or one of its chapters can sup-

ply you with lawyers' names. One line of defense may be to not sign the client's contract and instead issue your own terms in your work agreements, delivery memos, and invoices. Make sure that all of your documents have consistent terms and conditions! Make sure that what you and your client agreed to do appears in the document. Missing or different terms may be no more than an oversight, but it may mean you are about to be bamboozled. If clients insist that their forms be used, strike out offending terms with a single line in ink, and replace them with your own language. (Hint: Refer to your own paperwork for terms and conditions language). If any client refuses to honor any terms negotiated earlier, be prepared to walk away and find other clients who will treat you with respect.

"Writing a Usage Rights Statement," in chapter 2, makes clear how very specific and limiting an invoice must be to protect you and your work. If in doubt, consult an attorney knowledgeable about entertainment and intellectual property law.

There are some overreaching phrases to be wary of in contracts, purchase orders, invoices, and any paperwork presented by photo buyers:

- Vague or indefinite language such as "electronic use."
- Sweeping and all encompassing terms such as "all media by any and all means whether now known or hereinafter created."

Make the other party specify exactly what uses are needed before you sign.

On the other hand, there are some phrases that should appear in your paperwork or you should try to have included in a client's contract to help safeguard your work from use beyond what you agreed to or were paid for:

- "Rights granted do not include Internet, World Wide Web, or other online or digital use unless specifically stated"
- Grant only "nonexclusive rights"
- "Rights not specifically granted are reserved to the photographer"
- "No permission is granted for altering or manipulating any image beyond the requirements of normal image enhancement or cropping, and nothing may be done to change the integrity of any image"

In sum, does the fact that the role of photography in electronic media is in such flux mean you should wait to enter the field? Only if you want to postpone what appears, in one form or another, to be the future. Unlike some forecasters, the authors do not accept the polar positions that the only people who will be image makers in the future will be those who sit at computers, or that electronic media and digital imaging are overtaking and destroying photography. To the contrary, the potential of digital imaging and electronic media appear to offer exciting possibilities for image makers, now and in the future. In the next few years, trends we can only guess at now will have become more discernible, and ways of working with electronic media will become more standardized. Truly, this may be the most exciting time in which to be a photographer.

Buyer's Guide

There are no secrets in this book. The information and advice presented to photographers is either common sense or established industry practice. And, if you have skimmed this book, you know that most of the advice, with a slight turn of angle, is also applicable to you as a buyer of photography. Your goal is virtually the same as that of the photographer: a good photograph that suits your purpose, on time and at a fair price. The purpose of this chapter is to highlight the ways you can help make that happen.

Buying Photography

In the hands of a creative person, buying photography is an art in itself. Matching the right photographer to a project or knowing the best source for a particular style of stock photography results in the brilliant ad campaigns or stunning magazine articles that dazzle us all. It's how reputations are made. The pedestrian way of merely finding a picture, any picture, at the lowest price, usually ends up as a waste of money. A mundane approach brings a mundane result.

Photography is bought by almost everyone—from a top art director, photo editor, or art buyer to the greenest assistant or, sometimes, even a secretary.

If you're new to the business, you may not be aware that the term "buying" photography is not accurate but merely the colloquial term used in the industry. Rather than buying photographs, you are actually obtaining a license or grant of use, which allows you to use a specific photograph in a stipulated way. There's more on this in chapter 1, throughout the book, and in the discussion of rights later in this chapter.

Having the Information

Be armed before starting out, not to vanquish, but to get the most from your photographer. Know what you want and why.

Have courage. If you are down the line of command and don't have access to all the information about a photography project, insist that your bosses take the time to clarify their needs. (After all, mind reading wasn't on your job description.) Let them know that you can get them what they want only if you know what they want. Ask them the same questions that a photographer or stock agent will ask you. Posing these questions helps make sure that the creative people requesting the photograph have made their internal visions clear to you. When they understand why you need the information, your questions will seem helpful rather than pestering. The art director who doesn't have time to clarify for you now may spend double the time in extra research later on. And, if you're the one initiating the photo search, the same clarity is essential.

The more you involve the stock agent or photographer in a photo request, the better the results will be. They're human, and they're professionals, like you. They enjoy a challenge, and they can do much more than merely process pictures. The more information you share with your source, the more creative their suggestions will be.

If they, and you, don't understand the purpose of the photo, you won't be able to find the very best picture for the purpose. Listen to this scenario:

AD AGENCY ART DIRECTOR TO PHOTO RESEARCHER: "Get me a dynamite shot of the Grand Canyon."

PHOTO RESEARCHER TO STOCK AGENT: "I need a dynamite shot of the Grand Canyon."

STOCK AGENT: "Happy to help. What is your concept? What exactly about the Grand Canyon are you trying to show?"

PHOTO RESEARCHER: "Well, that doesn't matter. We just need a great shot. But you know, it's odd that I haven't been able to find the right thing with all the pictures of the Grand Canyon around. I just can't seem to please my art director . . . I'm in a bind. Find me something wonderful."

STOCK AGENT: "I'd like to, but I really need to know what you are trying to say with it. Is it to show the grandeur of nature? The romance of travel? What does the copy say?"

PHOTO RESEARCHER: "Well, actually it's for an investment firm ad to go with a headline, "Don't throw your money into a hole in the ground." And the Grand Canyon is the biggest hole there is, right?"

STOCK AGENT: "Ahaa, that helps. Let me look some more. It actually wouldn't have to be the Grand Canyon if it looks like a big hole, right?"

The final photo used was a dramatic angle in Bryce Canyon. Case closed.

In addition to the specifics, know your priorities for a photograph. It's easy to say the photo has to be brilliant, unique, fresh, exclusive, and cheap. But pie in the sky isn't a category so easily filled. Have a realistic view of your priorities before making a photo request or discussing an assignment. Which element is of paramount importance: the graphic impact of the photograph, the emotional content of the photograph, the literal content, the schedule, the budget, the style, the freshness of the image? If you bring in the wrong photo, you'll find out fast enough what the art director's priorities were.

Be as clear as possible. Give a photographer or stock agent as much information as you have. Holding back seldom pays, and it could waste your time or cost you more later on. Some people hold the misguided notion that you will be taken advantage of if you divulge information. By sharing information, you'll get not only better results from a photographer but probably also get some extra ideas in the bargain.

Stock or Assignment—Choosing What's Best for You

Circumstances may dictate which route you'll take when looking for photography. If you need a still life including the logo of your client's product, or an executive portrait in front of a newly constructed facility, or a photo essay on the newest NBA sensation, then you'll have to assign the photography. When you need a photograph on a short deadline, or want a generic summer scene in the depths of winter, or have a committee of twelve who must sign off on the picture approval, or

want to see a wide variety of creative approaches, then stock is probably the answer.

The choice between assignment and stock is not always clear-cut, and you'll need to weigh many factors.

RISK
With stock there is none. You have it in hand. You get what you see. But an assignment has risk. There can be transportation delays, models who don't perform well, technical mishaps—almost anything can go wrong. Good photographers, however, know how to minimize those risks.

APPROVAL
With stock, everyone knows in advance what the picture looks like, how well it works with the concept and in the layout. An assignment photo can be a pig in a poke. It may not come up to your imagined expectations, or it may far exceed expectations when in the hands of a fine photographer.

SCHEDULE
With stock, once you've found it, you've got it. There are no hold-ups. An assignment handled by a skilled professional will be done on time, but sometimes there are delays like weather, which are beyond anyone's control. They should be factored into any assignment schedule.

CONCEPT
When you are developing an idea, you can benefit equally from working with an imaginative assignment photographer or a creative stock photographer or stock agent.

FRESHNESS
An assignment will guarantee you a photograph that has never been published before, one that is unique to your project, tailor-made for your use. On an assignment you can take advantage of an exciting creative collaboration with the photographer or be the beneficiary of the magical unpredictability that can happen on a shoot, when things work even better than anyone imagined. That's the upside of risk.

STYLE

When style is a critical element, art buyers, in general, will search to find an assignment photographer with the right look or graphic approach for the project, then have that photographer craft the concept or subject matter using his or her unique vision. These days, you can find a remarkable variety of up-to-date photographic styles in a stock agency. Though, for truly fresh work, an assignment should be a strong consideration.

MARKET

The audience for your photograph may determine whether you choose stock or assignment for the style you need. If the target audience is the young, emerging, digital professional (generation D), you may choose an assignment photographer with a leading edge or experimental style, something that has not yet shown up in a stock agency. However, if your audience is the general public, there may be a wide variety of excellent imagery already available in stock.

EXCLUSIVITY

Many, but not all, stock agencies have the sophisticated equipment to monitor usage and guarantee exclusivity. Be cautious. If exclusivity is essential, either you will be limited in your choice of agency or you may need to assign the photography.

RELEASES

When setting up an assignment, you can specify the release protection you need and make sure the photographer also turns in copies of the appropriate release for each person or any recognizable property in a photograph. Not all stock photos are released; however, a reputable stock agency can tell you if a release is on file for a given photograph. They'll also advise when a release is needed. Be sure to ask for a copy of a release, particularly if you intend to use a photograph in a sensitive context, such as tobacco or alcohol ads, or with implications of health problems or criminal activity. However, a release will not necessarily protect you if there is a derogatory or defamatory use. For example, use of a released photo of a courtroom scene may or may not be advisable with a magazine article about medical malpractice. It can depend on the implications in the article, the relationship to the photograph, and the wording of the caption. Know the law regarding releases and libel (see the bibliography).

Buying Assignment Photography

You can increase the likelihood of success on an assignment in dramatic ways if you work with your photographer in a spirit of partnership.

What may sound strange, at first, is that most professional photographers want you, their client, to get a very good deal just as much and perhaps more than they want it for themselves. The keystone in a creative collaboration is the satisfaction the photographer gets from solving your joint needs, aesthetic and logistical. Carrying off a creative coup is fun. It feels good to do a good job. It feels even better when the person you're doing it for knows it and appreciates the effort.

HOW TO GET THE BEST DEAL IN ASSIGNMENTS

Deals usually mean money. To consider money alone is short-sighted; there are many valuable, intangible extras that add to a "deal." Professionals must be measured by what they deliver, not what they cost. It costs more to patch up a botched job than to do it right the first time.

Time for a war story. A photographer, while courting a new client, learned that the client had been getting a great "deal" for several years from another photographer. His work was good and the fee for all rights was really low but The photographer leaned forward, listening intently. The client said there was only one problem—nothing was organized. Models didn't get paid, releases didn't match photos, and worst of all, he was consistently late with the photographs.

When she heard the astoundingly low fee the previous photographer had been charging, our colleague ventured an explanation that one of two possibilities was likely: either the photographer was a terrible businessman and just didn't realize that he wasn't charging enough money to allow for a professional job; or he was shrewd but unethical in accepting a fee he knew to be deficient, then knowingly letting slip the aspects he couldn't

afford to handle. She got the next assignment from these folks, granting limited rights and charging a professional-level fee.

WHEN YOU HAVE A TIGHT BUDGET

To get a good financial deal, be clear and be fair. Explain what you need, what your limits are. On the occasions when you really have a tight budget (not the common garden variety, "get it as cheap as you can," tight budget)—one with true limitations—let the photographer help you formulate the budget and design the shoot to get the most for the money you have. By suggesting where and how to spend, they can help make the most of a lean budget. A photo buyer may actually waste money, or worse, undermine the entire project by unilaterally slashing in the wrong places. Enlist the photographer's expertise. For example, the photographer may advise you that cutting out a stylist won't save enough to be worth the loss of quality, but that an extra expense for set construction could be avoided by shooting from a different angle.

GETTING THE MOST FOR YOUR MONEY

Give support and appreciation. A photographer will walk across hot coals (if that should be of use to you) for a client who is constructive in criticism, unstinting in praise, and has a good sense of humor!

Professional photographers will give you an honorable job for the fee you pay, but often you can get much more than your money's worth from photographers by treating them fairly and involving them in the process.

The extras a photographer can give are sometimes simply an intangible pushing of the limits. A more concrete instance is when they continue to work past the limits of the assignment. Consider the tired photographer heading to the airport, the morning after a grueling two-day corporate shoot, who looks back and sees spectacular light on the facility and the wetlands nearby, stops, gets some terrific shots, and has to hustle to make the plane. Technically, the photos are not part of the assignment, but our well-treated photographer includes them in the edit. The wetlands pictures are a bonus to the corporation—and the result of having a fair and open relationship with the photographer.

In a few cases, photographers have found it a double-edged sword to offer something extra. They have had clients tell them not to waste film on a subject they didn't request. That certainly appears to be a squashing of creative initiative, but if you don't want anything beyond the limits of the assignment, make that clear to your photographer in the beginning.

On the other side of the coin, if you have a photographer who is giving more than full measure, be careful. Don't drive them to the point of exhaustion. Over-using their good will and obsessive dedication to work can lead to a point of diminishing return.

HOW DO I PROTECT MY INVESTMENT?

Some buyers attempt to buy all rights or many more rights than they need, out of fear that photos from their assignment will show up in a competitor's materials. That's easy to avoid by working with the photographer to develop protective restrictions and time limits, perhaps like paying for exclusive usage for an appropriate time period. It shouldn't come as a shock to you to know that photographers want your assignment to be protected as much as you do.

By investing in an assignment instead of using available stock, you are making the opportunity for photographers to create new work. Being a professional means more than talent and skill; it means ethical and honorable dealings as well. Not only is protecting your assignment the hallmark of a professional—it's enlightened self-interest. Professionals certainly don't want to jeopardize the faith you have in the assignment process or in them. It's also why professionals must insist on a sufficient fee to cover all the extra protection that you have a right to expect.

WHAT DO I GET FOR MY MONEY?

Or, "If I pay for it, why don't I own everything?"

On an assignment you get whatever rights, time limits, and protective restrictions you have negotiated with the photographer.

It's dangerous to make assumptions, on either side, about what rights are being granted or obtained. You and the photographer must have a clear agreement, and it should be in writing.

"But still, if I pay for it, why don't I own it?"

Just because you paid for someone's time doesn't necessarily mean you own the photographs. When you rent a car, you don't expect to own it. So, too, with a photograph, which is comprised of a bundle of rights, you are granted the ones you need, for as long as you need them.

"But I pay all the expenses."

Yes, and you get extra benefits for that investment, which include first use, time limit exclusivity, and protection from competition, benefits that may not come with stock.

Buying Stock Photography

Buying rights to stock photography can be relatively straightforward when you work with the many reputable stock agencies and stock photographers. But there are ways to increase the efficacy of your stock buying, and there are pitfalls to be avoided.

For this discussion, references to stock "sources" will be assumed to include photographers licensing stock as well as stock agencies. Though sometimes on a different scale, individual photographers offer the same services and bear many of the same costs as a stock agency, so the comments in this chapter apply equally to both.

HOW TO GET THE BEST DEAL IN STOCK

Although it may not seem necessary to say it, establish a good working relationship with your stock sources. Treat them, the photographs, and the service they offer with respect, and you'll reap great rewards. You can build good will with an agency if you follow a few simple guidelines.

Don't shop just for the sake of it. There are many stock catalogs, in print as well as online or on CDs, to use for idea searches. Be serious about your requests. Though you may pay a research fee for the privilege of viewing a selection of images, this fee is a token and covers only a very small portion of the cost of providing a stock submission of originals. Do your preliminary selection on a Web site. If you have no choice but to search further for ideas, say so, and be straight about it. Let them know you're not sure what you need. They'll help.

Don't set unrealistic or unnecessarily tight deadlines. We all know what happens when wolf is cried too often.

Don't hold photographs longer than needed, or without notifying the source. An agency doesn't like to charge holding fees. It's another symbolic fee, but it doesn't touch the cost of not having the pictures available for licensing to others. What's not in the file can't be sold. Again, use an agency's Web site for your initial research, then request an additional selection only if you can't find your photo online. Today, you may find that only a portion of a stock agency's vast files is available in digital form. But that is changing rapidly, as new images are scanned daily.

Give preference to the sources that are most responsive. A stock agent doesn't assume that his or her company is your only source, but in the event that you have a favorite source or two (whether photographer or agency), let them know when you are giving them a first crack at your request.

As with assignments, good deals in stock don't always mean money. Good service can be more valuable than a low reproduction fee when you're in a tight spot and the agent you've built a relationship with comes through for you.

GETTING THE MOST FOR YOUR MONEY IN STOCK

You are getting the best bargain in the business even if you pay the top fee currently charged by a source. That's because stock reproduction fees and assignment fees have lagged behind the dramatic increases in photography costs over the past twenty years. Fees have barely changed, while costs to produce photography have soared. And now there are the costs of maintaining Web sites with constant updating for new work. Stock already gives you risk-free photography at an excellent price.

"Okay, fine, but now how can I save money?"

One way is to negotiate at the outset all the uses you envision over a period of time. An agency is usually more inclined to give a discount when you buy a package of rights.

That brings us to the sticky subject of volume discounts. It makes sense that a source will offer a break when you use many photographs from its collection.

For agencies, discounts can be problematic. They want to give some benefit to a client who buys a lot but can't do it at the expense of the individual photographers who may have only one photo included in a deal. They must provide their contributing

129

photographers sufficient income to allow reinvestment in new work, or else the flow of quality photography you demand will dry up.

WHAT DO I GET FOR MY MONEY?

You get an extraordinary selection of excellent images by the world's leading photographers, immediately. Often overnight, you'll have top quality photographs on your lightbox, ready for review or available on a Web site or delivered digitally by e-mail.

In order to offer the immediate service you need on a deadline, stock agencies and stock photographers must maintain sophisticated and expensive tracking systems and Web sites. They keep records on exclusivity, model release files, and caption information.

SHOULD I PAY FULL FEE TO AN INDIVIDUAL PHOTOGRAPHER?

After all, they only get half from their agency, anyway.

When you pay a stock fee, it covers your usage, whether for a magazine article, a point of purchase ad, or a greeting card. Your usage is no different when you get the photograph from an individual photographer. It serves your purpose or it doesn't, regardless of source.

You are also getting backup services from the source providing those images. It must not be assumed that photographers can afford to charge less since they are providing not only the same usage rights but also most of the same service an agency would for the image you need. Individual stock photographers have overhead and service costs to maintain filing systems, process your submissions, and cover promotion and advertising in source books, catalogs, and Web sites, to name a few. Many have also invested in top-end computer systems with imaging capabilities.

To compete with a stock agency for your business, today's individual stock photographers must offer a level of quality and service that is very expensive and requires full fees to maintain.

Copyright

As you saw in chapter 1, copyright is the right to control all uses of the image. Congress, through the Federal Copyright Law, gave (independent, nonemployee) creators the control of the tangible results of their efforts, whether commissioned by a client or done on their own time. The nonemployee photographer owns the copyright from the moment the shutter clicks, and that copyright remains with the photographer unless it is transferred in writing. It is well worth reading more about copyright in the books suggested in the bibliography.

Note: An idea cannot be copyrighted. Only the tangible expression of that idea, the resulting photograph (or sculpture, illustration, novel, etc.), can be copyrighted.

COPYRIGHT INFRINGEMENT

"I have this picture, can you shoot one like it?"

Imagine this situation: The art director at your agency comes to you with a photograph clipped out of a magazine and says: "This is an interesting shot—it'll work for our XZY campaign. Get Charlie Cheap to shoot it for us. Do the same thing, just change it around a bit." Any problems? Yes, you would probably be guilty of infringement of copyright. It's against the law to take anything that you don't own the rights to and copy it, even with some modification. It's not always clear-cut when an infringement has occurred, but "substantially similar" is the phrase in the law and a measuring stick for a judge or jury to use when deciding if infringement has occurred. There are many articles in the trade press about copyright infringement. It's smart to stay informed and to know the current legal cases.

The way out, instead of copying, is to find the person who took the shot you like so much and negotiate for the rights needed on your campaign. If the photograph is not available due to competitive restrictions, talk with the photographer of the original shot (you liked the lighting, composition, creative approach, right?) about creating a different photograph to suit your needs. You'll benefit by getting a fresh photograph and will be well clear of dangerous infringement waters as well.

DIGITAL INFRINGEMENTS

Current computer capabilities make merging many photographs into a seamless new image a reality, making infringement difficult to detect. What's important to understand, especially for

newcomers to the field, is that merging parts of images into a new whole without the permission of all copyright owners is illegal, no matter how difficult to detect.

Regardless of the ease of taking images, one reason prevents art directors from pirating images now, just as in the past—that is, because it is dishonorable. Truly professional, creative people don't pirate in order to be successful.

WORK-FOR-HIRE—AND WHY YOU DON'T REALLY NEED IT!

It costs too much. That's the number one reason. You are, in effect, buying the whole pie when you may need only a few slices. (See chapter 1 for an explanation of work-for-hire.)

Also, it discourages the very best photographers from working with you. Creative, innovative photographers have enough respect for their work to want to keep the copyright. Just think, by asking for work-for-hire, you, as the client, become the creator as if the photographer never existed. The photographer loses all control over the image for all time, including the ability to show the work in a portfolio, gallery show, or retrospective. The tangible expression of a life's work is gone. It's a serious matter to a creative person, and it can be a major detriment to the photographer's economic survival.

Few photographers' clients who ask for work-for-hire really need it, and most are simply doing so out of convenience, so that they won't have to bother thinking about usage again, now or later. In actuality, you really don't need to own everything; there is a less expensive way.

The best way to get the protection that some clients believe they achieve with work-for-hire is to negotiate up front exactly what they need, think they might need, or even suspect they might need later. The wise negotiator doesn't try to control or own everything through intimidation (in this case, "Do work-for-hire, or you don't get the job")—rather they try to achieve a mutually agreeable resolution.

PERCEPTIONS—WHY DO PHOTOGRAPHERS CHARGE SO MUCH?

There is a perception among some photo buyers that "photographers charge a fortune" and that they must therefore make a fortune.

Evaluating an Assignment Photographer

In the process of hiring an assignment photographer, portfolio samples are only the first step, and price shouldn't be the second. The professionalism of the person chosen to handle your work will be the key to the success of a project.

Use careful research, astute observation, and assessment to make sure you select based on the following abilities:

- *Creativity*. Judge by portfolio samples and promotion pieces. Judge also by imagination shown in discussions about a potential assignment.
- *Technical ability*. Judge by portfolio samples and promotion pieces, and also by technical solutions and suggestions in discussions about the problems of a shoot.
- *Equipment available*. Ask about the range of equipment a photographer uses and has available.
- *Professional business practices*. Judge by use of detailed forms and paperwork, knowledge of photographic law, model releases, and property releases.
- *Problem solving/logistical planning* of locations, set design, transportation, interpreters.
- *Management* of assistants, stylists, budget, and schedule.
- *Intelligence*. Being informed on issues.
- *Dependability*. Are there many repeat clients in the portfolio?
- *Good nature/pleasant manner.* Will this person represent you and your client well, and be easy to work with on a job?
- *Energy/enthusiasm*. Keep your ear tuned to recognize genuine excitement about your project.

If all of these attributes are positive, then your money is well spent with your chosen photographer.

At first glance, from the point of view of a salaried employee, some confusion about costs and earnings is understandable. It can look as if a photographer earns more in one day than the art buyer does in a week. If you multiply that by fifty weeks a year, the result appears to be the wealth of Croesus.

Unfortunately, the photographer does not earn a "salary" of that level. Experienced buyers know that photographers' creative fees cover much more than their time. Look in chapter 2 for an idea of some of the typical photographer's overhead costs necessarily incurred in the running of a photography business. In addition to talent, a photographer is expected by you, the client, to have available sophisticated equipment which costs thousands of dollars to purchase and maintain, just to be ready for the day you call.

Photography fees reflect the cost of being in business, not the photographer's salary.

Building a Relationship

At the very least, a professional relationship should be productive and cordial. In the best of situations, photographers and clients become friends, people of like interests working together to solve a creative problem and enjoying the process.

Professionalism on both sides is a given. Loyalty, which is the outcome of understanding, mutual respect and fair dealings, may be the most valuable ingredient to foster in the relationship between photographer and client.

Appendix of Forms

One of the best, and easiest, things you can do for your business is to move beyond mere letters and oral agreements. Letters don't contain enough transaction detail, and oral agreements are forgotten and can be easily disputed. By using form agreements for image delivery, confirmations, and invoicing, not only will you be perceived as more professional than many other photographers, but you will also find it much easier to keep track of your affairs, and in the event of a dispute, you will have a record of paperwork that supports your position.

You don't have to use these suggested forms, of course, but use some type of form paperwork, and use it every time—whenever you or your client promise something to the other, always present the appropriate form and get it signed.

A word of warning: If you delete or add terms or conditions to these forms, without consulting a lawyer in your state, you may inadvertently weaken or destroy your rights or your client's duties or obligations to you. The cost of a lawyer's review of any forms you intend to use is cheap insurance.

<photographer's letterhead>

ASSIGNMENT PHOTOGRAPHY
DELIVERY MEMO

CLIENT _____

Address _____

Telephone _____

Contact _____

Date _____

Delivery Memo # _____

Purchase Order # _____

Photo ID. # or Roll #	Description	Value*	Format/ Size	Original/ Dupe/ Digital	BW/ Color

Value is in case of loss, theft, or damage.

Total BW _____

Total Color _____

This submission does not constitute authorization to use the enclosed Photographs—Images may be used only upon payment of invoice in full and receipt from Photographer of a written agreement ("*License*") to use or reproduce Image(s). An additional fee may be incurred for unlicensed use of any kind.

Check the count of Photographs delivered that accompany this Memo, and acknowledge receipt by signing and returning one copy of this Memo to Photographer. Count shall be considered accurate and quality deemed satisfactory for reproduction if a copy of Memo with all exceptions duly noted is not received by Photographer within seven (7) days of this Image delivery to Client.

By signing below, you agree that you are authorized by the Client to act in their behalf in the capacity of accepting Photograph deliveries. Acceptance of this delivery constitutes Client's assent to all terms and conditions on both sides of this Memo, whether signed by you or not.

Acknowledged and Accepted By:

Date

Signature By

Print Name

TERMS AND CONDITIONS

[1] **Acceptance.** This agreement acknowledges the delivery of photographs by Photographer named above to the addressee named above (*"Client"*).

[2] **Definitions.** "Image(s)" means all viewable renditions furnished by Photographer along with this document, whether captured or stored in photographic, magnetic, optical, or any other medium.

[3] **Purpose.** Submission is for examination only. Images may not be reproduced, copied, projected, or used in any way without (a) full payment of the Invoice, and (b) express written permission (*"License"*) on Photographer's Invoice–License stating the use rights granted and the terms governing the License. The reasonable and stipulated fee for any unlicensed Image use shall be three times Photographer's customary fee for that usage.

[4] **Ownership and Copyright.** Title in the copyright and physical entity of all Images created or supplied pursuant to this agreement remain the sole and exclusive property of Photographer. There is no assignment of copyright, agreement to do work-for-hire, intention of joint copyright, or grant of rights other than for examination, expressed or implied in this document.

[5] **Loss, Damage, Return.** Client understands that each original photographic transparency or film negative is unique, does not have an exact duplicate, and it may be impossible to replace or recreate it. Client assumes insurer's liability (a) to indemnify Photographer for loss, damage, or misuse of any Images, and (b) to return all Images prepaid and fully insured, safe and undamaged, by secure mode of shipment. Client assumes full liability for its employees, principals, agents, affiliates, successors, and assigns (including without limitation independent contractors, messengers, and freelance researchers) for any loss, damage, delay in returning, or misuse of Images. Reimbursement by Client for loss of or damage to each Image that is an original transparency or negative, or each other Image, shall be in the amount of One Thousand Five Hundred Dollars ($1,500), or other amount set forth on the face of this document or on an attached schedule. Client agrees that the stipulated amounts represent the fair and reasonable value of each Image and that Photographer would not sell all rights to any Image for less than that amount.

[6] **Indemnification.** Client will indemnify and defend Photographer against all claims, liability, damages, costs, and expenses, including reasonable legal fees and costs arising out of any unlicensed use of any Images.

[7] **Miscellany.** Client may not assign or transfer this agreement or any of the rights granted. This agreement binds and inures to the benefit of Photographer, Client, and Client's employees, principals, agents, and affiliates, and their respective heirs, legal representatives, successors, and assigns. Client and its employees, principals, agents, and affiliates are jointly and severally liable for the performance of all payments and other obligations created in this document. No amendment or waiver of any terms of this document is binding unless set forth in writing and signed by the parties. This agreement incorporates by reference Article 2 of the Uniform Commercial Code and the Copyright Act of 1976, as amended.

[8] **Dispute Resolution.** Except as provided in [8][c] below, any dispute regarding this agreement shall be, at Photographer's sole discretion, either:

[a] arbitrated in [*photographer's city and state*] under rules of the American Arbitration Association and the laws of [*photographer's state*]. Judgment on the arbitration award may be entered in any court having jurisdiction. Any dispute involving $ —— [*limit of small claims court*] or less may be submitted without arbitration to any court having jurisdiction, or

[b] adjudicated in [*photographer's city and state*], under the laws of [*photographer's state*].

[c] Client hereby expressly consents to the jurisdiction of the Federal courts with respect to claims under the Copyright Act of 1976, as amended.

Client shall pay all arbitration and court costs, Photographer's reasonable legal fees and expenses, and legal interest on any award or judgment if granted in favor of Photographer.

<photographer's letterhead>

STOCK PHOTOGRAPHY
DELIVERY MEMO

CLIENT _____
Address _____

Telephone _____
Per Request of _____
Photo Return Due Date _____

Date _____
Delivery Memo # _____
Purchase Order # _____

Extension Due Date _____

Photo ID. #	Description	Value*	Format/ Size	Original/ Dupe/ Digital	BW/ Color

Total BW _____
Total Color _____

Value is in case of loss, theft, or damage.

Submission of Photographs is for examination only. Photographs are enclosed in sealed protectors that may be opened only upon receipt from Photographer of a written agreement ("*License*") to use or reproduce Image(s). A broken seal creates a presumption of Image use, and Client will be invoiced a use fee for each broken seal.

Check the count of Photographs delivered that accompany this Memo, and acknowledge receipt by signing and returning one copy of this Memo to Photographer. Count shall be considered accurate and quality deemed satisfactory for reproduction if a copy of Memo with all exceptions duly noted is not received by Photographer within seven (7) days of this delivery to Client.

Unlicensed Images must be returned to Photographer within fourteen (14) days following receipt of this delivery by Client. After fourteen (14) days, a holding fee of one dollar ($1) per day will be charged for each unlicensed Image that has not been returned.

By signing below, you agree that you are authorized by the Client to act in the Client's behalf in the capacity of accepting Photograph deliveries. Acceptance of this delivery constitutes Client's assent to all terms and conditions on both sides of this Memo, whether signed by you or not.

Acknowledged and Accepted By:

Signature By

Date

Print Name

TERMS AND CONDITIONS

[1] **Acceptance.** This agreement acknowledges the delivery of photographs by Photographer named above to the addressee named above (*"Client"*).

[2] **Definitions.** "Image(s)" means all viewable renditions furnished by Photographer along with this document, whether captured or stored in photographic, magnetic, optical, or any other medium.

[3] **Purpose.** Submission is for examination only. Images may not be reproduced, copied, projected, or used in any way without [a] full payment of the Invoice, and [b] express written permission (*"License"*) on Photographer's Invoice-License stating the use rights granted and the terms governing the License. The reasonable and stipulated fee for any unlicensed Image use shall be three times Photographer's customary fee for that usage.

[4] **Ownership and Copyright.** Title in the copyright and physical entity of all Images created or supplied pursuant to this agreement remain the sole and exclusive property of Photographer. There is no assignment of copyright, agreement to do work-for-hire, intention of joint copyright, or grant of rights other than for examination, expressed or implied in this document.

[5] **Loss, Damage, Return.** Client understands that each original photographic transparency or film negative is unique, does not have an exact duplicate, and that it may be impossible to replace or recreate it. Client assumes insurer's liability [a] to indemnify Photographer for loss, damage, or misuse of any Images, and [b] to return all Images prepaid and fully insured, safe and undamaged, by secure mode of shipment. Client assumes full liability for its employees, principals, agents, affiliates, successors, and assigns (including without limitation independent contractors, messengers, and freelance researchers) for any loss, damage, delay in returning, or misuse of Images. Reimbursement by Client for loss of or damage to each Image that is an original transparency or negative, or each other Image, shall be in the amount of One Thousand Five Hundred Dollars ($1,500), or other amount set forth on the face of this document or on an attached schedule. Client agrees that the stipulated amounts represent the fair and reasonable value of each Image and that Photographer would not sell all rights to any Image for less than that amount.

[6] **Indemnification.** Client will indemnify and defend Photographer against all claims, liability, damages, costs, and expenses, including reasonable legal fees and costs arising out of any unlicensed use of any Images.

[7] **Miscellany.** Client may not assign or transfer this agreement or any of the rights granted. This agreement binds and inures to the benefit of Photographer, Client, and Client's employees, principals, agents, and affiliates, and their respective heirs, legal representatives, successors, and assigns. Client and its employees, principals, agents, and affiliates are jointly and severally liable for the performance of all payments and other obligations created in this document. No amendment or waiver of any terms of this document is binding unless set forth in writing and signed by the parties. This agreement incorporates by reference Article 2 of the Uniform Commercial Code and the Copyright Act of 1976, as amended.

[8] **Dispute Resolution.** Except as provided in [8][c] below, any dispute regarding this agreement shall be, at Photographer's sole discretion, either:

[a] arbitrated in [*photographer's city, state*] under rules of the American Arbitration Association and the laws of [*photographer's state*]. Judgment on the arbitration award may be entered in any court having jurisdiction. Any dispute involving $_____ [*limit of small claims court*] or less may be submitted without arbitration to any court having jurisdiction; or

[b] adjudicated in [*photographer's city, state*], under the laws of [*photographer's state*].

[c] Client hereby expressly consents to the jurisdiction of the Federal courts with respect to claims under the Copyright Act of 1976, as amended.

Client shall pay all arbitration and court costs, Photographer's reasonable legal fees and expenses, and legal interest on any award or judgment if granted in favor of Photographer.

<photographer's letterhead>

ASSIGNMENT PHOTOGRAPHY
ESTIMATE / CONFIRMATION / INVOICE—LICENSE

Date _____

_____ Estimate
_____ Confirmation
_____ Invoice—License
Job # _____

CLIENT _____
Address _____

Client Purchase Order # _____
Client Contact _____
Assignment Description _____

Due Date _____

GRANT OF RIGHTS Upon receipt of full payment, Photographer shall grant to client the following nonexclusive rights:

For use as _____
For the product, project, publication named _____
In the territory _____
For the period of time or number of uses _____
Other limitations _____
Credit: The Photographer ___ shall ___ shall not ___ receive a credit notice adjacent to each Image in this form:
© [*photographer's name*] [*year*]

EXPENSES

Assistants	$ _____
Casting	$ _____
Crew / Special Assistance	$ _____
Equipment Rental	$ _____
Film & Processing	$ _____
Insurance	$ _____
Location	$ _____
Messengers	$ _____
Models	$ _____
Props/Wardrobe	$ _____
Sets	$ _____
Shipping	$ _____
Styling	$ _____
Travel/Transportation	$ _____
Telephone	$ _____
Other expenses	$ _____
Total Expenses	$ _____

FEES

Creative Fee	$ _____
Space or Use Rate (*if applicable*)	$ _____
Other Fees	
Digital $ ___ /day	$ _____
Pro–production $ ___ /day	$ _____
Post–production $ ___ /day	$ _____
Travel $ ___ /day	$ _____
Weather $ ___ /day	$ _____
Postponement $ ___ /day	$ _____
Cancellation $ ___ /day	$ _____
Reshoot	$ _____
Total Fees	_____

Total Expenses	$ _____
Total Fees	$ _____
Subtotal	$ _____
Sales Tax	$ _____
Total	$ _____
Less Advances	$ _____
Balance Due	$ _____

By signing, you agree that you are authorized by the Client to act in their behalf in accepting the terms and conditions of this agreement.

Photographer

Client Name

Authorized Signatory, Title

Use of any image described above, or payment in full of this Invoice, constitutes acceptance of all terms and conditions expressed on both sides of this document.
Invoice and License are subject to all terms and conditions on both sides of this document.

PHOTOGRAPHY LICENSE TERMS AND CONDITIONS

[1] **Definitions.** *Image(s)* means all viewable renditions furnished by Photographer, whether captured or stored in photographic, magnetic, optical, or any other medium. The addressee of this form is known as the "*Client.*"

[2] **Grant of Rights.** Usage specifications stated in this document convert to copyright license [i.e., permission to use] ["*License*"] only upon receipt of full payment of Invoice. All rights not specifically granted are reserved to Photographer. Usage other than that specifically described in the "Grant of Rights" section of this document requires written license from Photographer and additional payment prior to use. No grant of derivative rights is made with this License, including digital or electronic rights that may involve scanning, using, transmitting, or storing Image(s) on the Internet, World Wide Web, CDs, or other electronic medium or network, unless expressly authorized in writing. Title in the copyright and physical entity of all Images created pursuant to this agreement remain the sole and exclusive property of the Photographer. There is no assignment of copyright, agreement to do work-for-hire, intention of joint copyright, or grant of rights, other than those listed in the "Rights Granted" section on the front of this form, expressed or implied in this document. The reasonable and stipulated fee for any unlicensed Image use shall be three times Photographer's normal fee.

[3] **Payment.** Invoices are payable on receipt. Unpaid invoices are subject to a monthly rebilling fee of two percent (2%) of the unpaid balance.

[4] **Alterations.** Unless otherwise provided in a writing from Photographer, Client may not make or permit alterations or manipulations of any Images beyond the requirement of slight or reasonable image enhancement (i.e., alterations of contrast, brightness, and color balance, or cropping), consistent with reproduction needs, that do not materially change the integrity of any Image. Alterations or manipulations include but are not limited to additions to, subtractions from, or adaptations, alone or with any other material, produced optically, mechanically, electronically, or digitally. No alteration or change may be made to the physical entity of any photograph supplied by Photographer. Any alteration, manipulation, reproduction, or production charges must be borne by Client.

[5] **Value, Image Return.** Client understands that each original photographic transparency and film negative is unique, does not have an exact duplicate, and it may be impossible to replace or recreate it. Client assumes insurer's liability (a) to indemnify Photographer for loss, damage, or misuse of any Images, and (b) to return all Images prepaid and fully insured, safe, and undamaged, by a secure mode of shipment within thirty (30) days after the date of final licensed use. Client assumes full liability for its employees, principals, agents, affiliates, successors, and assigns (including without limitation independent contractors, messengers, and freelance researchers) for any loss, damage, delay in returning, or misuse of Images. Reimbursement by Client for loss of or damage to each Image that is an original photographic transparency or film negative shall be in the amount of One Thousand Five Hundred Dollars ($1,500), or other amount set forth next to each listed Image on the face of the Delivery Memo or on an attached schedule. Reimbursement by Client for loss of or damage to each other Image shall be in the amount set forth next to each Image on the face of this document or on an attached schedule. Client agrees that the amounts represent the fair and reasonable value of each Image and that Photographer would not sell all rights to any Image for less than that amount.

[6] **Authorship Credit.** Proper copyright notice that reads: "© [*Photographer's Name*] [*Year*]" must be displayed alongside Image or on the same page(s) that Image(s) appear, unless provided otherwise in writing. Omission of required notice results in loss to the Photographer and will be billed at triple the invoiced fee.

[7] **Expenses.** All estimates of expenses may vary by as much as ten percent (10%) in accordance with normal trade practices. In addition, the Photographer may bill the Client in excess of the estimates for any overtime that must be paid to assistants and freelance staff for work that runs more than eight (8) consecutive hours.

[8] **Resoots.** If Photographer is required by the Client to reshoot the Assignment, Photographer shall charge in full for additional fees and expenses, unless (a) the reshoot is due to acts of God or is due to an error by a third party, in which case the Client shall only pay additional expenses but no fees; or (b) if the Photographer is paid in full by the Client, including payment for the expense of special contingency insurance, that covers a reshoot. The Photographer shall be given the first opportunity to perform any reshoot.

[9] **Cancellation.** In the event of cancellation by the Client, the Client shall pay all expenses incurred by the Photographer, and in addition, shall pay the full fee unless notice of cancellation was given at least _____ hours prior to the date photography was to begin, in which case fifty percent (50%) of the fee shall be paid. For weather delays, Client shall pay the full fee if Photographer is on location and fifty percent (50%) of the fee if Photographer has not yet left for the location.

[10] **Publication Samples.** Client must supply Photographer with a minimum of two (2) free copies of publication(s) in which Image(s) appear.

[11] **Releases.** Client will indemnify and defend Photographer against all claims, liability, damages, costs, and expenses, including reasonable legal fees and costs arising out of any use of Image(s) that are unlicensed, for which no release was furnished, that are altered by Client, or use that exceeds the uses allowed by a release. Unless furnished, no release exists. Photographer's liability for all claims shall not exceed in any event the total amount paid under this Invoice.

[12] **Assignment.** Client may not assign or transfer this agreement or any of the rights granted. This agreement binds and inures to the benefit of Photographer, Client, and Client's employees, principals, agents, and affiliates, and their respective heirs, legal representatives, successors, and assigns. Client and its employees, principals, agents, and affiliates are jointly and severally liable for the performance of all payments and other obligations created in this document. No amendment or waiver of any terms of this License is binding unless set forth in writing and signed by the parties. This agreement incorporates by reference Article 2 of the Uniform Commercial Code and the Copyright Act of 1976, as amended.

[13] **Dispute Resolution.** Except as provided in [c] below, any dispute regarding this agreement shall be, at Photographer's sole discretion, either:

[a] arbitrated in [*photographer's city, state*], under rules of the American Arbitration Association and the laws of [*photographer's state*]. Judgment on the arbitration award may be entered in any court having jurisdiction. Any dispute involving $_____ [*limit of small claims court*] or less may be submitted without arbitration to any court having jurisdiction, or

[b] adjudicated in [*photographer's city, state*], under the laws of [*photographer's state*].

[c] Client hereby expressly consents to the jurisdiction of the Federal courts with respect to claims under the Copyright Act of 1976, as amended.

Client shall pay all arbitration and court costs, and Photographer's reasonable legal fees and expenses, and legal interest, on any award or judgment if granted in favor of Photographer.

<photographer's letterhead>

STOCK PHOTOGRAPHY
INVOICE—LICENSE

Date _____
Invoice—License # _____
Telephone _____

CLIENT _____
Address _____

Client Purchase Order # _____
Client Contact _____
GRANT OF RIGHTS Upon receipt of full payment, Photographer shall grant to client the following nonexclusive rights
For use in _____
For the product, project, publication named _____
In the territory _____
For the period of time or number of uses _____
Other limitations _____
Credit: The Photographer ____ shall ____ shall not receive adjacent credit in the following form on reproduction:
© [*photographer's name*] [*year*] _____

Photo ID. #	Description	Color/BW/ Digital	Use Size/ Placement	Fee

Total Reproduction Fee $ _____
Research Fee $ _____
Holding Fee $ _____
Subtotal $ _____
Sales Tax $ _____
Total $ _____

By signing, you agree that you are authorized by the Client to act in their behalf in accepting the terms and conditions of this agreement.

Client Name

Authorized Signatory, Title

Photographer

Use of any image described above, or payment in full of this Invoice, constitutes acceptance of all terms and conditions expressed on both sides of this document.
Invoice and License are subject to all terms and conditions on both sides of this document.

PHOTOGRAPHY LICENSE TERMS AND CONDITIONS

[1] **Definitions.** *Image(s)* means all viewable renditions furnished by Photographer, whether captured or stored in photographic, magnetic, optical, or any other medium.

[2] **Grant of Rights.** Usage specifications stated in this document convert to copyright license [i.e., permission to use] [*"License"*] only upon receipt of full payment of Invoice. All rights not specifically granted are reserved to Photographer. Usage other than that specifically described in the "Grant of Rights" section of this document requires written license from Photographer and additional payment prior to use. No grant of derivative rights is made with this License, including digital or electronic rights that may involve scanning, using, transmitting, or storing Image(s) on the Internet, World Wide Web, CDs, or other electronic medium or network, unless expressly authorized in writing. Title in the copyright and physical entity of all Images created or supplied pursuant to this agreement remain the sole and exclusive property of the Photographer. There is no assignment of copyright, agreement to do work-for-hire, intention of joint copyright, or grant of rights, other than those listed in the "Rights Granted" section on the front of this form, expressed or implied in this document. The reasonable and stipulated fee for any unlicensed Image use shall be three (3) times Photographer's normal fee.

[3] **Payment.** Invoices are payable on receipt. Unpaid invoices are subject to a monthly rebilling fee of two percent (2%) of the unpaid balance. Licenses that are canceled thirty (30) days after Invoice date are payable in full whether Images will be used or not.

[4] **Alterations.** Unless otherwise provided in a writing from Photographer, Client may not make or permit alterations or manipulations of any Images beyond the requirement of slight or reasonable image enhancement (i.e., alterations of contrast, brightness and color balance, or cropping), consistent with reproduction needs, that do not materially change the integrity of any Image. Alterations or manipulations include but are not limited to additions to, subtractions from, or adaptations, alone or with any other material, produced optically, mechanically, electronically, or digitally. Any alteration, manipulation, reproduction, or production charges must be borne by Client.

[5] **Notice.** Proper copyright notice which reads: "© [*Photographer's Name*] [*Year*]" must be displayed alongside Image or on the same page(s) that Image(s) appear, unless provided otherwise in writing. Omission of required notice results in loss to the Photographer and will be billed at triple the invoiced fee.

[6] **Value, Image Return.** Client understands that each original photographic transparency and film negative is unique, does not have an exact duplicate, and it may be impossible to replace or recreate it. Client assumes insurer's liability (a) to indemnify Photographer for loss, damage, or misuse of any Images, and (b) to return all Images prepaid and fully insured, safe, and undamaged, by secure mode of shipment within thirty (30) days after the date of final licensed use. Client assumes full liability for its employees, principals, agents, affiliates, successors, and assigns (including without limitation independent contractors, messengers, and freelance researchers) for any loss, damage, delay in returning, or misuse of Images. Reimbursement by Client for loss of or damage to each Image that is an original photographic transparency or film negative shall be in the amount of One Thousand Five Hundred Dollars ($1,500), or other amount set forth next to each listed Image on the face of the Delivery Memo or on an attached schedule. Reimbursement by Client for loss of or damage to each other Image shall be in the amount set forth next to each Image on the face of this document or on an attached schedule. Client agrees that the amounts represent the fair and reasonable value of each Image and that Photographer would not sell all rights to any Image for less than that amount.

[7] **Publication Samples.** Client must supply Photographer with a minimum of two (2) free copies of publication(s) in which Images appear.

[8] **Releases.** Client will indemnify and defend Photographer against all claims, liability, damages, costs, and expenses, including reasonable legal fees and costs arising out of any use of Image(s) that are unlicensed, for which no release was furnished, that are altered by Client, or use that exceeds the uses allowed by a release. Unless furnished, no release exists. Photographer's liability for all claims shall not exceed in any event the total amount paid under this Invoice.

[9] **Assignment.** Client may not assign or transfer this agreement or any of the rights granted. This agreement binds and inures to the benefit of Photographer, Client, and Client's employees, principals, agents, and affiliates, and their respective heirs, legal representatives, successors, and assigns. Client and its employees, principals, agents, and affiliates are jointly and severally liable for the performance of all payments and other obligations created in this document. No amendment or waiver of any terms of this License is binding unless set forth in writing and signed by the parties. This agreement incorporates by reference Article 2 of the Uniform Commercial Code and the Copyright Act of 1976, as amended.

[10] **Dispute Resolution.** Except as provided in [10][c] below, any dispute regarding this agreement shall be, at Photographer's sole discretion, either:

[a] arbitrated in [*photographer's city, state*], under rules of the American Arbitration Association and the laws of [*photographer's state*]. Judgment on the arbitration award may be entered in any court having jurisdiction. Any dispute involving $_____ [*limit of small claims court*] or less may be submitted without arbitration to any court having jurisdiction, or

[b] adjudicated in [*photographer's city and state*], under the laws of [*photographer's state*].

[c] Client hereby expressly consents to the jurisdiction of the Federal courts with respect to claims under the Copyright Act of 1976, as amended.

Client shall pay all arbitration and court costs, Photographer's reasonable legal fees and expenses, and legal interest on any award or judgment if granted in favor of Photographer.

Bibliography and Resources

Useful Publications

A.G. Editions. *The Guilfoyle Report: A Quarterly Forum for Nature Photographers*, New York: quarterly.

The American Society of Media Photographers. *ASMP Professional Business Practices in Photography*. 6th Ed. New York: Allworth Press, 2001.

The American Society of Media Photographers (ASMP). *Valuation of Lost Transparencies*, Michael D. Remer, 1992.

Bagshaw, Cradoc. FotoQuote (pricing software), The Cradoc Corporation, PO Box 10899, Bainbridge Island, WA.

Crawford, Tad. *Legal Guide for the Visual Artist*. 4th Ed. New York: Allworth Press, 1999.

Heron, Michal. *How to Shoot Stock Photos That Sell*. 3rd Ed. New York: Allworth Press, 2001.

Heron, Michal. *Stock Photography Business Forms*. New York: Allworth Press, 1997.

Lawrence, Peter, and Jeff Cason. *The Photo Marketing Handbook*. New York: Images Press, 1991.

McCartney, Susan. *Nature Photography*. New York: Allworth Press, 1994.

McCartney, Susan. *Travel Photography*. 2nd Ed. New York: Allworth Press, 1999.

Photo District News. Monthly newspaper for professional photographers. New York: Visions Unlimited Corporation.

2001 Photographer's Market. Cincinnati: Writer's Digest Books, annual.

Pickerell, James H. *Negotiating Stock Photo Prices*, 2nd Ed. 110A Frederick Avenue, Rockville, MD 20850.

Pickerell, James H. *Taking Stock*. Monthly newsletter. 110A Frederick Avenue, Rockville, MD 20850.

Piscopo, Maria. *The Photographer's Guide to Marketing and Self-Promotion*. 3rd Ed. New York: Allworth Press, 2001.

Purcell, Ann, and Carl Purcell. *Stock Photography: The Complete Guide*. Cincinnati: Writer's Digest Books, 1995.

Seed, Brian. *The Stock Photo Report*. Monthly newsletter for professionals. (708) 677–7887.

Standard Rate & Data, Co. Standard Rate & Data (Red Book). Wilmette, Illinois: *Standard Rate & Data*, Co., periodical.

Helpful Organizations

Advertising Photographers of America (APA)
606 North Larchmont Boulevard
Los Angeles, California 90004
Tel: (800) 272–6264
www.apanational.org

American Society of Media Photographers (ASMP)
150 North Second Street
Philadelphia, Pennsylvania 19106
Tel: (215) 451–2767
Fax: (215) 451–0880
www.asmp.org

American Society of Picture Professionals (ASPP)
409 South Washington Street
Alexandria, Virginia 22314
Tel/Fax: (703) 299–0219
www.aspp.com

David MacTavish, Esq.
Attorney at Law
www.MacTavish_Law.com
E-mail: David@MacTavish_Law.com

Professional Photographers of America, Inc.
229 Peachtree Street NE
Suite 2200
Atlanta, Georgia 30303
Tel: (404) 522-8600
www.ppa.com

U.S. Copyright Office
Library of Congress
101 Independence Avenue SE
Washington, D.C. 20559
Tel: (202) 707–3000
www.loc.gov/copyright

Glossary of Licensing Terms

AD SLICK: An advertisement prepared and distributed to advertisers (e.g., franchises, product representatives, and so on) for placement by them.

ADVERTISING: The promotion of goods, services, ideas.

ADVERTISING POSTER: A poster used for promotional purposes.

ADVERTORIAL: Publication advertising that is presented as editorial material.

ALL RIGHTS: Licensing of all copyright rights—although time, geographic territory, publication, publisher, and so on, should limit the grant. Note: this term lacks universal definition, so care is urged in the use of the term. Many licensees believe it is a transfer of ownership or it is an unlimited grant of all rights. Compare: EXCLUSIVE, BUYOUT.

ANIMATIC: Television commercial test based on storyboards, using photographs or illustration filmed in stop-motion, accompanied by the scripted audio.

ANNUAL: A yearly publication, often produced by trade or educational institutions, listing students, staff, events, accomplishments, and so on. See YEARBOOK.

ANNUAL REPORT: Yearly financial report of a company, detailing income, expenditures, goals, accomplishment, plans, and so on for distribution to shareholders and other interested persons.

ARTIST REFERENCE: Photographs used as a guide in creating another work.

ARTIST RENDERING: The creation of a substantially similar picture by someone other than the original author.

ART PRINT: Photograph displayed as a work of art, usually framed. This is different from a photograph that is used in the sale of picture frames.

ASSIGNMENT: Photographs commissioned by a particular client; also, the transfer of copyright or other rights, duties, or obligations to another person(s) or firm.

ASSOCIATION MAGAZINE: A publication for the members of a particular organization.

AUDIO VISUAL: A presentation using sound and images (e.g., projected or otherwise viewed still images, video or film for meetings, events, public viewing, and so on).

A.V. See AUDIO VISUAL.

BACKGROUND: The use of a photograph as a background for television, film, or stage. See SET DECOR.

BANNER: A hanging sign, usually large and made of flexible material (e.g., paper, cloth).

BILLBOARD: A large sign used for print advertising. Traditionally an outdoor display, they are now found inside arenas and other large indoor structures.

BOOK: Written or printed pages, bound along one side, enclosed by protective pages; distinguished from magazines and periodicals and pamphlets. Photographs are often used on the cover, jacket, and inside. See COFFEE TABLE BOOK, EDUCATIONAL BOOK, HANDBOOK, PAPERBACK BOOK, PICTURE BOOK, SCHOOL BOOK, TEXT BOOK.

BOOK JACKET: A wraparound, paper cover of a book.

BOOKMARK: Something used to mark one's place in a book; usually flat and thin; sometimes carrying a photograph.

BOX: A container for a product or merchandise.

BROCHURE: A pamphlet; often promoting or advertising goods or services.

BUYOUT: A term lacking universal definition; often held to be a license to reproduce a photograph in advertising that is totally unlimited, or unlimited in some aspect but restricted in others (e.g., unlimited number of uses, but limited to a specified geographical area).

CALENDAR: A table varying in size and design showing the months, weeks, and days in at least one specific year. Calendars may be sold as retail products or distributed as promotional items. Single hanger calendars typically contain one photograph. Multiple hanger calendars typically display a different photograph each month. Desk calendars may display a different photograph for each week or each day.

CAPTIVE READER PUBLICATION: A publication distributed to a captive audience, typically passengers on airliners and cruise ships, hotel guests, and so on; not a commonly used term.

CARD: A flat, usually rectangular piece of stiff paper, cardboard, or plastic, that may be a set or pack bearing numbers, symbols, or figures, used in games; a greeting card, post card.

CARDBOUND BOOK: See HARDBACK BOOK.

CASSETTE: A small case containing two reels and a length of magnetic tape that winds between them for use in audio or video tape recorders or players; a lightproof container containing photographic film. See CD–ROM, DVD, VIDEO.

CATALOG: A listing or itemized display of articles or goods for exhibition or sale, usually including descriptive information or photographs.

CD/CD-ROM: A small optical disc on which digitized information such as images, data, or music is encoded. CD-ROMs, or compact discs, read only memory: Information can be read and played only by computer or CD player. CD-RWs read and write, allowing computers or player-recorders to both play and record information to the disk. See DVD.

CHARITY: A nonprofit institution or a fund established to help the needy. See NONPROFIT, PUBLIC SERVICE.

CHECK DESIGN: A photograph illustrating the face of a bank check.

CIRCULATION: The distribution of publications in a specified period of time.

CLIP ART/DISKS/IMAGES/PHOTOS: Euphemisms for the practice of making images available with few or no rights restrictions, generally at a very low price or for free; the word "clip" is often attached to the other words to indicate artwork or media carrying the artwork.

COFFEE TABLE BOOK: A large-format book, usually heavily illustrated by photographs.

COLLAGE: An assemblage of diverse photographs arranged to form a new image.

COLLECTIVE LICENSING: Cooperative administration of holders' copyright rights. License managers are controlled by the copyright holders, with a standardized licensing fee structure or individually established fees.

COMMERCIAL: An advertisement of goods or services on television; typically using motion images but sometimes still photographs.

COMMISSION: An assignment; a sum paid to an agent for work done— may be paid directly, or the agent may deduct from the amount collected. Compare ROYALTY.

COMP: In advertising—finished artwork; also, an abbreviation for something that is complimentary in some manner.

COMPENDIUM RIGHTS: License to bind existing publications to make a single volume.

COMPUTER CD-ROM: Media capable of holding digitized information, images, and sound.

CONSUMER MAGAZINE: A paperback periodical published for the general public.

COPY TRANSPARENCY: See DUPLICATE.

COPYRIGHT: An intangible right granted by law to the author or originator of literary or artistic productions, giving the author the sole and exclusive privilege of reproducing copies of the work, publishing, distributing, licensing, or selling them. See COLLECTIVE LICENSING, PRIMARY RIGHT, SECONDARY RIGHT, LICENSE, FIRST GENERATION PUBLICATION RIGHT, SECOND GENERATION PUBLICATION RIGHT, REUSE RIGHT.

COUNTER CARDS: Advertising or promotional piece placed where a product is sold or near a cash register to promote sales. Also known as Header Cards, Point of Purchase or POP.

COVER: The front page of a publication, usually containing the publication name, publisher's name, and often a photograph or illustration to attract buyer attention. See FRONTISPIECE.

CREDIT or CREDIT LINE: Acknowledgment of a photograph's author, copyright holder, or an agency, usually placed adjacent to or near the photograph.

CREDIT CARD: A card offering charging privileges to the bearer, often displaying a photograph.

DAMAGE FEE: A charge made for damage to or loss of a photograph or its mount.

DELIVERY MEMO: A document listing and accompanying a shipment of photographs with terms and conditions controlling the shipment, use, return, and ownership of the photographs.

DERIVATIVE: Under the copyright law, a work based on pre-existing work. Only the holder of copyright in the underlying work (or one acting with the holder's permission) may prepare a derivative work; preparing a derivative work without permission is an infringement. See INFRINGEMENT.

DESK CALENDAR: See CALENDAR.

DIGITAL IMAGING: To translate photographs or other pictures by computer into numbers, which can be manipulated to change the photograph, or which can be transmitted to a remote location and then reconverted into pictures by another computer.

DIRECT MARKETING/DIRECT MAIL: Promotional work mailed to a market, group, or list of names.

DISPLAY PRINT: Photograph used in a display or exhibit, also known as EXHIBITION PRINT.

DISTRIBUTION AREA: A geographic territory (e.g., local, regional, national, international or worldwide) specified in a license restricting the rights granted.

DOWNLOAD: The act of copying online information (e.g., images, text, and so on) to one's computer from a computer disc, other computer, or the Internet (i.e., World Wide Web). See WEB, WEBSITE, INTERNET.

DUMMY: A publication prototype, usually with sample photographs and text, to convey the proposed size and format of the finished work.

DUPLICATE/DUPE: An exact copy or reproduction of a transparency, usually in the same format.

DURATRANS: A back-lighted positive transparency, generally used in advertising or promotion.

DVD: Digital videodisc, a small optical disc on which digitized information such as video, film, and sound may be encoded; similar to CD-ROMs.

EDITION: The total number of copies of a publication printed from a single typesetting or at one specified time. May also refer to the form that a publication takes (e.g., hardbound, paperback). The means of identifying the various versions of a publication.

EDITORIAL: Publication of a photograph in a journalistic manner that is not intended for promotional or advertising use.

EDUCATIONAL BOOK: A publication containing information on a subject studied in the classroom by students. Editions may include student editions and a teacher's handbook. Also known as TEXTBOOK.

ELECTRONIC RIGHTS: Licensing of copyrighted work for use in digital media, including CD-ROMs, data bases, and Web sites: See RIGHTS.

ENCYCLOPEDIA: A publication, traditionally in book form but now on CDs and Web sites, providing information on many branches of knowledge; usually organized alphabetically and containing photographs and illustration.

EUROPEAN RIGHTS: License to exploit copyright rights in Europe. Note: this is an undefined geographic region, and a written license should state the countries included with specificity. See GEOGRAPHIC TERRITORY, INTERNATIONAL RIGHTS, RIGHTS, TERRITORY.

EXCLUSIVE: Licensing of copyrighted work that excludes others from obtaining similar rights. Rights may be limited by time, territory, industry, client type, product type, and so on. Note: This is a term lacking a universally accepted definition, so caution is urged in the use of the word. Many licensees believe that the term includes all copyright rights. Compare ALL RIGHTS, BUYOUT. See RIGHTS.

EXHIBITION: Can be noncommercial—typically available in libraries, schools, museums, etc.; or, commercial—advertising, promotional—possibly in a corporate building lobby, pay-to-view, and so on.

EXHIBITION CATALOG: A publication containing a list of exhibited objects.

EXHIBITION PRINT: A displayed or exhibited image. Also known as DISPLAY PRINT.

EXTERNAL HOUSE PUBLICATION: A publication for shareholders, for the general public and other interested parties, and possibly for employees of a company or organization. Although the publication may appear to be a journalistic piece, most house publications have a promotional emphasis. Also known as a "house organ." See INTERNAL HOUSE PUBLICATION.

FILE FORMAT: The form of an electronic file, whether an image or text file, and, more specifically, what type of image or text file it is.

FILM STRIP: A length of film usually containing specific still images; not part of a motion film; traditionally used without sound, but now often accompanied by a sound track utilizing a tone or other notice to advance the film strip one frame. See AUDIO VISUAL.

FIRST GENERATION PUPLICATION RIGHT: The right to reproduce an image, regardless of the media in which it is captured, that is delivered to the licensee by the copyright holder (e.g., a magazine publisher printing a photographed delivered by the photographer). See SECOND GENERATION PUBLICATION RIGHT.

FIRST RIGHT: The right to be the first to publish a picture in a territory or a medium. Not to be confused with First Generation Publication Right.

FLAP: Part of a book jacket, often containing the author's photograph.

FLASH: A use right; the limited use of a photograph in a television commercial, usually lasting five seconds or less.

FORMAT: The dimensions and size of a book, piece of paper, film (e.g., 4″ × 5″, 35mm), or photographic print. See FILE FORMAT.

FREE STANDING INSERT: Advertising supplements that are inserted in publications like magazines, journals, or newspapers; they contain no editorial material.

FRONTISPIECE: An illustration that faces or immediately precedes the title page of a book, book section, or magazine.

FSI: See FREE STANDING INSERT.

HARDCOVER/HARDBACK: A hard cover bound publication. See BOOK, SOFTCOVER.

HEADER CARDS: Promotional piece appearing on shelving or stand holding a product. Also known as counter card, pole topper. See POINT OF PURCHASE.

HOLDING FEE: A charge made for the retention of copyrighted work by a licensee, or person or entity who has requested to examine the work, beyond the agreed-upon period of time.

HOUSE JOURNAL: Also known as house organ. See IN HOUSE PUBLICATION. Compare EXTERNAL HOUSE PUBLICATION.

ILLUSTRATED BOOK: A book of photographs or other illustrations; often elegantly printed and designed. See COFFEE TABLE BOOK, PICTURE BOOK.

IMAGE: Generally, the thing that is reproduced on film in a camera. More specifically, a reproduction of the form of a person or an object; an optically formed duplicate, counterpart, or other representative reproduction of an object, especially an optical reproduction of an object formed by a lens. Compare PHOTOGRAPH.

IMAGING: See DIGITAL IMAGING.

INFRINGEMENT: An unlawful invasion of another's copyright rights (i.e., unauthorized use, reproduction, publication, public display, distribution, etc.).

IN-FLIGHT MAGAZINE: The airline company publication distributed to on-board passengers. See CAPTIVE READER PUBLICATION, EXTERNAL HOUSE PUBLICATION.

IN–HOUSE PUBLICATION/INTERNAL HOUSE ORGAN: See INTERNAL HOUSE PUBLICATION.

INSERT: A printed piece distributed to customers along with a firm's invoice or other mailing. Compare FREE STANDING INSERT.

INSERTION: A use right; inclusion of a photograph in an advertisement. Calculating price based (in part) on insertions is usually determined by media type (e.g., magazines, newspapers, etc.), title of publication(s), number of insertions, length of time, and so on. See LENGTH OF TIME RUNNING, RIGHTS.

INTERNAL HOUSE PUBLICATION: A company or organization publication for employees and sometimes shareholders; generally not made available to the public. See EXTERNAL HOUSE PUBLICATION.

INTERNATIONAL RIGHTS: A use right; rights granted that permit use of a copyrighted work in another country or countries. The license should limit the grant by specifying countries by name, unless the grant is broadly intended to include any foreign territory. See GEOGRAPHIC TERRITORY, INTERNATIONAL RIGHTS, RIGHTS, TERRITORY.

INTERNET: A system of worldwide, electronic, digital communication by computer. See WEB SITE.

JACKET: Paper wraparound cover of a book. See BOOK, COVER, FLAP, FRONTISPIECE.

JIGSAW PUZZLE: A puzzle often made up of a photograph that is cut into small, irregular pieces and later reassembled by the purchaser.

JOURNAL: A publication (e.g., magazine) that is periodically issued. Often used to report legal, medical, scientific, or academic subjects.

LABEL: A tag identifying a manufacturer and defining a product, including information about materials in the product. See also HANG TAG, TAG, SWING TAG.

LANGUAGE RIGHTS: Permission to use copyrighted work in specified languages. The right is not restricted to text but includes images published in works employing certain languages (e.g., "Permission granted to use image in the XYZ textbook, to be published in English, German, and French"). See RIGHTS.

LAYOUT: A presentation of elements proposed for an advertisement or other graphic work, typically displaying the planned placement of photographs, text, and other graphic elements. Layouts typically have two stages—a rough or preliminary layout, sometimes called a mock-up, followed by finished artwork. See COMP, PRESENTATION.

LEAFLET: A pamphlet, typically used to promote or advertise. See BROCHURE.

LENGTH OF TIME: A use right—the specified time period in a licensing agreement permitting use of a copyrighted work (this may be expressed as a limitation on the number of insertions during a time period, or as the time period a photograph may appear on a Web site). See INSERTION, LICENSE, RIGHTS.

LICENSE: Generally, permission from an authority to do some act; specifically, to exercise certain of the rights in a copyrighted work—e.g., authorizing the right to reproduce, distribute, display, or make a derivative work. This permission may be by restricted by time, amount (e.g., press run), or geographical area. See COLLECTIVE LICENSING, COPYRIGHT, RIGHTS.

LICENSE FEE: An amount of money charged for the right to exercise certain granted privileges, like the right to reproduce an image. See HOLDING FEE.

LOSS FEE: A charge made for the loss of a copyrighted work, typically based on the earnings potential of the work plus the actual cost of replacement or a predetermined rate to cover replacement. See DAMAGE FEE.

MAGAZINE: A periodical containing a collection of articles, stories, pictures, or other features, that may be aimed at the general public or a limited group of professionals or hobbyists; may be paid for through retail sales or subscriptions or given away.

MAGAZINE NETWORK: A company that owns or publishes several publications.

MAGNET: A novelty item that may carry a copyrighted work as decoration.

MAT AD: A promotion or advertisement that is prepared and distributed to advertisers for placement at their discretion. Also called an ad slick.

MEDIA KIT: Information distributed by a company, person, or organization to interested parties (e.g., the press and potential investors).

MOCK-UP: Typically the first stage in the preparation of an advertisement. See LAYOUT.

MODEL RELEASE: An agreement signed by the subject of a photograph allowing use of the image(s); typically relinquishes all rights of control or interest the subject might have claimed in an image. Licensees often require proof of release before image(s) are used in advertising or promotion. Compare PROPERTY RELEASE. See RELEASE.

MONTAGE: A grouping of photographs or other elements to produce a new image. See DERIVATIVE.

MOTIVATIONAL POSTER: A poster, often of limited press run or circulation used internally by a company or other organization to encourage achievement, or sold at retail typically with a larger press run and distribution. See POSTER.

MOUSE MAT: A small, smooth mat upon which a computer mouse is moved around.

MULTIPLE HANGAR CALENDAR: See CALENDAR.

MULTIPLE RIGHTS: Licensing rights permitting more than one use of the same image(s). See RIGHTS.

MURAL: A large image, typically a painting or enlarged photograph, applied directly to a wall or ceiling.

NEW EDITION: A version of an earlier publication in which greater changes or additions have been made than those of a new printing; often assigned a new ISBN number.

NEWSPAPER: A periodical news publication typically issued daily or weekly, with national or regional circulation, usually purchased but sometimes free, often presenting advertisements in addition to the journalistic pieces.

NONEXCLUSIVE: Image licensing that doesn't exclude others from using the image. Compare EXCLUSIVE. See RIGHTS.

NONPROFIT: An organization or firm, typically engaged in public service activities, that does not operate with profit as a goal. May indicate a grant to use an image(s) without charge or for a reduced charge. See CHARITY, PUBLIC SERVICE.

NUMBER OF INSERTIONS/NUMBER OF TIMES USED: See INSERTIONS, RIGHTS.

OFFLINE: Digitized information or material stored in electronic form in a database not directly connected to a network on the Internet. See ONLINE.

ONE-TIME RIGHTS: A license granted for single reproduction of a picture. See RIGHTS.

ONLINE: References both to a computer that is connected to, and information available on, the Internet or other computer network.

ORIGINAL: Generally, something that precedes all others in time; the source from which a copy, reproduction, or translation is made; not derived from something else; fresh and unusual, showing a marked departure from previous practice; new. In photography, a positive or negative film-based image that is either the first or master image.

OUTTAKES: Images taken at the same time, or during the same assignment, that are rejected during film editing; may be identical or similar to those selected. Compare SIMILARS.

OVERHEAD PROJECTION: Enlarged images of written or pictorial material projected onto a screen or wall from a transparency placed horizontally below the projector and lighted from underneath. See AUDIO VISUAL.

PACKAGING: A box, container, or wrapping that encloses merchandise, often carrying photographs as decoration.

PAGE RATE: A method of calculating photography use fees, based on the area taken by an image on a page, occasionally used by newspapers and magazines for editorial images. This method of pricing could offer an advantage to photographers who negotiate the page rate with knowledge of the space rate that is paid by advertisers in the publication.

PAPERBACK: A paper or card bound book. See BOOK.

PATERNITY FEE: A charge made for failure to attribute authorship of an image; the agreement for attribution must be made contractually. In the United States it is not a copyright right; rather, it is an obligation incurred by contract.

PERPETUITY: For all time. More specifically, a use right that can be granted but that in reality lasts only for the duration of copyright, at which time the copyrighted work falls into the public domain and may be used by anyone.

PERSONAL PRINT: A single copy of an image for noncommercial, private use; typically for private display, such as personal portraits or wedding photographs.

PHOTOGRAPH: An image fixed on photographic medium, usually film or a print. To reduce confusion between the use of "image" and "photograph," it may be more precise to use this term when referring to the physical object that holds the image, and to use "image" when referring to the reproduction or representation of the subject that was photographed—that is, the thing that is viewed on the film or print. Compare IMAGE.

PICTURE BOOK: A publication, liberally illustrated, usually with photographs. See BOOK, COFFEE TABLE BOOK.

PICTURE FRAME INSERT: A photograph or illustration used in a frame to promote the sale of the frame by showing how an image looks when mounted in the frame. The image may also appear in advertising or point of sale pieces for the frames.

PLACEMAT: A protective table covering, which may contain photographic images as decoration.

PLACEMENT: The position of an image in a publication (e.g., front or rear cover, inside page, or cover flap).

PLAYBILL: A poster promoting a theatrical production.

PLAYING CARD: A card marked with its rank and suit and belonging to any of several decks used in playing various games. May carry a photograph(s) on the reverse side as decoration.

POINT OF PURCHASE: Promotional piece displayed where a product is sold, often next to or on top of the product. Also known as HEADER CARD, counter card, shelf talker, point of sale, pole topper.

POP: See POINT OF PURCHASE.

POSTCARD: Generally, a card carrying an image on one side with room for an address and postage on the other side. Sold at retail, cards often carry images of local points of interest for travelers or to support messages of a personal nature. Cards used by businesses typically hold an image(s) for promotion or advertising.

POSTER: A large, printed placard, bill, or announcement, often illustrated, posted to advertise or publicize something; often an artistic work or a reproduction of an original painting or photograph, printed on a large sheet of paper.

PRESENTATION: A layout of a printed piece shown to a client for approval. See COMP, LAYOUT, SAMPLE PRINT.

PRESS KIT: Information, typically including photographs, specially prepared and packaged for the press or other interested persons, distributed at a news conference or before the release of a new product.

PRESS RELEASE: Information, often including photographs, sent to the press, often by public relations companies, to promote persons (often business leaders or politicians), products, or events.

PRESS RUN: The number of copies printed, whether by printing press, computer printer, or any other means of printing.

PRIMARY RIGHT: Copyright rights given greater value based on the use and value to the user. Traditionally, this has been the right licensed to users, but secondary rights may become most common as a result of the growing ease of copying and transmitting images. See SECONDARY RIGHT.

PRINT RUN: More correctly, press run, the number of copies printed. See PRESS RUN.

PROGRAM: A listing of the order of events and other pertinent information for a presentation.

PROJECTION/PROJECTED: The appearance of an image on a surface, typically produced by beaming light through a photographic transparency so that the light strikes a screen. See AUDIO VISUAL, OVERHEAD PROJECTION, SLIDE SHOW.

PROPERTY RELEASE: An agreement signed by the owner of property allowing use of the image(s) in which the property appears; the owner typically relinquishes all rights of control or interest in the image(s). Licensees often require proof of release before image(s) are used in advertising or promotion. Compare MODEL RELEASE. See RELEASE.

PUBLIC RELATIONS: The art of establishing and promoting a favorable relationship with the public on behalf of a person, company, product, service, cause, and so on, often through the use of photographs.

PUBLIC SERVICE: A service performed for the benefit of the public, especially by a nonprofit organization. May indicate a grant to use an image(s) without charge or for a reduced charge. See CHARITY, NONPROFIT.

PUBLIC SERVICE ANNOUNCEMENT: A televised message broadcast on behalf of a charity, nonprofit, or public service organization. May indicate a grant to use an image(s) without charge or for a reduced charge. See CHARITY, NON–PROFIT, PUBLIC SERVICE.

PSA: See PUBLIC SERVICE ANNOUNCEMENT.

RECORD ALBUM: See PACKAGING.

REPRINT: An additional printing of a book, brochure, or other publication without substantial revision. See BOOK, EDITION, REVISION.

RESALE POSTER: A poster sold at retail for personal use. See POSTER.

RESEARCH FEE: See SEARCH FEE.

RETAINING/RETENTION FEE: A charge made for the retention of copyrighted work by a licensee or a person or business requesting to examine the work beyond the agreed upon period of time. Also known as HOLDING FEE.

REUSE RIGHT: A licensee's right to use a photograph previously published under a prior license granted to that licensee (i.e., a second or subsequent use by the same publisher in a different publication). See SECONDARY RIGHT, SECOND GENERATION PUBLICATION RIGHT.

REVISION: An additional printing of an edition of a book with alterations. See BOOK, EDITION, REVISION.

RIGHTS: Authorization or permission (i.e., license) by the copyright holder to exploit specified copyright rights in a work. The grant may be limited by time, geographic or language area, quantity (e.g., edition, press run, circulation), and so on. See BUYOUT, COMPENDIUM, ELECTRONIC, EXCLUSIVE, FIRST GENERATION PUBLICATION, FIRST, INTERNATIONAL, LANGUAGE, LICENSE, MULTIPLE, NONEXCLUSIVE, ONE-TIME, PRIMARY, REUSE, SECONDARY, SECOND GENERATION PUBLICATION, SECOND USE.

ROYALTY: Compensation for the use of copyrighted property, often expressed as a percentage of profits made through use of the property. Compare COMMISSION.

SALES KIT: Printed pieces (and other items) supplied to sales personnel as presentation aids— can include, for example, brochures, product information sheets, postcards, posters, and less frequently video cassettes, CD-ROM, or DVD.

SAMPLE PRINT: A complimentary photographic print given to help a client or potential client decide if the image is appropriate for a specific project. May be called, but is more specifically part of, a LAYOUT.

SATELLITE: A method of transmitting television programs and, increasingly, digitized images. See TELEVISION.

SCHOOL BOOK: A book used in the classroom. See TEXTBOOK, BOOK.

SEARCH FEE: A fee charged to a client by a photographer or agent, compensating the photographer or agent for looking for specified existing photographs. The fee is sometimes waived if a license is negotiated and paid for by the client. Incorrectly known as a SERVICE FEE. Also known as a RESEARCH FEE.

SECONDARY RIGHT: Reprographic rights; the use of a published image by photocopying it and using it in only a few copies or publications with very small circulation. The fee is usually less than for primary rights and may be (likely will increasingly be) collected by collecting societies. Not to be confused with SECOND USE. See COLLECTIVE LICENSING, SECOND GENERATION PUBLICATION RIGHT.

SECOND GENERATION PUBLICATION RIGHT: Reprographic rights—the right to photocopy or otherwise reproduce an already published image and use it in very small circulation or lesser media. Compare with SECOND USE. See PRIMARY RIGHT, RIGHTS, SECONDARY RIGHT.

SECOND USE: An additional use in the same publication. Not to be confused with SECONDARY RIGHT, SECOND GENERATION PUBLICATION RIGHT. Compare REUSE. See RIGHTS.

SENSITIVE ISSUES: Situations that may be considered sensitive, especially to the subjects photographed; including but not limited to situations involving abortion; contraception; mental abuse, illness, or retardation; physical abuse, deformity, or illness; plastic surgery; race; religion; sex; sexuality; sexually transmitted diseases; and substance abuse.

SERVICE CHARGE/FEE: A fee charged for performing a service or act, typically as compensation for rebilling or additional billing of unpaid or partially paid invoices. Not to be confused with RESEARCH or SEARCH fees.

SET DECOR: Photographs that are used as part of the set of a television, film, or stage production. Compare BACKGROUND.

SHELF TALKERS: See POINT OF PURCHASE.

SHOW CARD: See POINT OF PURCHASE.

SIMILARS: Images taken by the same photographer, generally at the same time or on the same assignment, as an image chosen by a licensee. In this regard, SIMILARS are OUTTAKES. Compare OUTTAKES.

SINGLE HANGAR CALENDAR: See CALENDAR.

SLIDE SHOW: A presentation using projected mounted photographic transparencies, typically at a meeting, conference, or public event. The images may be editorial or promotional and are typically accompanied by a speaker or sound track.

SOFTCOVER/SOFTBACK: A paper or card bound publication. See BOOK, HARDCOVER.

SPECIAL TERMS: Out of the ordinary or atypical contractual conditions or language; generally, provisions added to or changed clauses in a standard (i.e., "boilerplate") contract. See RIGHTS.

STAMPS: A small piece of paper sold by the government, with adhesive on one side and often a photograph on the other, that is attached to letters and packages as proof that postage has been paid.

T-SHIRT: Loose pullover shirt, often with a picture printed on the front or back. See MERCHANDISE.

TAG: Tags hanging from items for sale. Also called hang tag, swing tag.

TAPE BOX: See PACKAGING.

TELEPHONE DIRECTORY: Compilation of telephone numbers from a specific locale in book or CD-ROM form.

TELEVISION: A means of receiving transmitted images and sounds. Photographs are often used in various ways. The two most common are editorial—nonpromotional news and theatrical programs; and commercial—clips used to promote or advertise goods or services. Issues to consider when negotiating and licensing copyrighted work to appear on screen include: distribution or number of viewers; how transmissions are made—broadcast, cable, or satellite; length of time the image(s) will appear; and percentage of screen the image will take up.

TELEVISION SCREEN TIME: A use right; the length of time a photograph appears on screen. See RIGHTS, TELEVISION.

TERRITORY: A use right; the geographic, political boundary, or language area for which a use is licensed. See RIGHTS.

TEXTBOOK: A book, usually dedicated to a large area of study (e.g., history, social studies), used in school classrooms; may contain photographs. Additional editions may be published, such as a teacher's handbook or special student editions. See BOOK.

THEATRE PROGRAM: A listing of the order of events and other pertinent information for a presentation.

151

TRADE MAGAZINE/JOURNAL: A publication aimed at a specific industry or group of workers; may be sold at retail or by subscription, or may be freely distributed.

TRADE UNION MAGAZINE/JOURNAL: A publication published by or for a union and its membership. Also known as UNION MAGAZINE.

TRANSPARENCY: A positive image, generally in color, on photographic film. Smaller film formats (e.g., 35mm, 2¼" × 2¼") are typically mounted in cardboard frames called mounts. May be an original or duplicate. See AUDIO VISUAL, DUPLICATE, ORIGINAL, PROJECTION, SLIDE SHOW.

TRAVEL BROCHURE: A printed work promoting a travel destination or advertising accommodations or transportation; produced by travel and tour industry service providers or governments.

UNION MAGAZINE: A publication for trade union members.

USE: A general term denoting the exercise of copyright rights, specifically the right to reproduce (copy), distribute, publicly display, or create derivative works. Because of its general, undefined nature, the word should always be qualified by the specific terms of a license (e.g., not "permission to use" but "permission to reproduce the image of XYZ in the MNO magazine, June 2002 issue, for distribution in North America.") See RIGHTS, LICENSE.

VIDEO: Televised images; productions stored on videotape or videodiscs; video equipment and technology. Usually refers to images in motion, but still photographs may appear in videos or be stored on the same technology. See CASSETTE, CD-ROM, DISC, DVD, TELEVISION.

VIDEO BOX: See PACKAGING.

WEB: See INTERNET, WORLD WIDE WEB.

WEB SITE: An address or site on the World Wide Web (i.e., WWW) where images, sound, text, illustration, color, and so on may be accessed either for information, promotion, or commercial purposes. Individuals and companies maintain Web sites as a means of communicating with other people and companies worldwide. Computer owners may often download images and other elements of a Web site for use. See DOWNLOAD, INFRINGEMENT, LICENSE, RIGHTS.

WORLD RIGHTS: Language in a license allowing the exercise of some or all of a holder's copyright rights (i.e., to reproduce, distribute, publicly display, or make derivative works) on a worldwide basis; geographic, political boundary, language, or other limitations may be imposed (e.g., " Time Inc. is granted world rights to publish my image of Santa Claus, with the exception of China. Additionally, my image may not be used to promote the sale of *Time* magazine.") See RIGHTS.

WORLD WIDE WEB: An interface allowing easy interaction with the Internet, a system of worldwide electronic communication between computers. See INTERNET, WEB, WEB SITE.

YEARBOOK: An annual publication, published by businesses, trade organizations, or educational institutions, often listing financial information, students, members, faculty, staff, events, and so on. Also known as ANNUAL.

Index

BOOKS FROM ALLWORTH PRESS

How to Shoot Stock Photos That Sell, Third Edition by Michal Heron (paperback, 8 × 10, 224 pages, $19.95)

ASMP Professional Business Practices in Photography, Sixth Edition by the American Society of Media Photographers (paperback, 6¾ × 9⅞, 416 pages, $29.95)

Photography: Focus on Profit by Tom Zimberoff (paperback, 6¾ × 9⅞, 448 pages, $35.00)

Business and Legal Forms for Photographers, Third Edition by Tad Crawford (paperback, 8½ × 11, 180 pages, includes CD-ROM, $29.95)

The Photographer's Guide to Marketing and Self-Promotion, Third Edition by Maria Piscopo (paperback, 6¾ × 9⅞, 192 pages, $19.95)

Talking Photography: Viewpoints on the Art, Craft, and Business by Frank Van Riper (paperback, 6 × 9, 288 pages, $19.95)

The Photographer's Internet Handbook, Revised Edition by Joe Farace (paperback, 6 × 9, 232 pages, $19.95)

The Photographer's Assistant, Revised Edition by John Kieffer (paperback, 6¾ × 9⅞, 256 pages, $19.95)

Stock Photography Business Forms: Everything You Need to Succeed in Stock Photography by Michal Heron (paperback, 8½ × 11, 144 pages, $18.95)

Mastering the Basics of Photography by Susan McCartney (paperback, 6½ × 10, 192 pages, $19.95)

The Photojournalist's Guide to Making Money by Michael Sedge (paperback, 6 × 9, 224 pages, $18.95)

The Business of Studio Photography: How to Start and Run a Successful Photography Studio by Edward R. Lilley (paperback, 6¾ × 9⅞, 304 pages, $19.95)

Photography Your Way: A Career Guide to Satisfaction and Success by Chuck DeLaney (paperback, 6 × 9, 256 pages, $18.95)

Law (in Plain English) for Photographers by Leonard DuBoff (paperback, 6 × 9, 208 pages, $18.95)

Historic Photographic Processes: A Guide to Creating Handmade Photographic Images by Richard Farber (paperback, 8½ × 11, 256 pages, $29.95)

Creative Black-and-White Photography: Advanced Camera and Darkroom Techniques by Bernhard J Suess (paperback, 8½ × 11, 192 pages, $24.95)

Travel Photography, Second Edition by Susan McCartney (paperback, 6¾ × 9⅞, 360 pages, $22.95)

Overexposure: Health Hazards in Photography, Second Edition by Susan D. Shaw and Monona Rossol (paperback, 6¾ × 9⅞, 320 pages, $18.95)

Please write to request our free catalog. To order by credit card, call 1-800-491-2808 or send a check or money order to Allworth Press, 10 East 23rd Street, Suite 510, New York, NY 10010. Include $5 for shipping and handling for the first book ordered and $1 for each additional book. Ten dollars plus $1 for each additional book if ordering from Canada. New York State residents must add sales tax.

To see our complete catalog on the World Wide Web, or to order online, you can find us at *www.allworth.com*.